THE

Rainbow
Atlas

First published in the United States of America in 2020 by Chronicle Books LLC.

Copyright © 2020 Quarto Publishing plc.

Conceived, designed, and produced by The Bright Press,
an imprint of The Quarto Group.

The Old Brewery, 6 Blundell Street,
London, N7 9BH, United Kingdom
T (0) 20 7700 6700 F (0) 20 7700 8066
www.QuartoKnows.com

Manufactured in Singapore.

The Bright Press
Ovest House, 58 West Street, Brighton,
BN1 2RA, United Kingdom

Publisher: James Evans
Art Director: Katherine Radcliffe
Managing Editor: Jacqui Sayers
Senior Editor: Caroline Elliker
Project Editor: Kath Stathers
Art Director: Katherine Radcliffe
Layout and Design: Anna Gatt
Picture Research: Susannah Jayes, Anna Gatt
Cover Design: Anna Gatt, Allison Weiner

10 9 8 7 6 5 4 3 2 1
Library of Congress Cataloging-in-Publication Data
Names: Fuller, Taylor, 1991- author.
Title: The rainbow atlas : a guide to the world's 500 most colorful places
/ Taylor Fuller.
Description: San Francisco : Chronicle Books, 2020.
Identifiers: LCCN 2019033490 | ISBN 9781452182827 (hardback)
Subjects: LCSH: Geography–Pictorial works. | Travel–Pictorial works. |
Photography in geography. | Photography, Artistic.
Classification: LCC G116 .F85 2020 | DDC 910.22/2–dc23
LC record available at https://lccn.loc.gov/2019033490

Chronicle Books LLC
680 Second Street
San Francisco, California 94107
www.chroniclebooks.com

MIX
Paper from
responsible sources
FSC® C016973

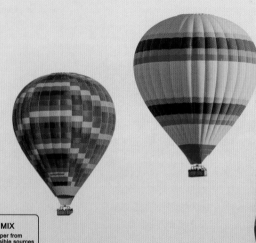

THE
Rainbow
Atlas

A GUIDE TO THE WORLD'S 500 MOST COLORFUL PLACES

TAYLOR FULLER

CHRONICLE BOOKS
SAN FRANCISCO

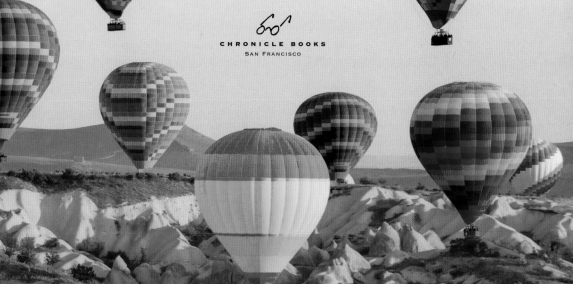

CONTRIBUTORS

Taylor Fuller • @taylor_fuller

Taylor is an American travel blogger who has been traveling the world looking for the most colorful cities and street art for more than five years. During that time she has called Paris, Florence, Thailand, and now London, home. Her popular blog, *Travel Colorfully*, focuses on capturing bold and beautiful places in the world. She loves exploring a new destination by interacting with locals, tasting the cuisine, and wandering through the streets.

Kristin Addis • @bemytravelmuse

Kristin is a native Southern Californian who has dedicated her life to solo traveling the world. Her award-winning blog and travel brand, *Be My Travel Muse*, helps women travel the world in a more adventurous, genuine way. She has published two books and is the founder of the Photo Muse Masterclass as well as a company organizing women's adventure tours around the world.

Melanie Faulknor • @girlaroundworld

Melanie is a writer and content creator who has been traveling the world since she was fourteen. She worked in a foreign embassy and space institute before founding the colorful Instagram gallery *Girl Around World* in 2016. After working and studying abroad, she returned to Canada where she concentrates on curating and creating content for *Girl Around World* and producing video games at a Triple-A game studio. She describes standing above the rainbows at Iguazú Falls as her most magical experience.

Chloe Gunning • @wanderlustchloe

With a passion for food, fun, and adventure, Chloe is the pint-sized Brit behind top travel blog *Wanderlust Chloe*. From volcano-boarding in Nicaragua, to sailing around Sicily, and eating her way around Japan, Chloe's travels have taken her to plenty of colorful and diverse destinations. As well as sharing travel tips and photos on her blog, she also creates content for *Metro* and Lonely Planet. She's currently planning her next big adventure—tying the knot with her travel blogger fiancé!

Emily Luxton • @em_luxton

Emily Luxton is a full-time travel blogger focusing on solo female travel and personal development. Whether she is eating her way around a new culture, or throwing herself into a new challenge, Emily is all about getting to know the world—and having fun doing it! Her travel writing has been published online in publications including Lonely Planet and *The Telegraph*. Her favorite place for color is Kyoto in the fall, when the temples are surrounded by scarlet and golden leaves.

Emma Jane Palin • @emmajanepalin

A specialist in creating content focused on design, culture, and color, Emma is a multi-award-winning blogger and writer based between London and Margate. She's an avid traveler with a keen eye for detail and finding the extraordinary in everyday life. Her favorite place for finding color is the city of Berlin, where there are colorful houses galore and a celebration of creativity at every turn.

Kath Stathers • @kstathers

Kath is a London-based writer and editor who spent half of 2018 living in northern Spain. She was lead author and editor for *The Bucket List: 1000 Adventures Big & Small*, and author of *The Bucket List: Wild*. Her travel writing has appeared in UK magazines for airlines, ferries, and national newspapers, and she has edited contract magazines for a number of clients, including the Youth Hostels Association. Her favorite place for color is the Oma Painted Forest in Spain, which perfectly combines the natural environment with the fun of color.

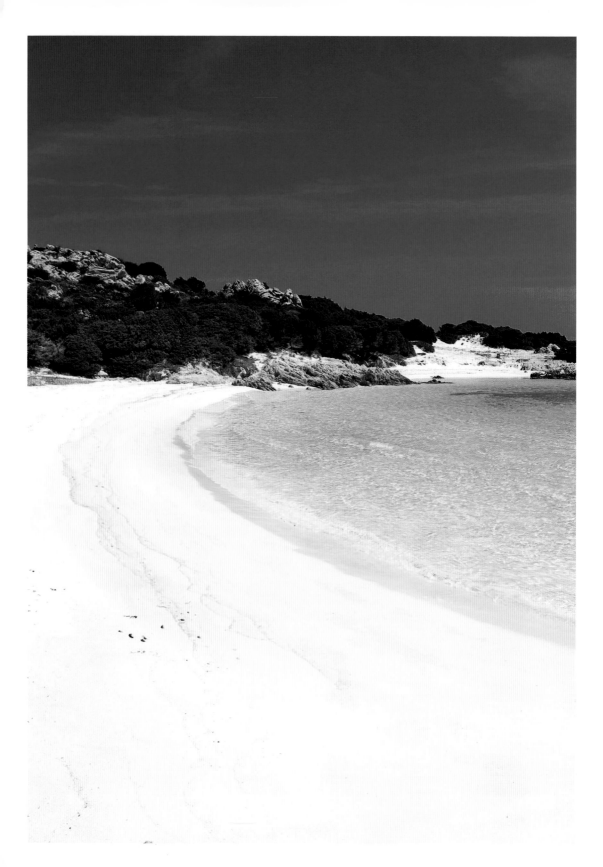

FOREWORD

The first time I picked up a camera I was eight years old. I was visiting family in Hawaii and they took me snorkeling. As soon as I dived into the water I was surrounded by a menagerie of tropical fish representing every color of the rainbow. It wasn't just cartoons anymore that were bright and beautiful; dazzling colors existed in the real world, too. The day I fell in love with photography was also the day that I truly fell in love with color.

In a time when oversaturated and heavily edited photos are all the rage, it's inspiring to see that Mother Nature, mural artists, and indigenous cultures the world over truly can be bright, beautiful, and better than a picture can ever convey. There are lakes in Patagonia and Canada that are bluer than the mind can conceive of; there are sunsets in the tropics that Photoshop can't improve upon; and there are pops of color in the regalia of chiefs and hill tribes tucked into all corners of the world, just begging to be discovered.

As photographers and world travelers, we have a unique opportunity and responsibility to show the world why nature and culture is so worth protecting. Over the past seven years, as I have traveled solo to many remote places, I have seen glaciers shrinking and trash filling the ocean. But I have also seen people becoming more concerned with "leave no trace" principles, preserving what we have, and recognizing the importance of asking people if it's OK to photograph them before taking their picture. As the world becomes more and more connected through social media, it's each of our responsibilities to fiercely protect and preserve it.

I hope that this book makes you fall in love with our gorgeous Earth and its people like it has for me. Let's all work together to love, share, and responsibly enjoy this beautiful world we live in.

Kristin Addis
@bemytravelmuse

CONTENTS

The entries in this book are arranged by longitude, starting in Alaska and traveling around the globe to New Zealand. Each entry's number is color coded:

Natural world
Urban art
Festival
Built environment
Leisure and culture
Place of worship

INTRODUCTION

One of the most common questions that people ask me when I tell them I'm a travel blogger is, "What's your favorite place that you've ever been to?" My response is always the same. I laugh and say: "You know, that's the worst question ever." Because every single place is different. There's no one thing that makes me fall in love with a place; it's a combination of things. It's the feeling I get when I see something truly beautiful; it's the mixture of the sights and sounds, and even smells, I experience; it's the people I meet along the way; the adventure I have while I'm there. It's everything.

Travel allows you to learn more about other cultures and to see how other people live. It's important we use this privilege to better the world. It's all too easy to rush off to some beautiful place you've seen on the internet to snap the most Instagrammable photo you can. But that neither enriches your life nor the place you're visiting.

Though I'm sure this book will inspire you to visit gorgeous, colorful places around the world, I also hope it fills you with the desire to learn more about these places. Take some time to learn about the history of an old European city; find out why houses are painted the colors they are; talk to a local and see a destination through their eyes. This is the true joy of travel, because while a picture tells one thousand words, your memories will tell you one thousand more.

I first fell in love with travel while living in Florence, Italy: eating pasta, meeting new people, and watching pastel colors paint the sky each evening. After Italy, I moved to Thailand to teach English.

I spent my weekends visiting ornate temples covered in millions of pieces of sparkling glass and snorkeling in crystal-clear water with vibrant coral reefs. It was here that I realized the influence color had on why I visited new places. And so my blog, Travel Colorfully, was born.

Over the next few years, I ventured to far-off places. I wandered down the streets of Havana dotted with colorful vintage cars. I explored cities such as San Francisco and New York, where vivid murals and street art can be found everywhere you look. I wandered far and wide on a hunt for the bold and the beautiful. This book gives me the opportunity to share some of those places with you. Use it as a guide to plan your next adventure, or keep it on a coffee table and flip through it to find something to brighten up your day.

I hope *The Rainbow Atlas* brings you as much joy to rifle through as I have had writing it; that you learn about new places, as I have learned from my fellow contributors: from pink lakes in Mexico and Australia, to buildings that look like a set of Lego bricks in Denmark.

The world isn't black and white. It's a rainbow filled with cotton-candy skies, azure oceans, and trees in every shade of green. So enjoy this book and the adventures it leads to; share it with your friends and family, and remember, always travel colorfully.

Taylor Fuller, Lead Author
@taylor_fuller
www.travelcolorfully.com

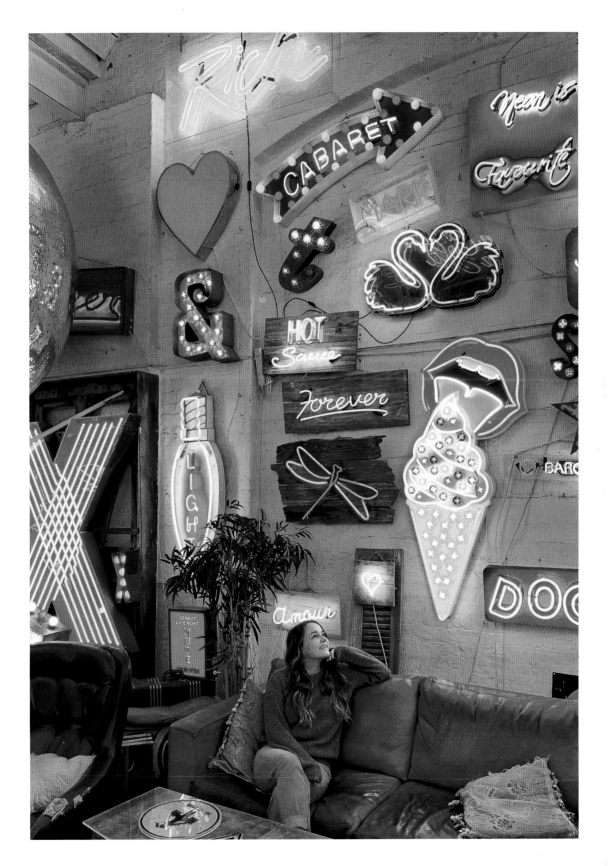

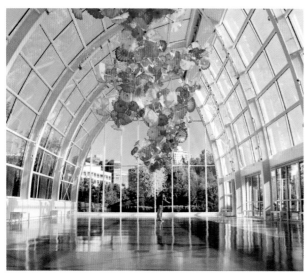

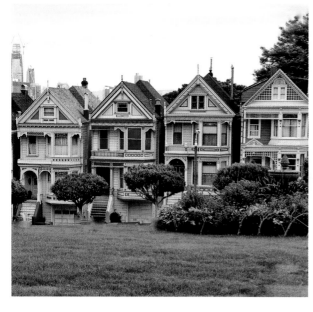

CHAPTER ONE

180°–120°

WEST

1 It's not just black and white

Black Rock Beach, Rarotonga Island, Cook Islands

Longitude: 159.7° W
When to go: April, May, September, and October for the best weather

This untouched oasis of white-sand beach and turquoise water has a mystical local history. The large basalt rocks don't just offer stunning coastal views: Local legend has it that human spirits depart from this part of the coastline, too.

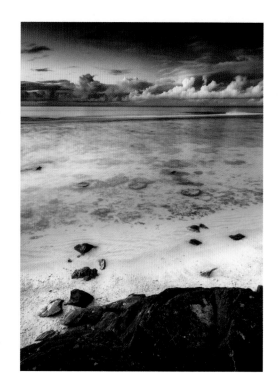

2 Mother Nature's garden

Nāpali Coast, Kauai, Hawai'i, U.S.A.

Longitude: 159.6° W
When to go: May to September

With blue water, emerald cliffs and shimmering waterfalls, Kauai's Nāpali Coast is a lush rainbow of natural beauty so stunning that even in a place dubbed The Garden Island, it stands out. The shore is accessible by land and sea. There is a fabulous three-day trek known as the Kalalau Trail. Or Zodiac tours can access the shore, and kayaking is permitted in the summer. Aerial tours via helicopter are a more expensive option and your feet won't touch the shore, but the whole coast is visible and it will be sure to leave you breathless without the physical effort.

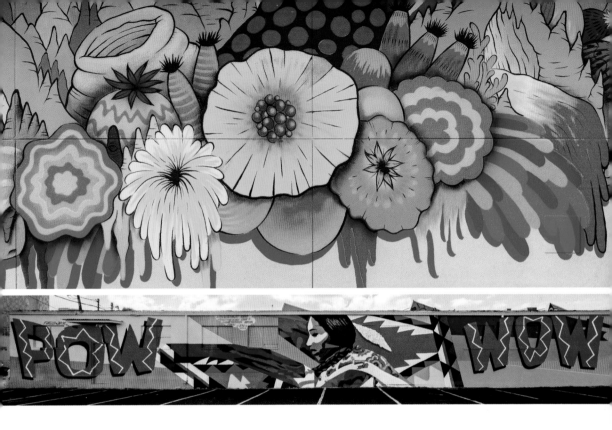

3 Come on, let's celebrate

POW! WOW! Festival, Honolulu, Oahu, Hawai'i, U.S.A.

Longitude: 157.8° W
When to go: February

For the week around Valentine's Day in the community of Kaka'ako, Honolulu, each year more than one hundred artists from around the world gather together to turn Honolulu into a living art gallery. The name *POW! WOW!* works on several levels. *Pow* for the impact art has on a person, and *wow* for the reaction of the viewer. Together it makes *pow wow*, a Native American word meaning "celebration of culture, music, and art," and that is the POW! WOW! Festival in a nutshell.

4 All because of a yellow lizard

Moorea Lagoon, French Polynesia

Longitude: 149.8° W
When to go: June and August

The island of Moorea, which means "yellow lizard" in Tahitian, earned its name because it's said that a giant lizard opened up the two bays of Cook and Opunohu with its tail. Nestled in between the bays is Moorea Lagoon, with its crystal clear turquoise water.

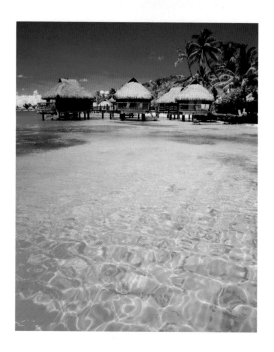

5 Treasure beyond measure

Autumn Tundra, Yukon Territory, Canada

Longitude: 135.0° W
When to go: September to October

Famous for the Klondike Goldrush of 1897 when a rampant stampede of prospectors hit the north in the hopes of striking it rich, the Yukon holds far more treasure than just hard metallic gold. In the fall, the tundra transitions from green to bright orange, golden yellow, and crimson red for two months, transforming a picturesque mountain meadow into an explosion of colors.

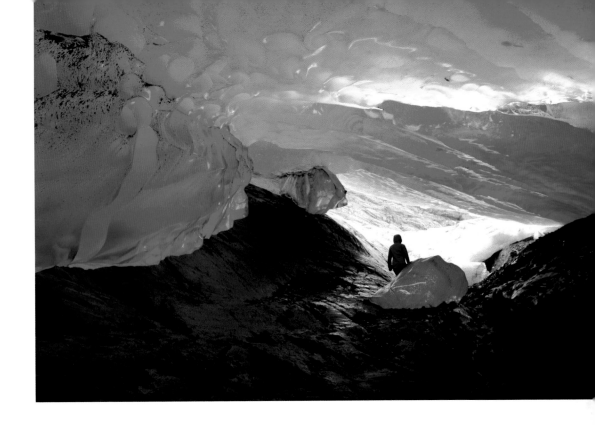

6 Blue end of the spectrum

Mendenhall Glacier, Tongass National Forest, Alaska, U.S.A.

Longitude: 134.5° W
When to go: All year, May to September for longer hours

There is a quiet majesty to all glaciers: with their age and timeless beauty that transforms landscapes. Mendenhall Glacier in Alaska's Tongass National Forest is one of thirty-eight large glaciers that flow from the Juneau Icefield. Formed over three thousand years ago during the Little Ice Age, it is 12 mi/ 19.3 km long and its crystal blues stand out against the snow and landscape. The spectacular colour is due to the air bubbles being squeezed out of the ice over the centuries, giving glaciers such as Mendenhall their sparkling blue tone. As with all nature,

it's affected by the environment around it and Mendenhall is retreating due to the climate crisis. The environmental impact from the retreat is severe, threatening sea levels and freshwater supplies, but the melting ice is also revealing secrets from the earth's past. The retreating glacier recently exposed a natural treasure trove of ancient trees with roots and bark, perfectly preserved under a blanket of gravel from the glacier. The best way to experience Mendenhall's sparkling splendor is to hike along the multiple trails of the surrounding area.

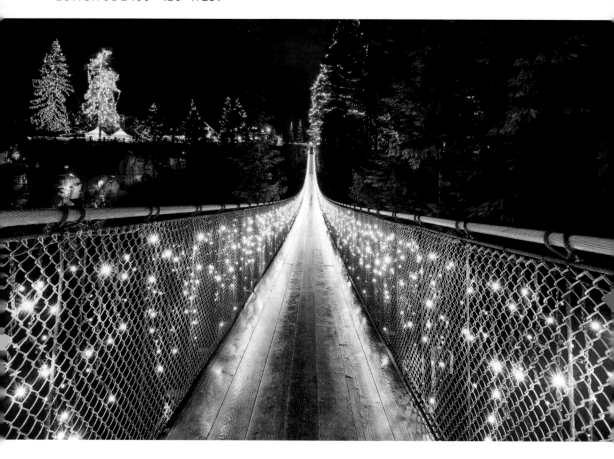

7 Light up the night

Canyon Lights, Capilano Suspension Bridge, North Vancouver, Canada

Longitude: 123.1° W
When to go: November to January

Every November the Capilano Suspension Bridge turns into an enchanted forest during Canyon Lights—a winter lights festival. Decorated with hundreds of thousands of colorful bulbs, the bridge, canyon, and surrounding rainforest are lit up like a fairy land, including eight Douglas firs that reach heights of 110 ft/33 m, making them the world's tallest decorated Christmas trees.

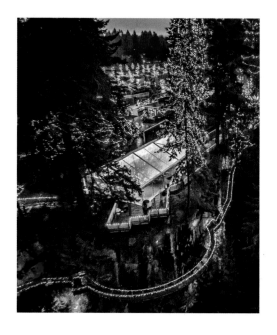

8 Tip-toe through the tulips

BLOOM, The Abbotsford Tulip Festival, Abbotsford, Canada

Longitude: 122.3° W
When to go: April to May

Celebrate spring's arrival by tip-toeing through a living rainbow made up of over 2.5 million tulips. The countless varieties, spread across 10 ac/40,000 m², mean the bloom lasts for around five weeks. A third-generation Canadian tulip farmer, Alexis Warmerdam, founded the festival believing the public would love frolicking through the tulips as much as she herself did, and how right she was.

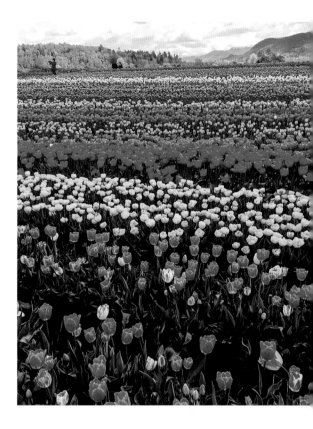

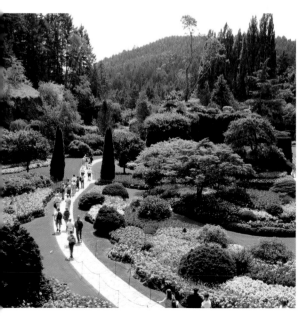

9 What you can do with a concrete base

The Butchart Gardens, Vancouver Island, Canada

Longitude: 123.4° W
When to go: All year

These stunning gardens were created by Jennie Butchart more than one hundred years ago to transform a disused limestone quarry which had been dug out by her husband's cement business. There are five gardens here now, each with its own variety of landscaping. The Sunken Garden alone boasts 151 flower beds and 65,000 bulbs.

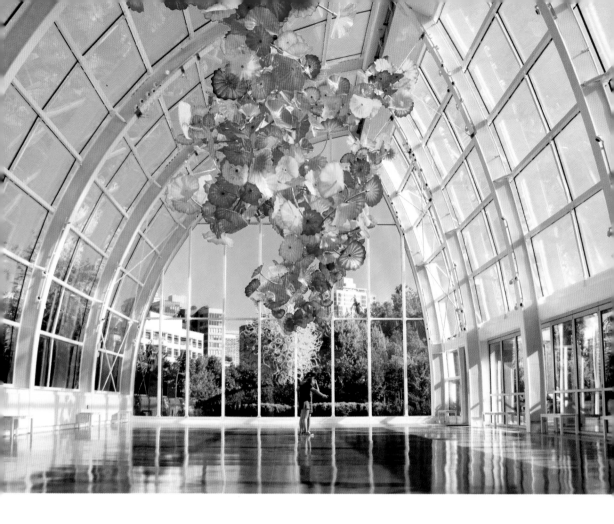

10 Wander in a wonderland

Chihuly Garden and Glass, Seattle, Washington, U.S.A.

Longitude: 122.3° W
When to go: All year

There can't be many exhibitions entirely devoted to glass, but this one in Seattle covers 1.5 ac/6,000 m² with eight galleries, several drawing walls, and a wonderful garden. Inspired by two of glass-artist Dale Chihuly's favorite buildings, Sainte-Chapelle in Paris and the short-lived Crystal Palace in London, his centerpiece is the Glasshouse. It displays a 100 ft/30 m long suspended sculpture of reds, oranges, yellows, and ambers totaling 1,340 pieces. Vibrant colors and whimsical designs throughout the exhibit create a wonderland to wander through.

11 Street art to desire

Balmy Alley and Clarion Alley, Mission District, San Francisco, U.S.A.

Longitude: 122.4° W
When to go: All year

The Mission District in San Francisco is exploding with color. Vibrant murals line the streets and alleyways. While several streets in the area are covered with art, the best is found around Balmy Alley and Clarion Alley. The first murals appeared in Balmy Alley in 1972, painted by a two-woman team who called themselves Mujeres Muralistas. In the mid 1980s, mural activists covered all the garage doors and fencing in the alley with meditations on Central American culture and the U.S.A.'s involvement in Central America. Although murals change regularly, the strong social and political messages remain. More than seven hundred murals have been created since 1992 in Clarion Alley alone.

12 Home is where the exquisite paintwork is

▼ Painted Ladies, Alamo Square, San Francisco, U.S.A.

Longitude: 122.4° W
When to go: All year, but September to November for warmer weather

During World War I and II, houses in San Francisco were painted with surplus Navy paint, known as "battleship gray." In the 1960s, artist Butch Kardum painted his Victorian-style house with blues and greens. Inspired, his neighbors followed suit, resulting in a colorist movement, filling entire neighborhoods with color.

13 It's a shore thing

King's Beach, North Shore of Lake Tahoe, California, U.S.A.

Longitude: 120.0° W
When to go: Summertime

With streets lined with old-timey hotels, quirky shops, and delicious restaurants, it's no wonder that King's Beach is the place to be in Lake Tahoe. And while the town is a funky little beach town that hasn't changed much over the years, the sparkling lake is what really draws people in.

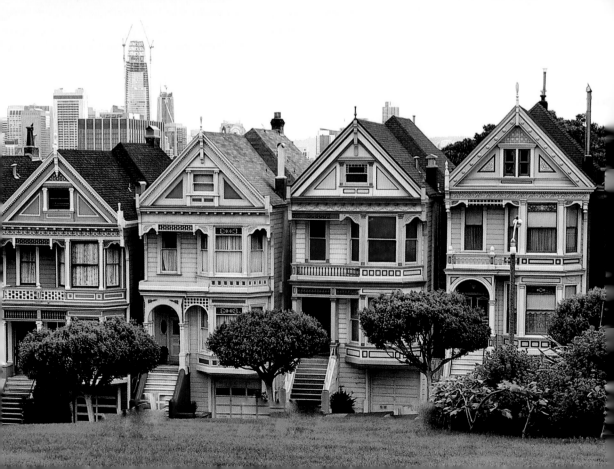

14 California dreaming

Capitola City Beach, Capitola, California, U.S.A.

Longitude: 121.9° W
When to go: May to October for best weather and beach activities

Little candy-colored beach houses with European flair, the condos of Capitola's Venetian Court sit directly on Capitola City Beach. Built in 1924, they are listed as one of the first condo seaside developments in California and, luckily for the rest of us, some of these little slices of beach heaven are available to rent. The beach really comes alive during the summer when evenings are filled with live music, outdoor dance floors, and movies on the beach. Fall brings wine and art festivals, and opera.

15 Spell it with color

The Alphabet District, Portland, Oregon, U.S.A.

Longitude: 122.7° W
When to go: All year

So-called because the street names all run alphabetically, Portland's Alphabet District is buzzing with shops, bars, restaurants, and cafés. There are all styles of architecture found in this historic city, but it is the brightly painted Victorian townhouses of the Pearl District that really steal the show.

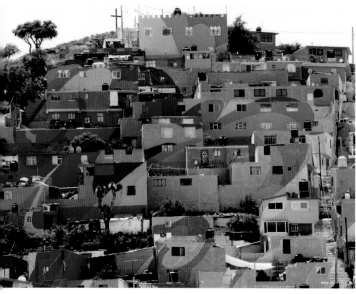

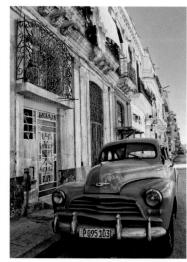

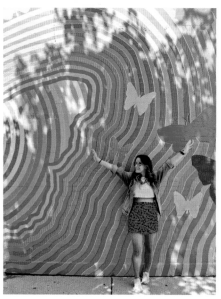

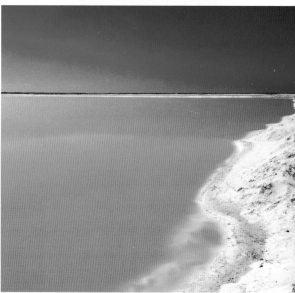

CHAPTER TWO

120°-80°

WEST

16 Somewhere under the rainbow

▶ Chromatic Gate, Santa Barbara, California, U.S.A.

Longitude: 119.6° W
When to go: All year

Coastline, mountains, palm trees, and white stucco walls with red tile roofs, Santa Barbara is an idyllic central Californian city with beautiful views of the Pacific Ocean. So in 1991, when an arts committee headed by Paul Mills, former Art Director of the Santa Barbara Museum of Art, erected Herbert Bayer's Chromatic Gate along the coast on Cabrillo Boulevard, not everyone was thrilled with the idea. The metal rainbow arch stands 21 ft/3.6 m tall and is dedicated to the artists of Santa Barbara. Bayer, a student and teacher at the Bauhaus School in Germany, was considered the last living member of the Bauhaus movement. He studied under Kandinsky and contributed to an astounding number of fields in the arts, earning his spot in the Smithsonian. The last decade of his life was spent in California and Mills saw the chance to celebrate art and a great artist in the area he called home. Over the years, the Chromatic Gate has become a beloved structure to the locals, a cheerful piece of art from an international artistic legend.

17 The hills are alive

California superbloom, southern California, U.S.A.

Longitude: 119.4° W
When to go: March to July

Southern California residents are regularly treated to "super blooms" in the national parks and hills of the state. The natural phenomenon occurs in spring or early summer, when, following good rainfall and cooler temperatures, the hills burst forth in flower. A wander through the beautiful trails (and please do keep to the trails) will reveal several hundred brightly colored plant species, from vivid purple desert lavender and sunflowers, to red poppies and magenta pink blossoms.

18 Spot the changes

Los Angeles Murals, Downtown L.A. Arts District, California, U.S.A.

Longitude: 118.2° W
When to go: All year

The city of Los Angeles has a complicated history with street art. In the 1990s, outdoor advertisers sued the city saying that it was unconstitutional to allow murals but not advertising. So the city banned both. In 2013, they rewrote the rules and street art flooded back in. Downtown L.A., in particular, became a canvas for street artists from around the world. Now the City of Angels is covered in colorful murals that are constantly changing year after year.

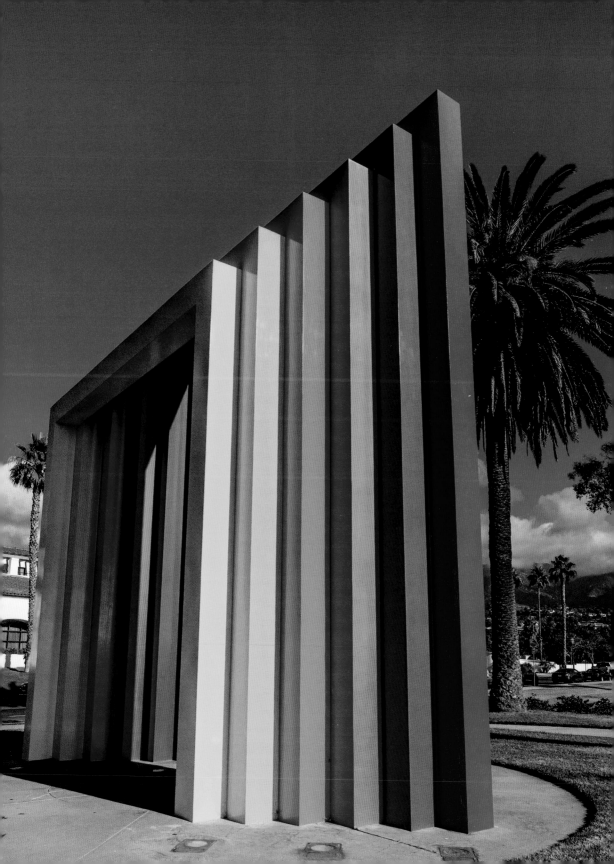

19 Water colors with a difference

Fly Geyser, Fly Ranch, Washoe County, Nevada, U.S.A.

Longitude: 119.3° W
When to go: All year

Like something from a sci-fi movie, Fly Geyser is a small but out-of-this-world colorful geothermal geyser on Fly Ranch, which is owned by Burning Man Project. The geyser blows a constant stream of hot water about 5 ft/1.5 m high and thermophilic algae inside the water color the surrounding rocks bright red and green. Notable for multiple conical openings, the geyser's story began in 1916 when an effort to drill a well failed after a geothermal source was hit. Near-boiling water wouldn't work for irrigation, so the site was abandoned, but the water continued to flow, depositing calcium carbonite and creating a cone. In 1964, a few hundred yards away from the first try, a second well was attempted by a geothermic energy company. Also unsuccessful, it was boarded up, but water still found a way out. The second site diverted pressure from the first and it turned into the multiple coned alien-esque spectacle now known as Fly Geyser.

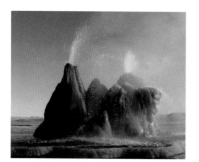

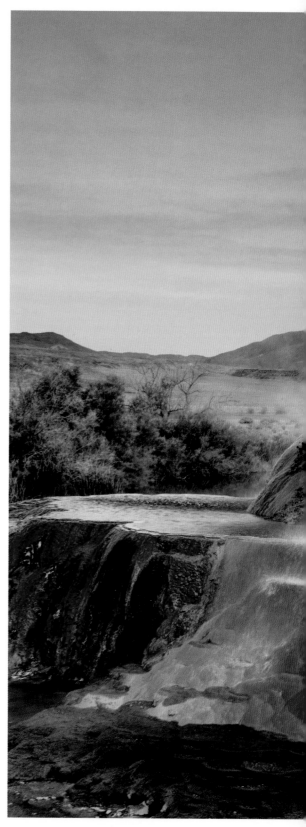

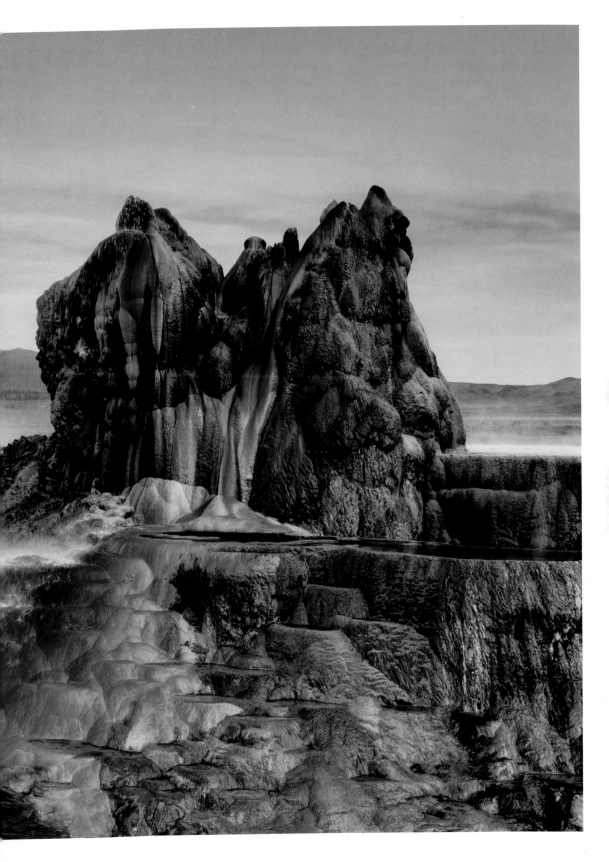

20 Dream in color

The Kinney, Venice Beach, California, U.S.A.

Longitude: 118.4° W
When to go: All year

Opened in 2016, the Kinney Venice Beach is more than just a hotel. The ink-blotted rainbow wallpaper and mustard yellow couches add flair to the bedrooms, while in the courtyard, technicolor murals and contemporary artwork line the walls, complemented by the pink outdoor lighting.

21 More than murals

Abbot Kinney Boulevard, Venice Beach, California, U.S.A.

Longitude: 118.4° W
When to go: First Friday of the month

With streets lined with colorful murals, vintage stores, chic boutiques, juice shops, and cafés, the 1 mi/1.6 km Abbot Kinney Blvd is brimming with culture. But the real way to see the Venice Beach street is on the first Friday of the month, when food trucks roll in to serve up flavor and fun.

22 **Desert bloom**

The Saguaro Hotel, Palm Springs, California, U.S.A.

Longitude: 116.5° W
When to go: January to April for ideal weather

Just a mile from the foot of the San Jacinto Mountains and a short ride away from Palm Springs, this colorful hotel is a Californian retreat. Designed by renowned architects Peter Stamberg and Paul Aferiat, the bold color palette has been created to reflect the vibrant spirit of the Coachella Valley desert and the indigenous desert flowers that inhabit it.

23 Stand-out stones

▼ Seven Magic Mountains, Interstate 15, Las Vegas, Nevada, U.S.A.

Longitude: 115.2° W
When to go: Early in the morning, all year

It's no wonder that a collection of whimsical, day-glo-colored boulder stacks set in the desert has a name like Seven Magic Mountains. The $3 million installation by artist Ugo Rondinone sprung up in 2016. Since then it has been stealing the show as people drive towards Las Vegas on Interstate 15. The bold towers pop against the natural earthy tones of the red sand and barren mountainside, creating an awesome contrast. The bright rocks lure tourists away from the overstimulation of the Vegas Strip and offer a moment of calm, if only for a while.

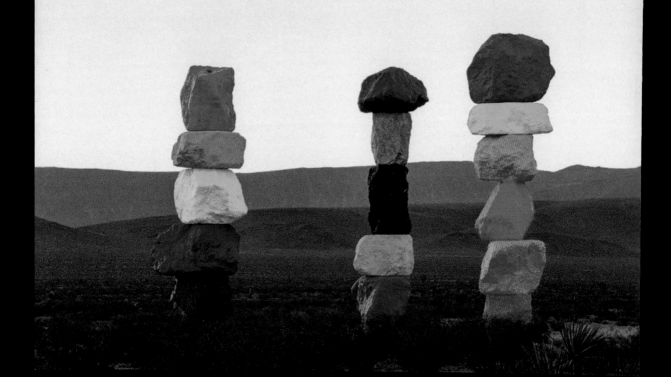

24 Written in lights

Neon Museum, Las Vegas, Nevada, U.S.A.

Longitude: 115.1° W
When to go: All year

What do Liberace's dry cleaner, a golden nugget, giant skulls, genie lamps, and a bunch of random old letters have in common? They all call the Neon Museum in Las Vegas home. Boneyard Park is home to several pieces of Vegas history ranging from old bar signs, to the giant Hard Rock Hotel guitar, to the ever-famous Stardust sign. During the day, you can see hundreds of old, vintage neon signs that have long since burnt out. At night, see Lady Luck, the Golden Nugget, and other notable signs come back to life in an epic light show.

25 Opportunity knocks

Palm Springs, California, U.S.A.

Longitude: 116.5° W
When to go: All year

With the Californian blue skies and palm tree backdrop, Palm Springs has always had a pop-art photogenic appeal, and with the advent of social media, it has become quite a phenomenon. Some of the most notable locations for stunning color combinations are The Saguaro and The Monkey Tree hotels, and the Pink Door house on East Sierra Way. Several private residences have also joined in the fun, changing the décor on their front patios to delight and surprise visitors. Keep in mind that the doors belong to private residences, so make sure their space is respected.

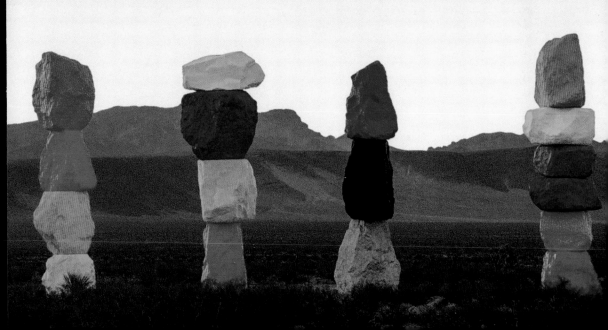

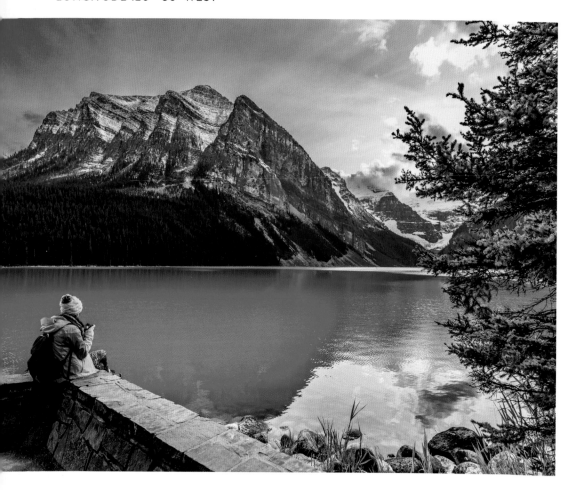

26 Flour and water makes turquoise

Lake Louise, Banff, Alberta, Canada

Longitude: 116.1° W
When to go: Late June to August for the most vivid water

With blue skies, mountain air, and turquoise water, Lake Louise is a fairy-tale destination. Nestled in the Canadian Rocky Mountains, the lake turns an extreme blue as melted glacier water flows into it. As the glacier thaws, with it comes silt, or "rock flour," which floats on the water's surface. Sunlight reflecting off the silt creates the stunning color. Even though it's a year-round destination with plenty of fun to be had in the winter, the lake doesn't thaw until June, so the best time to see the glittering turquoise is in the summer when the sun is out and the silt is still floating. For more brilliant blues, pop over to nearby Moraine Lake, also glacier-fed, but smaller—and with the added claim to fame that it graced the Canadian $20 bill between 1969 and 1979.

Grand by name, grand by nature

Grand Canyon, Arizona, U.S.A.

Longitude: 112.1° W
When to go: March to May or September to November

Carved out by the Colorado River nearly six million years ago, the Grand Canyon is one of the Seven Natural Wonders of the world. The air is among the cleanest in the United States, allowing hikers and visitors to breathe easy. It's 277 mi/445 km long and 18 mi/ 29 km across at its widest point, making it larger than the state of Rhode Island. From the North Rim to the South Rim, the panoramic views are filled with bold burnt-orange rocks. Small amounts of minerals, such as iron, are part of the layers of rock that make up the Grand Canyon and give it a red, yellow, green, and orange striped effect. As the sun rises and sets on the canyon, the colors shift with the ever-changing tones in the sky, leaving a golden hue everywhere you look.

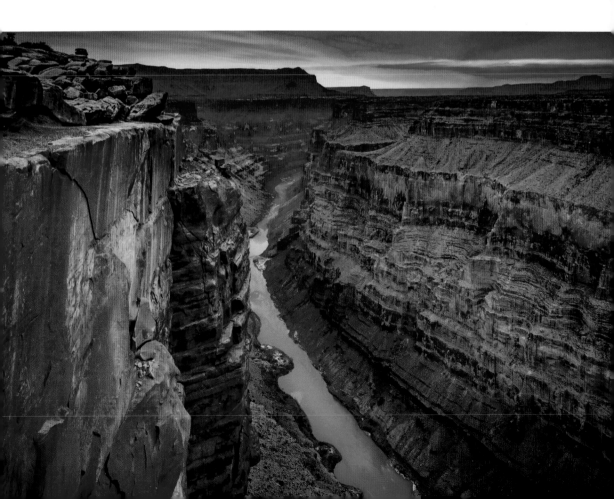

28 Take a trip

The Saguaro Scottsdale, Arizona, U.S.A.

Longitude: 111.9° W
When to go: Spring

Relaxing days in colorful cabanas, ice-cold margaritas, cozying up under a vibrantly striped blanket, and enjoying tasty tacos against a crazy beautiful background—these are the best parts of the Saguaro Scottsdale, a hotel that has been completely drenched in colors inspired by Arizona wildflowers. From bold, hot pink walls in the bedrooms to bright yellow, breezy loungers by the pool, lush, mauve carpets running down the hallways, and a fantastic façade covered in a technicolor rainbow, the Saguaro Scottsdale is a dreamland in the desert.

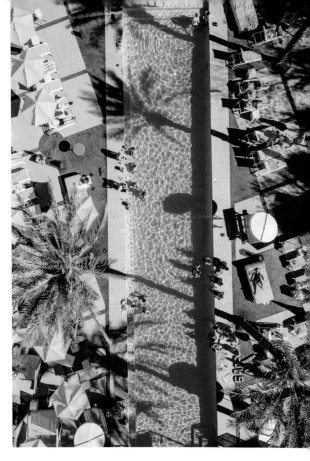

29 Feel the flow

Antelope Canyon, Arizona, U.S.A.

Longitude: 111.3° W
When to go: April to October

There is nothing more tenacious than nature whittling away at something over thousands of years. That is how the smoothly carved slot canyons of Antelope Canyon came to be: water flowing into a crack in the rock, gradually eroding the crack into an ever-larger gap. Rinse and repeat for over a thousand years and you have the miracle of a slot canyon. The icing on the swirly rock is the way the light enters the canyon through the cracks above and shines down to create a spotlight effect.

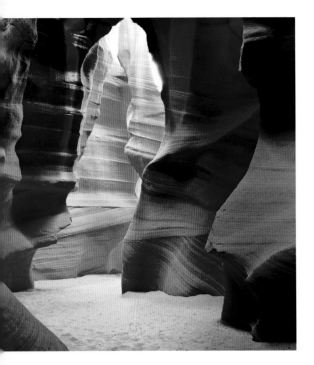

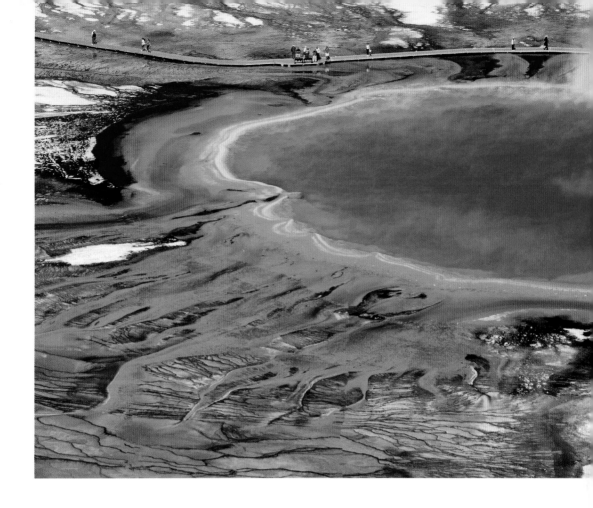

30 Spectacular spectrum

Grand Prismatic Spring, Yellowstone National Park, Wyoming, U.S.A.

Longitude: 110.8° W
When to go: May to September

Like white light refracting in a prism, Grand Prismatic Spring produces a spectrum of red, orange, yellow, and green colors around its blue water, creating the sequence of colors of its namesake. The rainbow ring comes from heat-loving bacteria that gradually cool as they move towards the outer rings. Seasonal temperature changes affect the brightness of the color: In the summer, when the water reaches 189°F/87°C, colors are vivid, whereas in cooler winter temperatures, the color fades. As well as being the most vibrant, the hot spring is also the largest in the United States (and third largest in the world), measuring 370 ft/113 m in diameter. Since 2017, there has been a viewing platform that makes it possible to see the spring from above. From this bird's eye view, the breadth of Grand Prismatic Spring's rainbow is nothing less than spectacular.

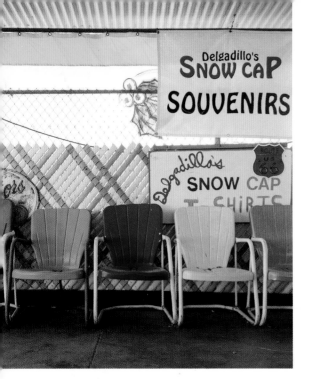

31 Get your kicks

Route 66, Seligman, Arizona

Longitude: 112.8° W
When to go: All year

The Mother Road—as John Steinbeck christened Route 66—may stretch from L.A. to Chicago, but Seligman, Arizona, is its birthplace. There is so much to do in this kitsch roadside town, but it's the vibrant building façades that will pull you in for a pitstop.

32 Home of the best westerns

Monument Valley, Utah and Arizona, U.S.A.

Longitude: 110.0° W
When to go: Spring and fall

A backdrop for the American Wild West, Monument Valley is filled with a cluster of sandstone buttes in vivid reds and oranges. Part of the semi-autonomous Navajo Nation, the largest Native American reservation in the United States, the park stretches between Utah and Arizona. The real magic happens at dawn and dusk as the light plays on the red sand and casts a glow on the rocks around you. Many Hollywood directors have used this epic setting in films, but it was the director of westerns such as *Stagecoach*, John Ford, who really took this valley's backdrop as his own. So much so that there is now a John Ford's Point named after him in the park.

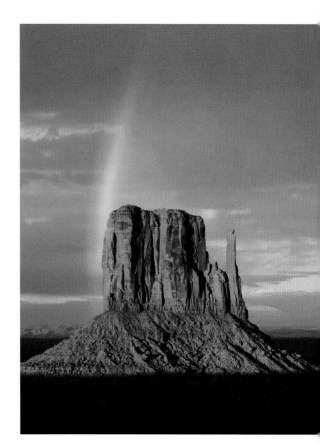

33 Ancient culture, modern color

Rosarito, Baja California, Mexico

Longitude: 117.0° W
When to go: All year

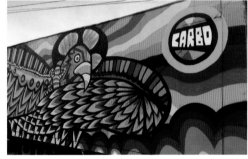

The artwork of Jaime Carbo can be found all over his Baja Californian hometown of Rosarito. The local artist blends together images and styles from Aztec and Mayan history with a strong element of modern pop culture and dazzling colors. Rosarito is just south of Tijuana, 10 mi/16 km from the border of the United States and Mexico. Its proximity to the United States meant that

during Prohibition, it became a popular haunt for Hollywood stars looking for a drink. But the charms of the resort's beaches lasted well after the prohibition was lifted: actors Rita Hayworth, Mickey Rooney, and Katharine Hepburn were all regular visitors. Today, the beaches are still as good, and the streets are bursting with colorful murals and dotted with art galleries.

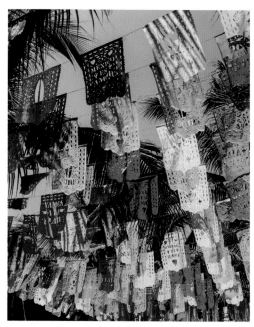

34 **Bold and bohemian**

Sayulita, Mexico

Longitude: 105.4° W
When to go: November to April

Bursting with color, vibrant Sayulita on the Pacific coast of Mexico is the perfect mix of bohemian flare and laid-back surfer vibes. With rainbows of flags draped over the main streets stretching from the balconies to the rooftops, boldly painted shop fronts, and boutiques overflowing with quirky items, Sayulita is anything but boring. The sleepy little beach town, known for its hippy influence, features a rich Huichol artisan culture. The Huichol, an indigenous tribe to Mexico, create bright, beautiful yarn paintings covered in wax that can be found lining the shops of Sayulita.

35 Color cascades

Guanajuato, Mexico

Longitude: 101.2° W
When to go: January to April

Colorful houses cascade down the hills that
surround Guanajuato. Ranging from baby
blue to lime green, tangerine, chartreuse,
and everything in between, there's no
pattern to the wonderful mish-mash. The
old houses in the colonial city center are
surrounded by pink bougainvillea that add
an extra level of color to the magic. A
UNESCO World Heritage Site, Guanajuato is
filled with history. Cobblestone lanes lined
with baroque and neoclassical buildings wind
steeply up the hills. And the bright saffron
yellow and deep red of the Basilica of our
Lady of Guanajuato pop against the bright
blue sky on a sunny afternoon.

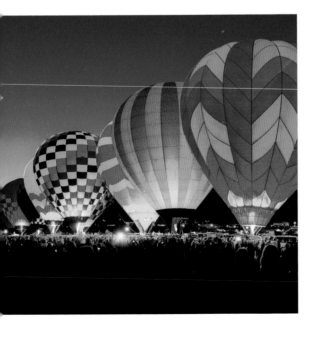

36 Nothing but hot air

Balloon Fiesta, Albuquerque, New Mexico

Longitude: 105.8° W
When to go: October

In 1972, thirteen hot air balloons launched
from a parking lot in Albuquerque. Those
humble beginnings have grown into the
largest ballooning event in the world. The
event lasts nine days, with the most
spectacular part being the mass ascension,
when five hundred balloons launch together,
making the clear blue skies dance with color.

37 Party like everyone's watching

Día de los Muertos, Mexico City, Mexico

Longitude: 99.1° W
When to go: October 31 to November 2

Between October 31 and November 2, Día de los Muertos, or Day of the Dead, is celebrated throughout Mexico, but in Mexico City it's bigger and better than anywhere else. The annual tradition is a time to remember and honor deceased family members. *Ofrendas*, or altars, are set up in plazas and cemeteries throughout the city. Orange marigolds are festooned around the ofrendas which also hold *pan de muertos*, *tamales*, *mole*, and candles to give the dead strength and light their way. The color isn't confined to the ofrendas, however. People dressed as "Catrina" skeletons, with intricately painted faces flood into the streets for the Day of the Dead parade. A relatively new tradition to the festivities, the parade was first staged for the James Bond movie *Specter* in 2016, but has become a staple since then with floats, dancers in vibrant skirts, and loud, festive music flowing along the Paseo de la Reforma and finishing with grand celebrations in the Zócalo—Mexico City's central square. This deeply personal holiday not only creates a beautiful positive relationship with death, allowing families to remember their ancestors and loved ones in a celebratory manner, it also brings color and vibrancy to the streets of the city.

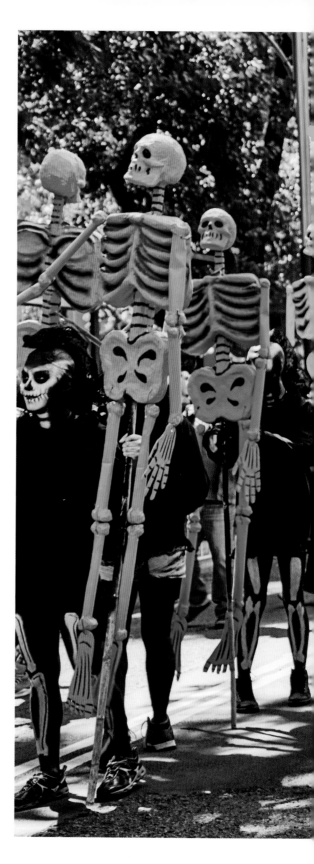

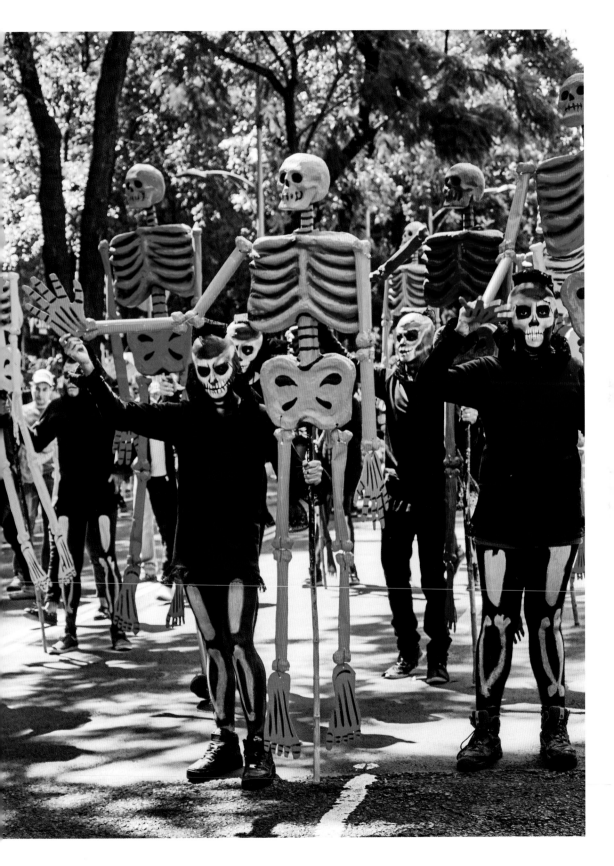

38 Praise the trashcan

Cathedral of Junk, Austin, Texas, U.S.A.

Longitude: 97.7° W
When to go: All year

Austin resident Vince Hannemann has built a cathedral to junk in his backyard. The ever-evolving tower is made up of 60 tons/ 54 tonnes of bicycles, old refrigerators, discarded TVs, and other unwanted goods, all painted in vibrant colors. Inside, the structure is lined with colorful walls made out of soda bottles, and festooned with patterns from objects such as old CDs, which cause light refractions and technicolor rainbows to fill the walls. Appointments must be made for a visit.

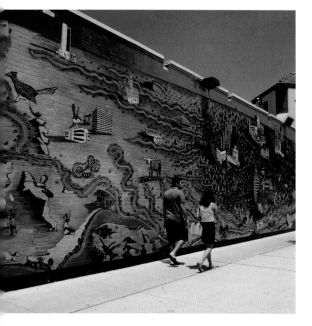

39 Say it with street art

Murals, Austin, Texas, U.S.A.

Longitude: 97.7° W
When to go: All year

From coffee shops to takeout joints to gas stations and sidewalks, there's one thing that's everywhere in Austin: street art. Whether it's spray painted graffiti, a mural, or a mosaic, no matter what corner of Austin it is, the walls, and sometimes the ground, are painted. One piece that is often posted on social media reads, "I love you so much" and is found on South Congress Ave.

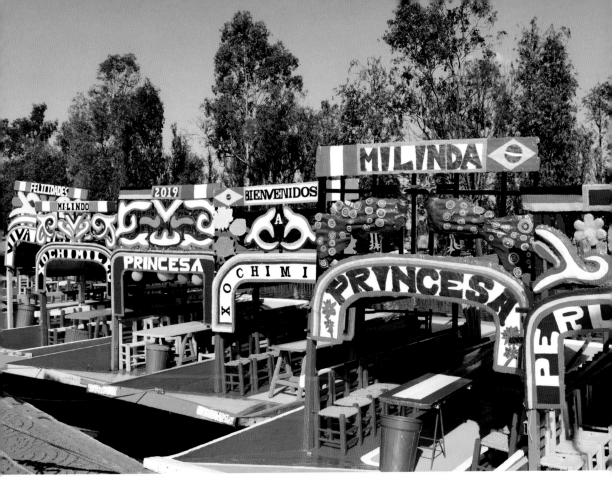

40 Float to the music

Trajineras, Xochimilco, Mexico City, Mexico

Longitude: 99.1° W
When to go: March to May for the best weather

In Xochimilco, a borough south of Mexico City, there is an extensive canal system that is a joy to behold. Colorful *trajineras*—brightly hand-painted flat-bottom boats—weave through the canals, to the sound of mariachi bands and the tempting aromas of the aquatic equivalent of food trucks. Xochimilco translates as "where flowers grow" and was designated as a UNESCO World Heritage site in 1987. Full of life and atmosphere, the canals are part of the neighborhood's Floating Gardens, so as you drift along, you're greeted with flowers, and beautiful views. The boats have bench seating for around twenty people—so you'll have someone to hug if you pass the creepy *Isla de las Muñecas* ("Island of the Dolls")—a spot adorned with dismembered doll-parts that are said to possess the spirit of a girl who mysteriously drowned there.

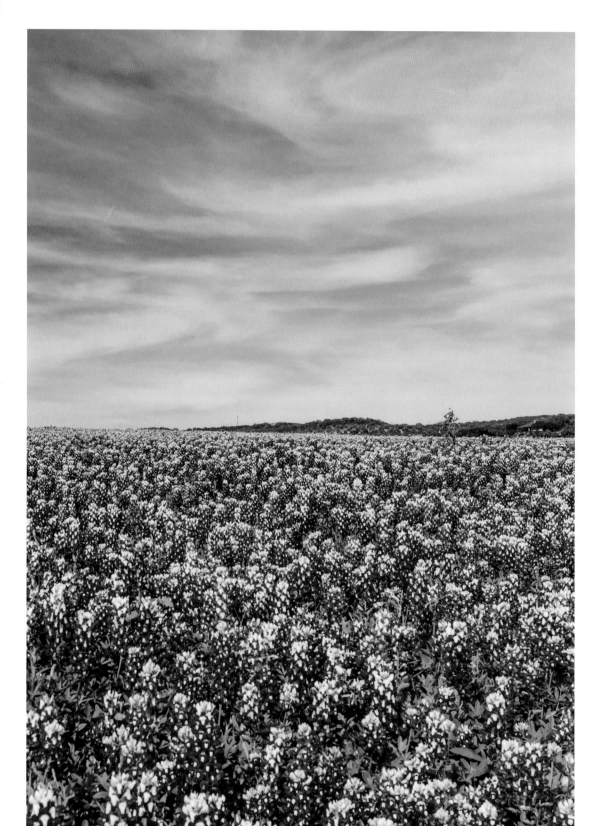

41 Get your bonnet on

◀ Bluebonnet Trails, Ennis, Texas, U.S.A.

Longitude: 96.6° W
When to go: April

Tens of thousands of visitors flock to Ennis every year to view the rolling royal hues of the bluebonnet bloom. Named for their petal's shape and color, there are more than 40 mi/64 km of mapped bluebonnet trails to explore. Throughout April the Ennis Garden Club drives the trails to keep the public informed of the prime spots to see the wildflowers which are usually at their peak during the third week of the month. Look but don't touch: it is illegal to pick the flowers.

42 It's hell to find a space

Cadillac Ranch, Amarillo, Texas, U.S.A.

Longitude: 101.9° W
When to go: All year

Created by the art group Ant Farm in 1974, Cadillac Ranch is one of the quirkiest roadside attractions in America. The Cadillacs were buried nose deep in the dirt in a cow pasture along Interstate 40. They did start off in peak condition with original paintwork and fittings. After a few years, though, the doors and chrome were taken and the cars were covered in spray paint. What's left is a vibrant collection of Cadillacs covered in autographs of passersby.

43 Old by name . . . young by nature

Antigua, Guatemala

Longitude: 90.7° W
When to go: November to April

Colorful and chaotic, Antigua is a small colonial city in Guatemala that is buzzing with local life. The *mercado* is brimming with vibrant fruits and vegetables and bright Mayan textiles. Bursts of color come into view on every corner of this UNESCO Heritage Site where crimson and saffron walls line the streets. Vivid displays of Guatemalan dresses, handmade earrings, and other souvenirs pour out of boutiques and shops while bright and bold buses make their way through the bustling streets.

44 Grade A for Port A

Port Aransas, Texas, U.S.A.

Longitude: 97.0° W
When to go: Summer

Mustang Island is home to the colorful gulf coast town of Port Aransas. As well as beaches and sunshine, the area is filled with boutiques, Mom-and-pop cafés and restaurants, delicious ice cream parlors painted in bubblegum pink, and candy-colored rental houses. The small Texas island comes to life in the summertime and vivid golf carts in every shade, from pink to neon orange, cruise the streets. Port A is bursting with color from the houses to the shops to the deep blues of the Gulf.

45 Paint the town

Macromural de Palmitas, Pachuca, Mexico

Longitude: 98.7° W
When to go: All year

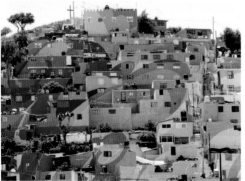

A group of young graffiti artists, Germen Crew, worked with local residents of the Palmitas barrio in Pachuca to transform their neighborhood. In a work that took around fourteen months to complete, they painted a "macromural" that covered more than two hundred homes in brightly colored shapes and shades. Head to the pedestrian bridge over the Río de las Avenidas for the best view of the full artwork.

46 Fly it with color

Festival de Barriletes Gigantes, Sumpango, Guatemala

Longitude: 90.7° W
When to go: November

On November 1 every year, the sky in this small Guatemalan town springs to life with dazzling handmade kites to celebrate All Saints Day, or Día de los Muertos. It's a significant day throughout Latin America to honor loved ones who have passed away and visit their graves. In Sumpango, the Giant Kite Festival has become part of the celebration. For participants it involves months of preparation and dedication. Kites, which can be up to 40 ft/12 m across, are painted by hand throughout the year, and adorned with images and messages. Flying in the sky, the kites are colorful works of art, made from paper, cloth, and bamboo, and a beautiful way to honor the circle of life.

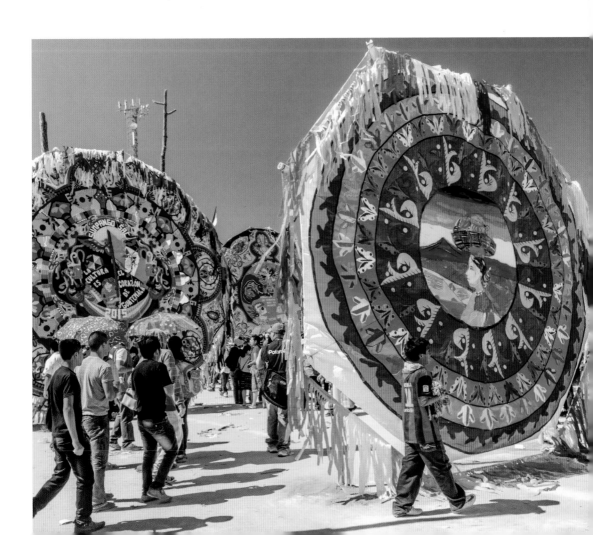

47 Worshipping color

La Iglesia de San Andrés de Xecul, San Andrés, Guatemala

Longitude: 89.9° W
When to go: All year

With its bold façade and Mayan details, La Iglesia de San Andrés de Xecul demonstrates the mix of indigenous Guatemala with colonial influence. A catholic church within, the exterior is decorated with images of corn, jaguars, quetzals, and bright colors, most notably, sunshine yellow.

48 Ride on time

Streetcars in New Orleans, U.S.A.

Longitude: 90.1° W
When to go: All year

What better way to soak up New Orleans' beauty, charm, and history than by riding on a colorful streetcar? The St. Charles Streetcar is one of the most famous dating back almost one hundred years. Going from the French Quarter down the beautiful St. Charles Avenue, it passes several popular landmarks.

49 Life on Mars

◀ Rabida Jervis Galapagos Red Sand Beach, Ecuador

Longitude: 90.7° W
When to go: December to May

Stunning red sand covers the beaches of Rabida Island. The deep crimson color, formed by the high iron content, lines the rough volcanic coastline of the island. Dotted along the beach are Galapagos cacti and *palo santo* trees. The uninhabited island of Rabida, part of the Galapagos archipelago, is arguably the most varied of them all with its transparent turquoise water and variety of unique wildlife species. The relatively small, arid island is almost extra-terrestrial, martian in its redness.

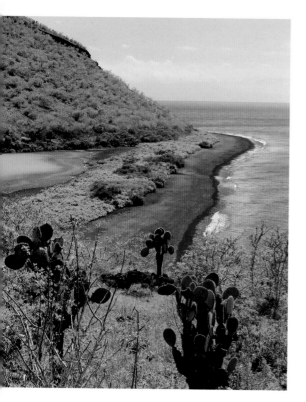

50 Backstreet blues

Bywater, New Orleans, Louisiana, U.S.A.

Longitude: 90.0° W
When to go: All year

Located a bit off the beaten path in New Orleans, the Bywater neighborhood is an eclectic area with laid-back bohemian vibes. Cool corner cafés, backyard wine shops, and unique boutiques are littered around the area. But, the real head-turners are the colorful murals and brightly painted houses.

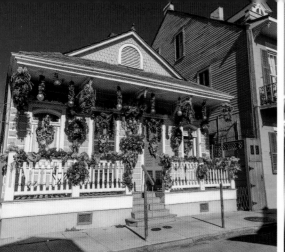

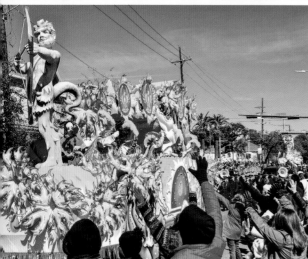

51 Cruise with the Krewes

▲ Mardi Gras, New Orleans, Louisiana, U.S.A.

Longitude: 90.0° W
When to go: February or March

New Orleans has the colorful French Quarter with cast-iron balconies and European architecture, but nothing explodes with music, color, and life more than New Orleans during Carnival. The party starts on January 6, but Mardi Gras, also known as Fat Tuesday, is the biggest party of the season and falls on the last night of Carnival's festivities. Parades are the heart of Carnival and Krewes spend enormous amounts of time and effort preparing for their big day, as their costumes, floats, and beads color the streets throughout this larger-than-life celebration.

52 A little bit of magic

Izamal, Yucatán, Mexico

Longitude: 89.0° W
When to go: All year

Once a place of pilgrimage for Mayans, the sun-colored city of Izamal is aptly known as *Ciudad Amarillo* (Yellow City), as all the buildings are painted yellow with a white trim. The city is an archeological wonder. When the colonial buildings went up, they were built on or around the existing Mayan buildings—rather than tearing them down.

So now, as you wander down the cobblestone streets, you are wandering through Mayan history. Mexico's Secretariat of Tourism named Izamal one of Mexico's *Pueblos Mágicos* (Magic Towns), due to its cultural richness and historical significance.

53 Flower power

Fiesta de las Flores y Palmas, Panchimalco, El Salvador

Longitude: 89.1° W
When to go: May

A small town in the department of San Salvador, Panchimalco's winding streets spring to life with vibrant flowers and decorated altars during the *Fiesta de las Flores y Palmas* (Festival of Flowers and Palms). The Festival happens every year on the first weekend of May to coincide with the rainy season and honor the Virgin Mother, uniting indigenous traditions and the Catholic religion. Festivities can last the entire week with plenty of dancing and food.

54 History at every step

Ataco, El Salvador

Longitude: 89.8° W
When to go: November to April

Concepción de Ataco is a drop of color in the otherwise uniformly green western mountain ranges of El Salvador. In 2004, residents entered the town into a government-sponsored competition called *Pueblos Vivos* (Towns Full of Life). Ataco received a colorful makeover and streets were covered in bright murals, giving the city a revival. The murals tell the story of a typical rural town of El Salvador as well as local traditions in the area, giving viewers a heavy dose of culture and history as they roam down the vibrant streets.

55 In the pink

Las Coloradas Pink Lakes, Río Lagartos, Yucatán, Mexico

Longitude: 87.9°W
When to go: All year

These awesome pink lakes in Mexico's Yucatan peninsula are in fact super shallow salt plains. They have been around for thousands of years—in Mayan times, salt was known as white gold—and are now part of a local salt factory. The sea water is allowed in to flood the plains and as it slowly evaporates in the hot Mexican sunshine, the concentration of a red algae that thrives in these salty conditions increases, leading to the spectacular color. It's the same algae that give the local flamingoes their kitsch shade of pink. When the water has all evaporated, the salt gets collected for consumption. The salt company doesn't like people swimming in the lakes, but it's still possible to visit—either by a couple of hours on public transportation from Valladolid or as part of a tour of the Rio Lagartos nature reserve.

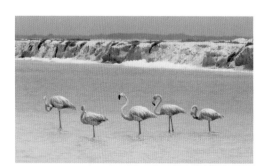

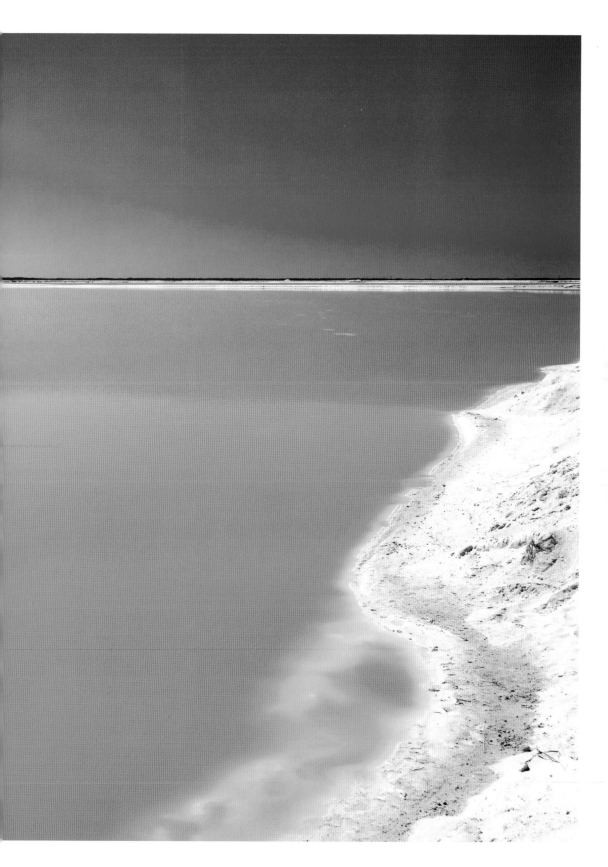

56 What a corker

Caye Caulker Village, Caye Caulker, Belize

Longitude: 88.0° W
When to go: Dry season, December to April

Once a stop for hippies along "Gringo Trail," Caye Caulker is a small island off the coast of Belize, and Caye Caulker Village is the ultimate beach town with every bar, café, house, cabana, and beach chair painted brightly, a bohemian rainbow among the natural blues and greens of the island's wilderness.

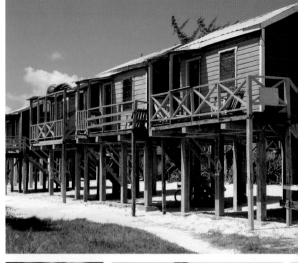

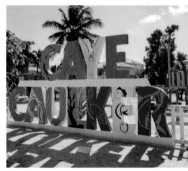

57 Don't hold back

Holbox, Mexico

Longitude: 87.3° W
When to go: November to March

The perfect mix of relaxation, sunshine and beauty, Isla Holbox is famed for the colorful murals that adorn its walls. Other highlights? The sea is such a bright shade of turquoise, you'll think someone's been doctoring the color contrast, and at sunset the sky turns a shimmery shade of gold.

58 Fifty shades of blue

Bacalar Lagoon Of Seven Colors, Bacalar, Mexico

Longitude: 88.4° W
When to go: December to March

Located close to the border with Belize, Bacalar is one of a Mexico's *Pueblos Mágicos* (Magic Towns) and when you see its stunning lagoon, you'll understand why. A whopping 26 mi/42 km long, it's known as the lagoon of seven colors, as the shade of blue differs depending on where you are. And not just by a little bit—it varies from an inviting pale aqua to bright turquoise and mysterious navy. The water is crystal clear, too, so it's a great place for swimming and snorkeling. There's even a *cenote* (a cave-like sinkhole unique to Mexico) within the lagoon, which is popular with scuba divers. As for life by this pretty lagoon? There's an emphasis on relaxation. Spend your days kayaking across the calm waters or lazing in a hammock before refuelling with a few *cervezas* and some tasty Mexican food.

59 Message or moose?

Murals, Chicago, Illinois, U.S.A.

Longitude: 87.6° W
When to go: Late Spring to early fall

Forty thousand ft²/3,700 m² of street art lines the neighborhoods of Chicago: from the South Loop to Milwaukee Avenue to Pilsen to Logan Square and everywhere in between. The expressive murals often have strong political messages that deal with race and immigration, family, and faith. Or not. There are an equal number of striking walls filled with neon butterflies, giant flamingos, and moose chewing gum. No matter the message behind the art, the murals in Chicago are created by talented artists who have plenty of pride for their city.

60 Color in the coral

Mesoamerican Reef, Roatán, Honduras

Longitude: 86.5° W
When to go: March to May

Known as the jewel of the Caribbean, the Mesoamerican Reef, or the Great Mayan Reef, is the second largest reef in the world, stretching from Mexico to Honduras. While the wildlife is worth the trip alone—dolphins, whale sharks, turtles, sea sponges, and moray eels—the dazzling coral shines like a superstar in a multitude of colors and shapes, including a massive coral wall.

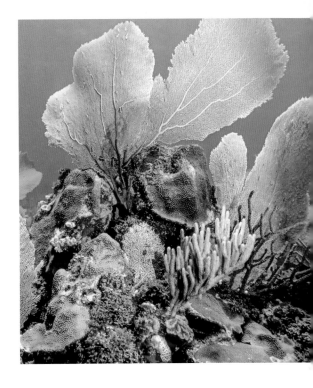

61 A vacation from vacation spots

Isla Mujeres, Quintana Roo, México

Longitude: 86.7°W
When to go: December to April

Once a quiet spot for those getting away from the Yucatan Peninsula's more bustling resorts, the 4.3 mi/7 km long island of Isla Mujeres is still a quaint place, just not as sleepy as it used to be. The houses and shops burst with color and life under the pure blue sky and green palm trees. Golf carts are the preferred mode of transportation and the activities available are endless: swimming with whale sharks, yoga, snorkeling, scuba diving, lounging, and soaking up the warm Mexican sun.

62 Green sky thinking

Northern lights, Nunavut, Canada

Longitude: 83.1° W
When to go: September to March

While it's possible to view the northern lights from other places, nowhere can provide quite the same experience as Nunavut. *Aqsamiit*, as the phenomenon is known in the Inuit language of Inuktitut, is what happens when solar particles enter Earth's atmosphere. Nunavut, Canada's largest and most northern territory, is sparsely populated, so light pollution doesn't drown out the intensity when the northern lights make an appearance. Like a ballet in the stars, the lights move and shine, painting the sky a surreal green. The lights are most visible during the winter when the skies are clearest, but the temperatures are the lowest. Fall and early spring also offer good likelihoods for the auroras appearance and the temperatures are a little more comfortable for an Arctic adventure under the stars.

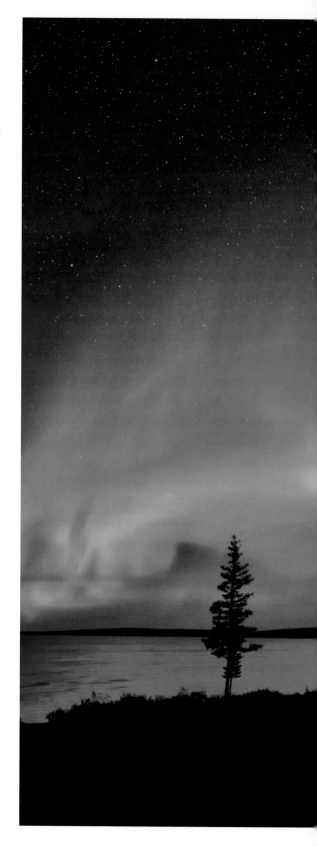

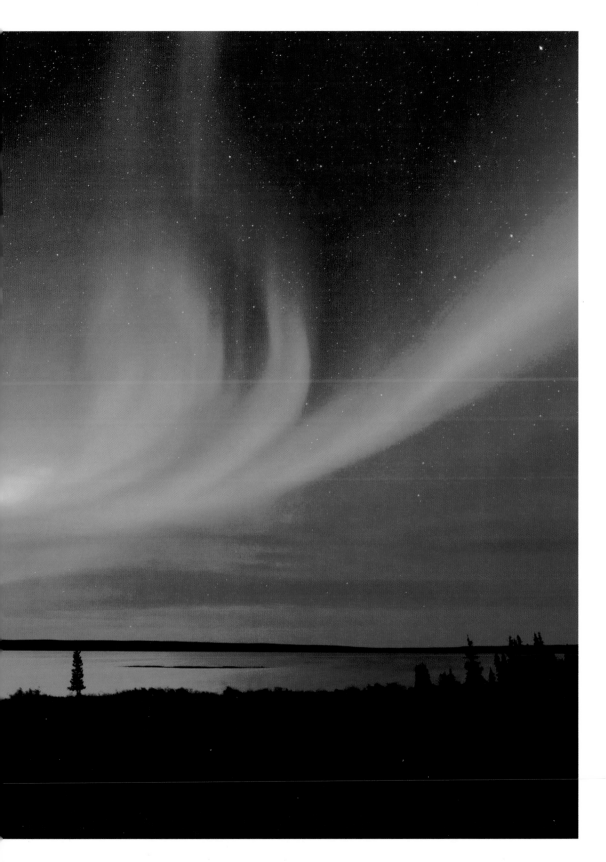

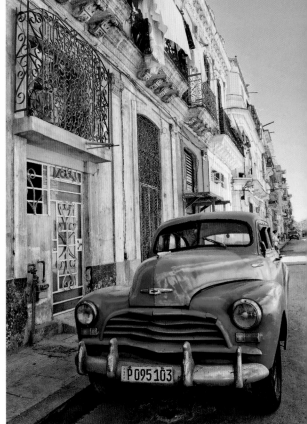

63 Feel the pulse

Havana, Cuba

Longitude: 82.3° W
When to go: December to May

There's nothing like feeling the rhythm of a city when you walk down the streets. And Havana, the beating heart of Cuba, has one unlike any other place in the world. Havana is hectic. It's colorful. It's crazy. It's old. It's historical. It's buzzing. So many words can be used to describe the beautiful city. Dilapidated buildings line the street, painted in bright colors or fading pastels. Old Cadillacs in every color of the rainbow drive up and down the Malecon taking it right back to the 1960s. Men sit on their stoops playing dominoes, kids chase each other in the streets, women pick up food from the markets, and everyone comes together in the energetic plazas. Everywhere, color fills the streets. In the neighborhood of Jaimanitas, just outside of Havana, artist José Fuster has turned the area into a colorful haven. Starting by decorating his studio in a mosaic, he later began painting his neighbors' homes and businesses. His whimsical imagination has added even more life to the area and has created an artist's paradise that has inspired those around him.

64 Talk about a revolution

León, Nicaragua

Longitude: 86.8° W
When to go: December to April

Flashes of intensely bold colors are splashed across the houses in León, Nicaragua. From aquamarine to lemon yellow to neon orange, color is everywhere. Vibrantly painted buses depart from the bus station, weaving through streets covered in art—often inspired by the Sandinista Revolution.

65 Putting the color in colonial

Granada, Nicaragua

Longitude: 85.9° W
When to go: November to April

Sitting on the shores of Lake Nicaragua, the light breeze from the water envelops the multicolored city of Granada. Street after street is painted in bold shades, adding an extra layer of character to the colonial architecture. Even the city's cathedral features a striking yellow façade that draws in visitors to the bustling plaza.

66 Shine bright

◀ St. Petersburg, Florida, U.S.A.

Longitude: 82.6° W
When to go: October

Artists from all over the world flood the streets of "St. Pete," Florida, during its annual SHINE festival that sees art spring up in public places. Taking place over several days, new murals are painted all over the city, adding life and commentary to the outdoor art gallery.

67 Animal magic

Tortuguero, Costa Rica

Longitude: 83.5° W
When to go: July to October

An ecological treasure trove, Tortuguero, which means "Land of Turtles," is a lush green oasis on a sandbar and home to eight hundred species of animal. Dark green hawksbill and giant leatherback turtles crawl out of the aquamarine water to lay their eggs on white-sand beaches. Neon green tree frogs hop from one massive trunk to another. Orange and black monarch butterflies flutter through the jungle. Rainbow macaws fly through the canopy. What a place to call home.

68 Soak with the sea cows

Crystal River, Florida, U.S.A.

Longitude: 82.6° W
When to go: December to February

Located north of Tampa, Crystal River is a beautiful area for wildlife lovers. The water around Three Sisters Springs is so pure it shimmers with a magical turquoise hue. But the big draw for visitors are the manatees. In the warmer months of the year, hundreds of these creatures congregate in Crystal River, and while they are a protected species, this is one of the few places you can get close to them. Once you've donned a wetsuit and snorkel, you enter the water and float next to them. Look but don't touch.

69 Bad farming, great results

Providence Canyon State Park, Georgia, U.S.A.

Longitude: 84.9° W
When to go: All year

Known as the Little Grand Canyon, Providence Canyon State Park, is a unique slice of land in Georgia. Created by poor farming practices during the 1800s and the combination of runoff and erosion increasing, stunning red and white pinnacles line the sides of a canyon colored with red, white, purple, pink, and orange soil.

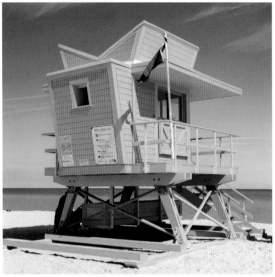
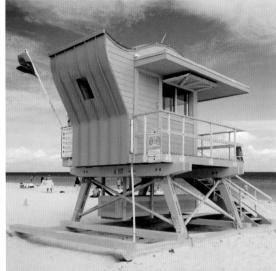
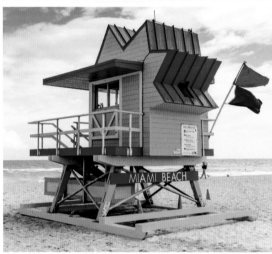
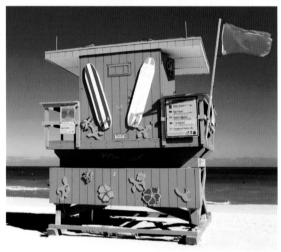

70 Rooms with a view

Lifeguard Stands, Miami Beach, Florida, U.S.A.

Longitude: 80.1° W
When to go: All year

Thirty-six brightly colored lifeguard stands dot the shoreline of Miami Beach. The stark contrast of the neon colors against the sparkling turquoise water adds even more flavor to the South Florida city. The first towers popped up in the early 1990s and they kept on popping up until they lined the whole beach.

71 Miami time machine

▶ South Beach Art Deco, Miami Beach, Florida, U.S.A.

Longitude: 80.1° W
When to go: All year

From Ocean Drive to Collins Avenue, art deco is alive and well in Miami's South Beach. Pastel painted hotels will transport you back to the 1930s as you stroll along. The iconic structures make up the highest concentration of art deco buildings in the world, making Miami a candy-colored time capsule.

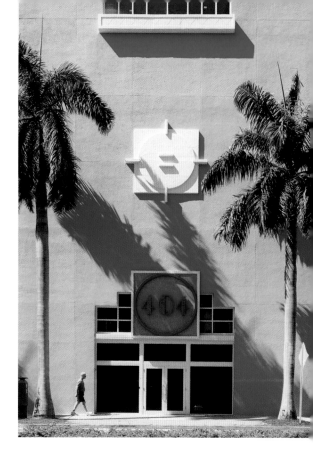

72 Havana-ooh-na-na

Little Havana, Miami, Florida, U.S.A.

Longitude: 80.2° W
When to go: All year

A stroll down Calle Ocho strip in Miami's Little Havana will make you feel as if you've teleported across the sea to Cuba. The vibrant area is full of culture and art, and is home to some of the best mojitos in the city. The air is a rich mix of tobacco and coffee, and Cuban music can be heard coming from the bars at nearly all times of the day. Explore the wealth of interesting art galleries such as Futurama, and celebrate Latin culture.

73 Neon, day and night

Bocas del Toro, Panama

Longitude: 82.2° W
When to go: February to March or September to October

Slow-paced island life meets crazy backpacker parties in Bocas del Toro. The main drag, Isla Colon, is a backpackers' mecca, dotted with colorful hostels, restaurants, and bars. The island is buzzing with dive shops and tour companies that are housed in neon-lit buildings up and down the roads.

74 **Where there's a will, there's a wall transformed**

▲ Wynwood, Miami, Florida, U.S.A.

Longitude: 80.1° W
When to go: All year

Filled with art galleries, boutiques, quirky bars, delicious eateries, coffee joints, and one of the largest open-air street-art installations in the world, Wynwood is Miami's art mecca. The bold area was once run down with neglected warehouses and abandoned buildings, leaving the perfect canvas for the Wynwood project. Since the early 2000s, artists from all over the world have been flocking to the area to showcase their work. The result is an insanely beautiful outside art gallery that extends past the gates of the Wynwood Walls and has overflowed into the streets. Colorful spray paint covers the streets, walls, parking lots, and businesses, adding a little extra flavor to the Miami neighborhood. Every Second Saturday of the month, the area gets a little bit busier during Art Walk, an event that keeps galleries open late, while an epic block party takes place down the street.

75 Small town, big artworks

Hobe Sound, Florida, U.S.A.

Longitude: 80.1° W
When to go: All year

In comparison to the pristine all-American feel of the nearby city of Stuart, Hobe Sound is cute, quirky, and off-the-wall. It's home to an impressive outdoor mural project that started as a way to increase community spirit and identity. There are now more than twenty-five murals covering the town's walls.

76 Heart deco hotel

Washington Park Hotel, Miami, Florida, U.S.A.

Longitude: 80.1° W
When to go: All year

Just two blocks away from the powder-sand beaches of Miami is the Washington Park Hotel. The boutique hotel has refurbished four landmark art deco buildings to create a creative space for locals and tourists. Each building features a brightly colored lobby ranging from a deep shade of periwinkle to baby pink.

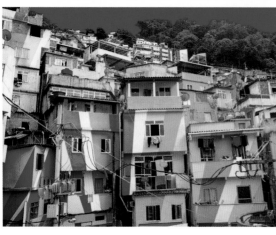

CHAPTER THREE

80°–40°

WEST

77 **A maze of color**

Trinidad, Cuba

Longitude: 79.9° W
When to go: December to May

Weaving down the streets of Trinidad, a colonial city in Cuba, colour can be found everywhere. A maze of cobbled alleys, restaurants, bars, and museums—it is eye-catching no matter which road you take. Houses are painted in bright colours with equally vibrant doors contrasting against them. There's a bright yellow church, Iglesia y Convento de San Francisco, and up the twisting, spiral staircase of the Palacio Cantero there's a wonderful panoramic view of the golden bell tower in front of the green mountains. Colorful vintage, American cars line the streets and when the city comes to life in the evening, the Plaza Mayor buzzes to the sound of salsa and fills with people soaking up the vibrant atmosphere.

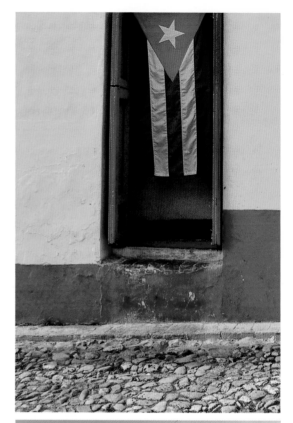

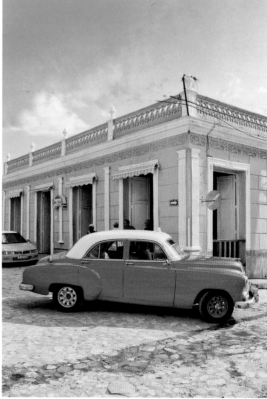

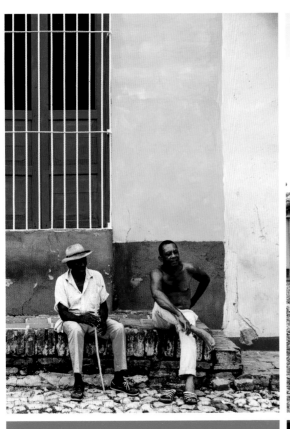
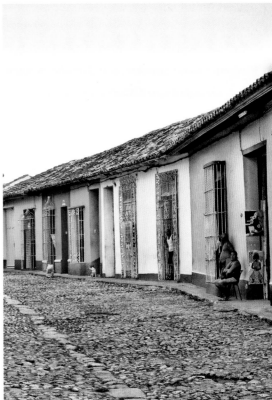
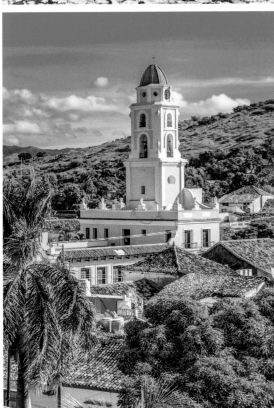
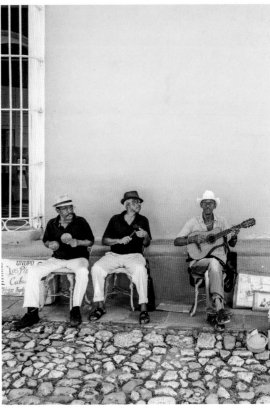

78 Find your way home

Rainbow Row, Charleston, South Carolina, U.S.A.

Longitude: 79.9° W
When to go: Spring and fall

Thirteen historical homes line East Bay Street in Charleston, South Carolina, each painted a different pastel color. Stories abound as to why the candy-colored houses were painted these various shades of the rainbow. Some say it was so that intoxicated sailors could remember which house they were staying in while others say it was to distinguish different storefronts.

79 Berry beautiful

Cranberry bog, Muskoka Lakes Farm and Winery, Bala, Ontario, Canada

Longitude: 79.6° W
When to go: October

The deep red hue of cranberries once made them a valuable trading commodity not just as a food source but also as a dye. There are many cranberry producers in Canada but at Muskoka Lakes Farm and Winery they offer year-round tours of the process. Later in the harvest the farm offers "The Cranberry Plunge." Outfitted in chest-waders, plungers can spend ten minutes wallowing in the bog living out their cranberry-bath dreams.

80 **State of the art**

El Otro Lado Private Retreat, Portobelo, Panama

Longitude: 79.6° W
When to go: Mid-December to mid-April

Candy-colored details can be found in every corner of El Otro Lado Private Retreat. This magical jungle paradise also operates the Portobelo Bay Foundation which works to make sure that visitors to the island bring benefits for the local community. The Foundation runs an art gallery featuring colorful local work and guests can take an art class guided by a local artist, giving visitors the chance to experience local life and meet local people.

81 Latin and lovely

Las Peñas, Guayaquil, Ecuador

Longitude: 79.9° W
When to go: June to September

A small bohemian area with colorful wooden houses and cobblestoned streets in the port town of Guayaquil, Las Peñas has attracted many famous faces over the years such as Pablo Neruda, Ernest Hemingway, and Che Guevara. From Las Peñas, take the four-hundred-plus stairs of Cerro Santa Ana, once a slum but now transformed into a colorful climb of shops and cafés leading up to Plaza de Honores where you're rewarded for your ascent with spectacular views.

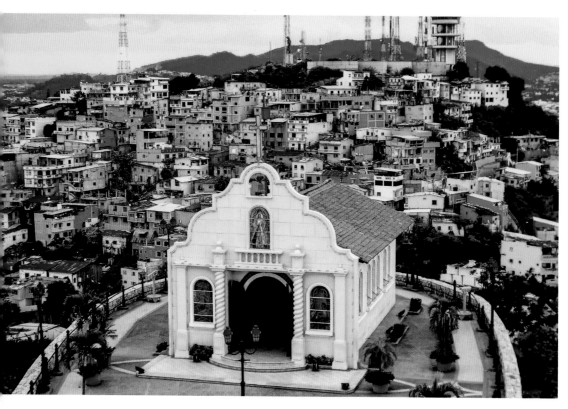

82 What color's cool?

Casco Viejo, Panama

Longitude: 79.5° W
When to go: Mid-December to mid-April

Steeped in history, the beating heart of Panama City is the hippest place to be. Rooftop bars, trendy hotels, and cool cafés line streets covered in murals. The colonial Casco Viejo—a UNESCO World Heritage Site—is pulsing with energy and you can feel it in every step.

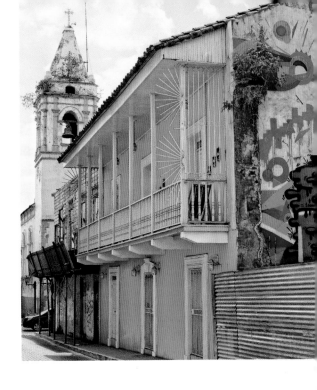

83 Light up the night fantastic

Fiesta de la Luz, Quito, Ecuador

Longitude: 78.4° W
When to go: Mid-August

After sundown for a few days in August, in celebration of its independence from Spain, Quito explodes with color and light in multiple locations around the Centro Historico. Installations of colorful lights or whole choreographed dancing films are projected onto the façades of major landmarks such as Plaza del Teatro or Capilla Museo de la Cuidad. In collaboration with Lyons in France, a master in light festivals for over 160 years, French artists work with locals to produce the visual pieces. The festival draws thousands of people onto the streets to marvel at the lights and celebrate Ecuador's independence.

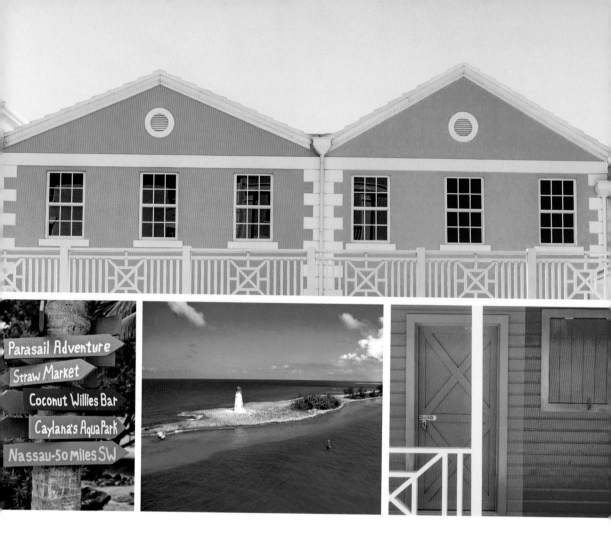

Parasail Adventure
Straw Market
Coconut Willies Bar
Caylana's Aqua Park
Nassau-50 miles SW

84 Live life in full color

Nassau, Bahamas

Longitude: 77.3° W
When to go: Mid-December to May

With shimmering, crystal-clear water, and colorful coral reefs, the Caribbean Sea is a backdrop for everything in the Bahamas. On dry land, the Nassau Straw Market, the most renowned open-air market in town, stocks every kind of souvenir, from colorful textiles to goatskin drums. Each year, at the end of April, over fifty thousand people flock to Nassau to attend Road Fever. Part of the Junkanoo carnival, the all-day party is filled with nonstop live entertainment and energetic cultural events. People in feathered costumes in every shade imaginable fill the streets.

85 Bimini blues

Bimini, Bahamas

Longitude: 79.1° W
When to go: Mid-December to mid-April

About 50 mi/80 km east of Miami lies a collection of islands known as Bimini. Made up of three islands (North Bimini, South Bimini, and East Bimini) and surrounded by the clearest azure water, the small area is one of the most beautiful and untouched parts of the Bahamas. At only 7 mi/11 km long, North Bimini is home to Alice Town, a collection of shops, restaurants, and bars on one long road—The King's Highway—which connects everything, including several powdery beaches. A highlight of a visit to Bimini is the sea. Explore gritty shipwrecks, colorful coral reefs, and swim with neon fish in the crystal-clear water. A short boat ride brings you to South Bimini, where you can drink from the famed Fountain of Youth and hike an epic nature trail surrounded by citrine palm trees.

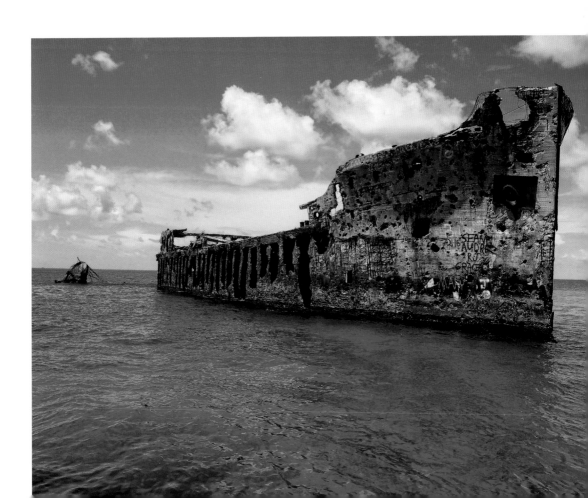

86 Historic hideaway

Georgetown, Washington D.C., U.S.A.

Longitude: 77.0° W
When to go: All Year

Cobblestoned sidewalks are lined with grand homes in beautiful and historical Georgetown, in Washington D.C. From luxurious shops to tasty restaurants and buzzing bars, this part of the city is bustling with tourists and locals. The real magic is on the side streets where old-fashioned row homes are painted a host of pretty colors.

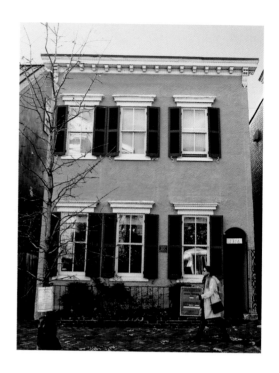

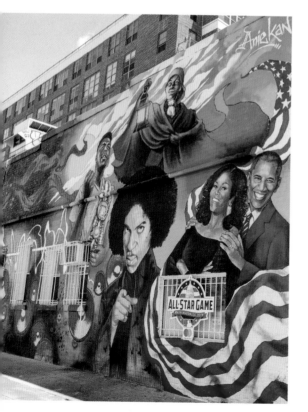

87 Come for the color, stay for the chilli

U Street, Washington D.C., U.S.A.

Longitude: 77.0° W
When to go: All year

Nicknamed *Black Broadway*, U Street was the hub in D.C. for African American culture. This heritage is reflected in the street's colorful murals. For a taste of history, visit Ben's Chilli Bowl and tuck into the legendary dish that Barack Obama, Ella Fitzgerald, and Martin Luther King Jr. have all enjoyed.

88 Color with a capital C

Washington D.C., U.S.A.

Longitude: 77.0° W
When to go: Mid-March to early April for cherry blossoms

Washington D.C. is home to multiple gems of color and life. Built in 1886 as a place of worship, the Friendship Baptist church was transformed into an arts center formerly known as Blind Whino, now called Culture House, and may be one of the city's most distinctive gems. The building's façade is a mix of Victorian and Romanesque architecture, but what stands out is the paint job it received in 2012 from the artist HENSE. Covered entirely in a mural of blue, pink, red, yellow, and greens, with the blend of old architecture and bold paint, Culture House is an artwork in itself. Another color injection happens every spring with the cherry blossom bloom, and if you're making a trip to the District, it's worth timing it with these springtime legends. The bloom usually happens in late March or early April and the best places to see them are at the Tidal Basin and along the water of East Potomac Park.

89 Walk this way

Cartagena, Colombia

Longitude: 75.4° W
When to go: January to March

Within the walls of Cartagena's Centro Historico is an explosion of color and spirit with vivid walls, doors, and balconies at every turn. Outside the walls, barrio Getsemaní bursts with rich façades, beautiful graffiti, and lively cafés. Walk through these neighborhoods to fully experience the colors, flowers, and flavors that are Cartagena. And stop to admire the flamboyantly painted buses with their pulsating salsa beats that add even more color to these atmospheric streets.

90 Salt of the earth

▼ Catedral de Sal de Zipaquirá, Zipaquirá, Colombia

Longitude: 73.9° W
When to go: All year

A former salt mine, Catedral de Sal de Zipaquirá was transformed into a Roman Catholic cathedral in 1953 after local miners and church officials persuaded the Colombian government to convert it into a place of worship. Around 600 ft/183 m below ground, colored lights illuminate the cavern, giving a beautiful royal hue to the cathedral walls.

91 Delight in the detail

Guatapé, Colombia

Longitude: 75.1° W
When to go: All year

Every building in Guatapé is so brightly painted that Lonely Planet has wondered whether it is "the most colorful town in the world," but what sets it apart from other colorful places are the *zócalos*, panels or designs on the lower part of each building that range from a simple picture to telling a story. Here the winning feature is the details.

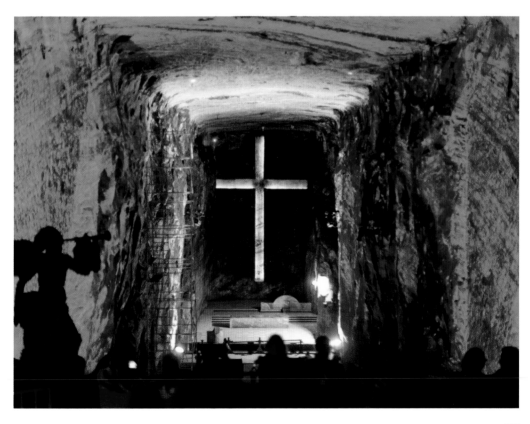

92 New York state of mind

LES Murals, New York, U.S.A.

Longitude: 73.9° W
When to go: All year

Brick walls have become canvases in the gritty Lower East Side of Manhattan. Famous artists such as Tristan Eaton, Sonni, and even Banksy have left their mark. From dancing skeletons to spray-painted hearts and a mural of Audrey Hepburn, it's hard to walk down the street without passing a new creation.

93 Bold and beautiful

DUMBO, New York, U.S.A.

Longitude: 73.9° W
When to go: All year

Bright and beautiful murals line the walls of the expressway Down Under the Manhattan Bridge Overpass—or DUMBO, as the area is better known. Beginning in 2012, eight artists were invited to the Brooklyn area to beautify the space. What's left now is a public outdoor gallery that brings the community together in a truly unique way.

94 Friend of art

Bogotá, Colombia

Longitude: 74.0° W
When to go: June to August

One of the most street-art-friendly cities in the world, Bogotá is bursting with color. Neighborhoods such as La Candelaria, Avenida El Dorado, and the downtown area are covered in murals from local and international artists. Once illegal, vibrant graffiti art and murals can now be found and celebrated on every edge of the city.

95 Rainbow flow

Caño Cristales, Serranía de la Macarena, Colombia

Longitude: 73.5° W
When to go: September to November

Most days it looks like any other river, but for several weeks each year, Caño Cristales becomes the "River of Five Colors." When seasons transition from wet to dry and the water level hits a particular mark, aquatic life comes alive, and the star of the show, the *Macarenia clavigera* plant, fills the blue river with vibrant reds, pinks, and purples.

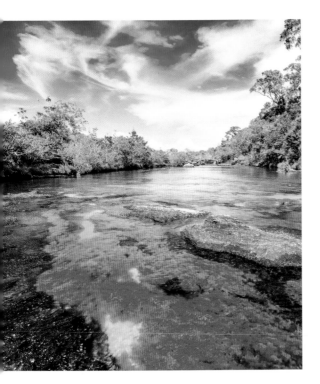

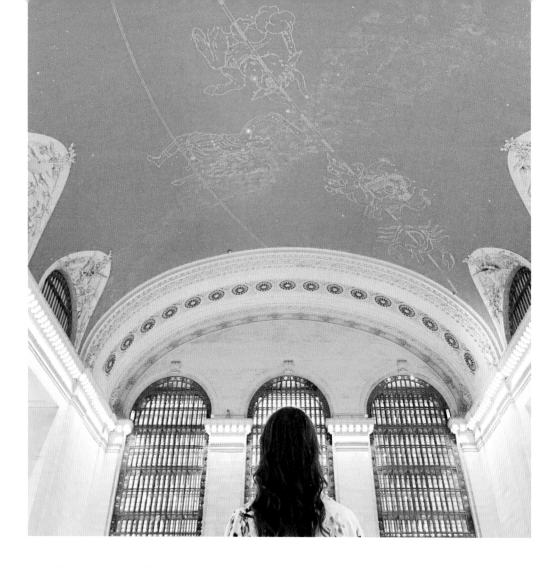

96 **Spot the deliberate mistake**

Grand Central Terminal, New York, U.S.A.

Longitude: 73.9° W
When to go: All year

If you find yourself in New York's iconic station, be sure to look up, as a luminescent mural of the night sky shines over those who walk through Grand Central's main concourse. The original mural was completed in 1913, a beautiful work of art, but soon after its reveal, a commuter noticed the constellations were back-to-front. Brushed off as artistic vision, claiming this perspective is looking down from the heavens, the mural was left alone. When it was renovated in 1944, the new mural paid tribute to the first by keeping the constellations as they were and adding the blue-green background.

97 Live by the beat of the drum

▼ Le Plateau-Mont-Royal, Montreal, Canada

Longitude: 73.6° W
When to go: All year

Cool and arty, Le Plateau-Mont-Royal has public art, relaxed restaurants, pretty residential streets, and a weekly drumming festival when thousands gather in Mount Royal Park to play drums and relax to the beats. What more could you ask for?

98 New year, new art

St-Laurent Boulevard, Montreal, Canada

Longitude: 73.6° W
When to go: All year

Saint-Laurent Boulevard is a constantly evolving living museum. Covered in enormous murals by artists from around the world, it oozes personality. Time your visit for June and you're in for a treat as artists take part in Montreal's Mural Festival, painting over the previous artworks and changing the area's identity.

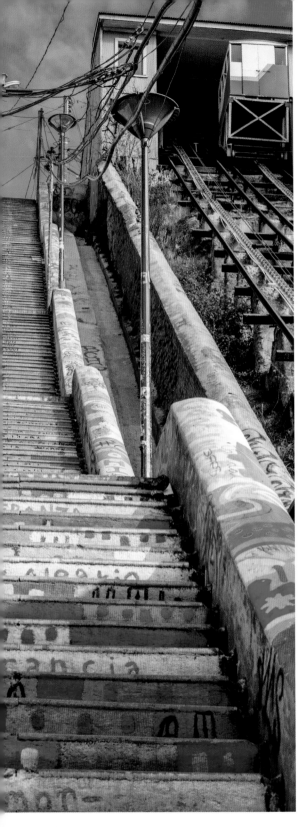

99 Message in mosaics

Valparaiso, Chile

Longitude: 71.6° W
When to go: December to March

Murals on the walls, pastel-hued houses, mosaic steps, and several stacks of shipping containers make the port city of Valparaiso one of the most colorful cities in the world. *Valpo* to its residents, it's located an hour and a half northwest of the capital, Santiago. The city's street-art scene began as a form of political expression. It was the social media of the day, with graffiti artists painting powerful and thought-provoking artworks in an attempt to shift people's beliefs. As for getting around a city that stretches across forty-three hills? That's an adventure in itself, but catching one of the brightly colored funiculars will save a few steep climbs.

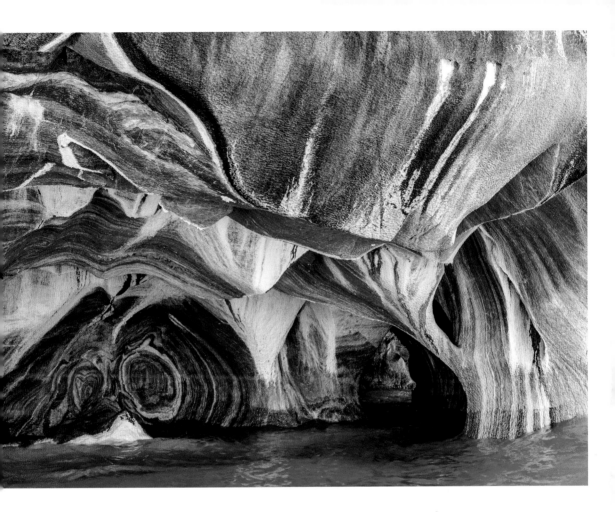

100 Marvel at the marble

▲ Marble Caves, General Carrera Lake, Patagonia, Chile

Longitude: 72.6° W
When to go: All year, early morning for best light

Waves gently lapping at marble for more than six thousand years have carved out these wondrous marble caves. Located in a cluster of rock islands on a remote glacial lake, the bright blue melted glacier water is reflected by the marble, creating a stunning sight on the cave walls and lake floor.

101 Still standing

Castro, Isla Grande de Chiloé, Chiloé Provence, Chile

Longitude: 73.7° W
When to go: All year, but January to March for the best weather

Castro in Chiloé could be a poster for perseverance, surviving multiple attacks, earthquakes, fires, and tidal waves, but the people of Chiloé's capital keep going. Richly colored churches, buildings, and the famous *palafitos*, wooden stilt houses, brighten the horizon and invite you to explore all the island has to offer.

102 Somewhere over the rainbow

Rainbow Mountain, Cusco, Peru

Longitude: 71.9°W
When to go: March to November (dry season)

Rainbow Mountain in Peru is a sensory experience, appearing as a layer cake of colors that intensify the closer you get to them—but you've got to work for the reward. Part of the Vilcanota mountain range in the Peruvian Andes, Montaña de Siete Colores, as it's known in Spanish, appears in its rainbow glory thanks to the minerals in this sedimentary rock: chlorite for the green, ferric sulphide for the yellow, and oxidized limonite for the red. Although Latin America has many rainbow-colored rocks, this is one of the most brilliant, and accessible. That said, Rainbow Mountain sits at 17,000 ft/ 5,200 m in elevation, which is only slightly lower than Everest Base Camp. That means that hiking to the top is an adventure into thin air, and one that, for most of us, doesn't come easily. There are various ways to access Rainbow Mountain, from a nine-day trek to a van-ride and single-day hike. For day hikers, it's a gentle upward slope, but the altitude makes every step a challenge. Local Quechua people, adorned in colorful shawls and traditional dress, offer horse rides to the top. For all those who make it, an impressive look at Rainbow Mountain and its surrounding similarly colorful cousins, is the reward. As anyone who has attempted this hike knows, the journey is truly the destination.

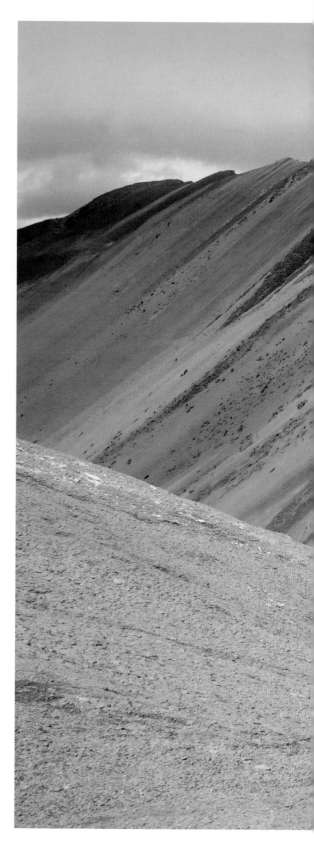

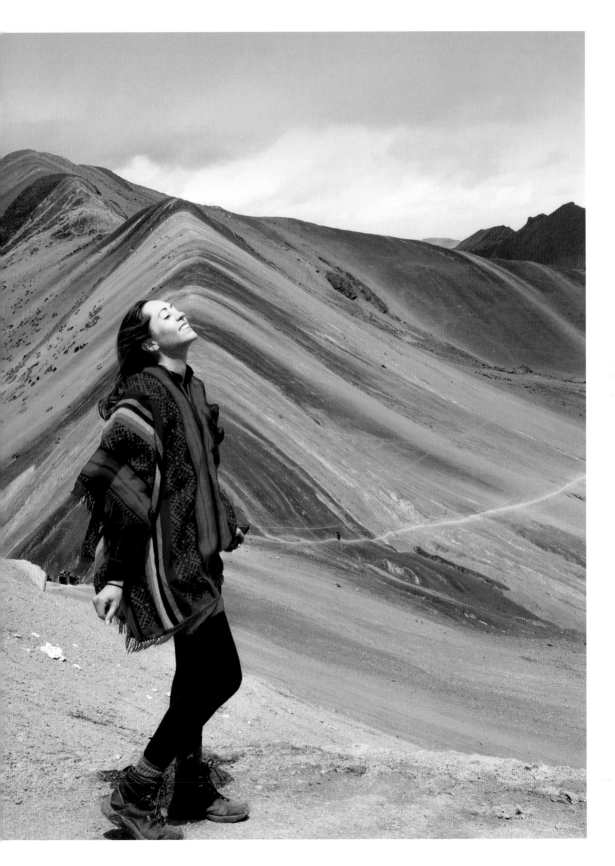

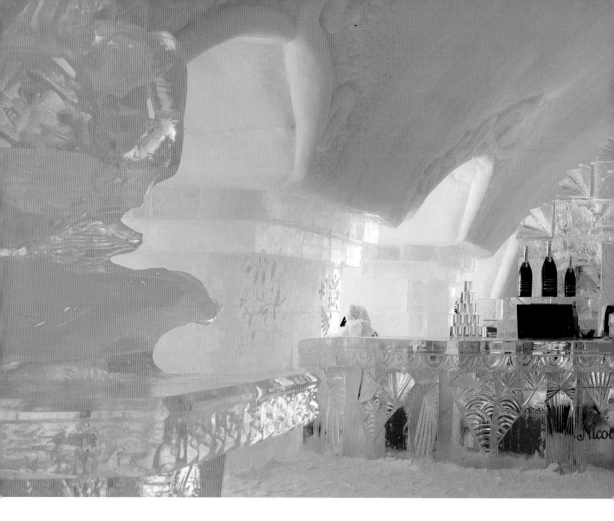

103 Ice dream

▲ Hôtel de Glace, Valcartier, Quebec City, Quebec, Canada

Longitude: 71.4° W
When to go: January to March

What started as a winter playground with toboggan runs in 1963 has over the years transformed into an all-season wonderland resort with the crowning jewel of Hôtel de Glace. Intricately carved from ice, the hotel is a marvel of art and ingenuity. Enter the grand hall, with impressive sculptures and carvings, and move on to the chapel where stained-glass-style ice windows adorn the walls. Rooms are made almost entirely of ice, even the furniture, aside from a layer of wooden blocks and the bed's mattress. Guests are provided with warm sleeping bags since the room temperature is between 23 and 27°F/-5 and -2°C. Hôtel de Glace boasts over forty rooms and themed suites with décor that changes yearly to match the hotel's greater theme.

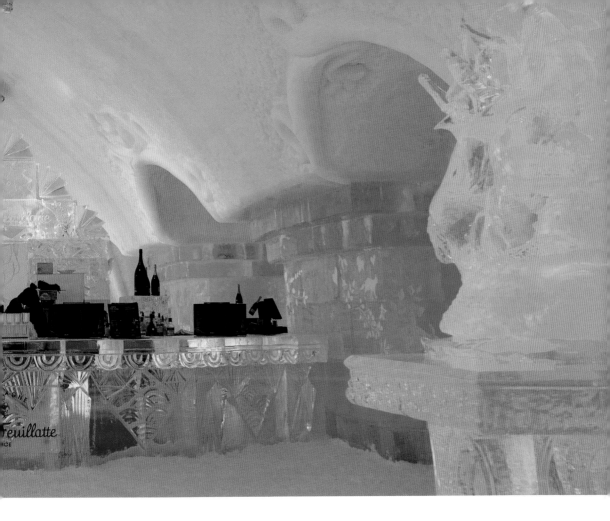

104 Feel at peace in an old monastery

Santa Catalina Monastery, Arequipa, Peru

Longitude: 71.5° W
When to go: All year

A stroll through the Monastery of Santa Catalina in Arequipa fills the visitor with a sense of calm and contentedness. The walls and cloisters are painted a deep and earthy ochre or a rich and vibrant blue. In the convent's early days, nuns were allowed luxuries such as furniture and servants.

105 Underwater light show

Laguna Grande, Reserva Natural Cabezas de San Juan, Puerto Rico

Longitude: 65.6° W
When to go: All year, best on moonless nights

As you paddle your kayak beneath the mangroves of Laguna Grande in Puerto Rico each stroke causes a mini explosion of fireworks under the water. This is bioluminescence caused by tiny algae living in the water here. As the algae are disturbed they light up in the most magical way.

106 Where nature blows your mind

Atacama's Lagoons, Chile

Longitude: 67.8° W
When to go: December to February

Outdoor adventure lovers will fall in love with Chile's epic views. The Atacama region in the north of the country is home to mind-blowing varied landscapes, including geysers, volcanoes, and salt flats. Looking out over Chaxa Lagoon, it's impossible not to be amazed by the pale blues, pinks, and whites of the scenery. This lagoon sits within a salt flat, and is particularly special due to its natural inhabitants—the elegant pink flamingos that call this serene watering hole home. From the edge of the lagoon you'll be close enough to see every feather, the spindlyness of their legs, and even watch them in flight. From Chaxa Lagoon, winding roads carve their way through salt flats, lunar landscapes, bright yellow grasses, steep mountains, and red rocks before emerging at Chile's Altiplantic Lagoons—Miscanti and Miñiques. To see them you'll need to wrestle with high altitudes (they're located 13,000 ft/4000 m above sea level) but the breathlessness is worth it when you see the mesmerising blue lagoons surrounded by desert and snow-capped mountains. It's a great place to spot vicuñas (similar to llamas) which often play by the shores of the lakes, lapping up the water.

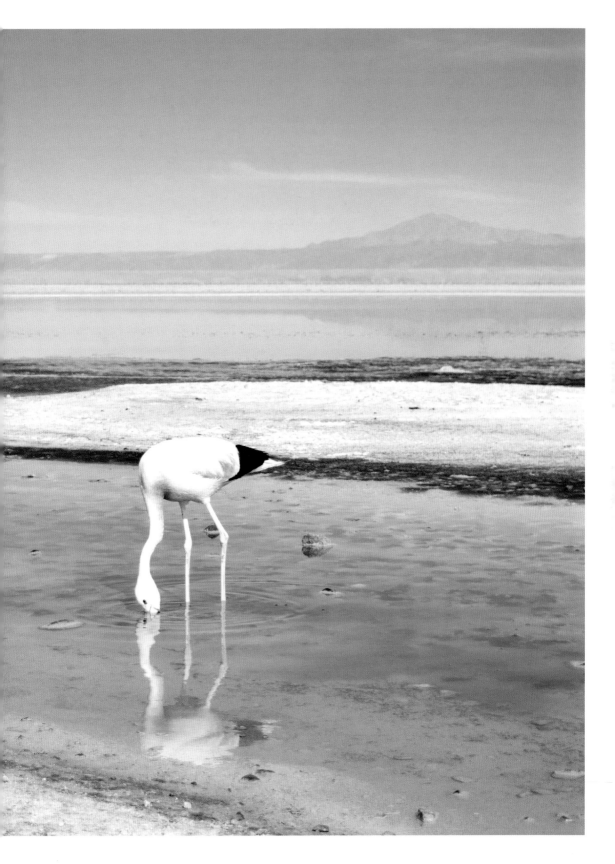

107 The city of firsts

Santo Domingo, Dominican Republic

Longitude: 69.9° W
When to go: January to April, November to December

Home to the first hospital, university, cathedral, monastery, and street of the New World, it's no wonder that Santo Domingo has been declared a UNESCO World Heritage Site. But, the real showstopper is Calle Jose Reyes, a street located in Zona Colonial, lined with the brightest buildings and vibrant homes.

108 Curative Curaçao

Willemstad, Curaçao

Longitude: 68.8° W
When to go: May to December

Locals will tell you that there is a solid reason as to why Willemstad is so doused in color. It dates back to the early 1800s, when the then Governor Albert Kikkert blamed his terrible migraines on the bright sun reflecting off the white buildings. Issuing a decree to paint all structures any color other than white, a colorful Willemstad was born.

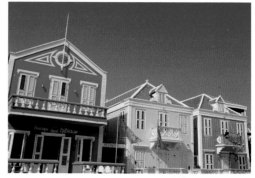

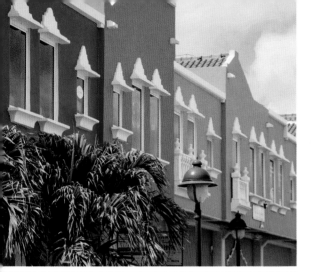

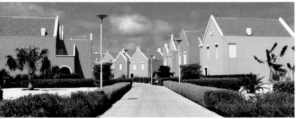

109 Find pink at the end of the rainbow

Kralendijk, Bonaire

Longitude: 68.2° W
When to go: January to July for the most flamingos

Kaya Grandi is bright with Caribbean hues, but the color trip to Kralendijk is worth more than the architecture alone. Close by is the Pekelmeer Flamingo Sanctuary, one of the largest flamingo breeding grounds in the Western Hemisphere with over ten thousand birds, so treat yourself to a rainbow stroll and end with a sea of pink.

110 Color catcher

Old San Juan, Puerto Rico

Longitude: 66.1° W
When to go: February to June

Cobblestoned streets and candy-colored houses almost vanished in Old San Juan, Puerto Rico in the 1940s. Buildings became decrepit and the government threatened to tear down the colonial city. Ricardo Alegria, an anthropologist, came to the rescue and created the colonial zone, preserving the colorful streets and keeping them from ruin.

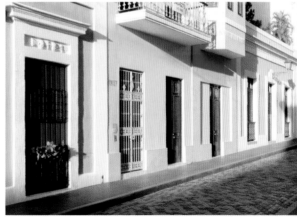

111 Where east meets west

Samarkand, Uzbekistan

Longitude: 66.9° E
When to go: March to June or September to
October

Samarkand is a city bursting with colorful
mosques, mausoleums, and madrassas. One
of the oldest cities in Central Asia, it lies
almost at the very middle of the historic Silk
Road. This central position made the city a
crossroads of two world cultures, something
which is still apparent in the architecture,
food, and culture of the city today. Blue and
turquoise are the dominant colors. The
Registan, also called Registon Square, is a
huge plaza surrounded on three sides by
madrassas, with towering blue-tiled minarets
and glinting cyan domes. The marble façades
of the ancient buildings are coated with
magnificent mosaics and majolica with
geometric, floral, and epigraphic motifs.
A little further on, the Bibi Khanum Mosque
was once one of the largest mosques in the
Islamic world. It features an abundance of
blue tilework, with an impressive arched
entry gate and ornately patterned
aquamarine domes. While nearby is the Guri
Amir, a mausoleum for the ancient conqueror
Timur. The magnificent tomb, with its azure
dome and intricate, gilded interiors is a
precursor to the Taj Mahal, which was built
by Timur's descendants.

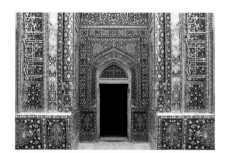

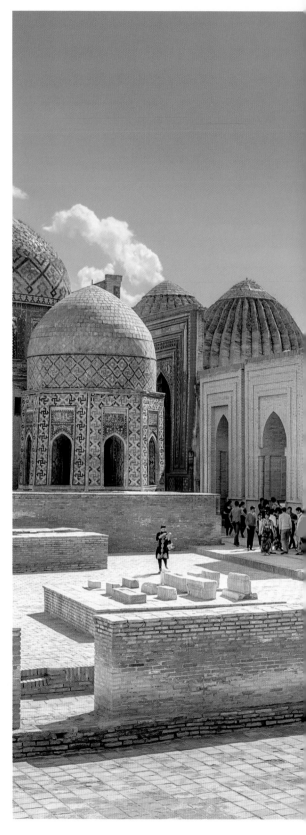

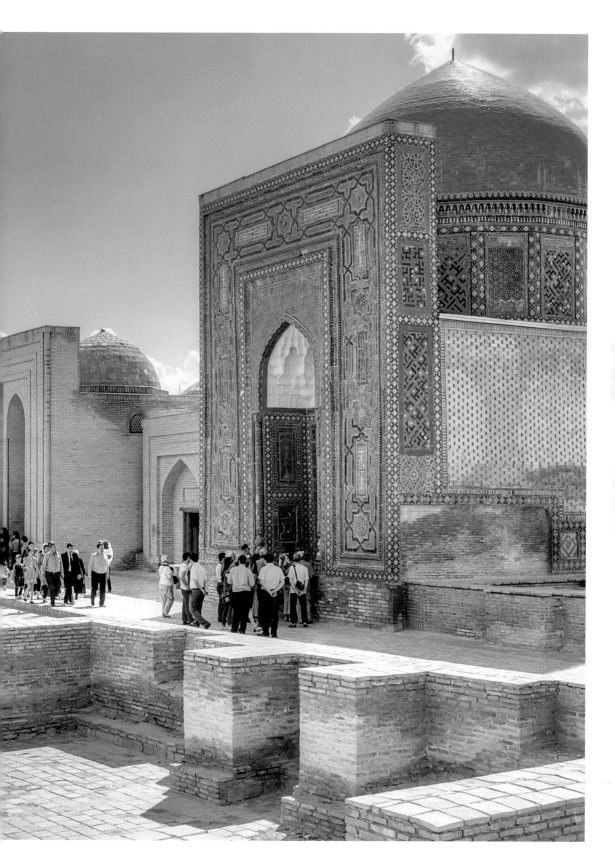

112 Blues, greens, and corals too

▲ Los Roques, Los Roques
National Park, Venezuela

Longitude: 66.6° W
When to go: February to May

Pristine swirls of green and blue water
against the sugary white sand beaches make
the Los Roques archipelago seem a perfect
deserted island. Found 103 mi/166 km
north of Venezuela's coast, Los Roques was
established as a National Park in 1972 in
order to protect its stunning coral covered
walls, huge coral pillars, underwater caves,
and fish of all sizes and colors. On land, the
islands are laid back and more than charming.

113 Seventh heaven

▶ Cerro de los Siete Colores,
Purmamarca, Argentina

Longitude: 65.5° W
When to go: All year

With its colorful market and adobe houses,
the village of Purmamarca in northwestern
Argentina is colorful enough. Yet it is the hills
behind the town which are truly spectacular.
Layers of red, pinks, golds and greens
have stacked up on top of each other as
sediments from different ancient rivers and
seas have settled here. A path leads from the
town on a short hike around the hills offering
fabulous views of the colorful mountains and
the weird rock formations within them.

114 **When inspiration hits**

El Alto, Bolivia

Longitude: 68.2° W
When to go: April to June (colder temperatures but it's the dry season)

A bricklayer turned civil engineer, Freddy Mamani established a new form of colorful architecture in one of the world's highest cities. Known as New Andean Architecture, his geometric-like designs add color to the city and are inspired by Aymaran textiles—richly colored fabrics—and ancient architecture from the imperial capital of Tiwanaku. Interiors match the distinctive exteriors, so when you find yourself admiring one of his buildings, be sure to step inside.

115 Blast from the past

Old Town, Lunenburg, Nova Scotia, Canada

Longitude: 64.3° W
When to go: May to October

As you walk the wharves of Lunenburg's Old Town, it's still possible to hear a blacksmith's hammer at work. Established in 1773, it's one of only two North American UNESCO World Heritage urban communities, full of vibrant old buildings and a ship-studded harbor.

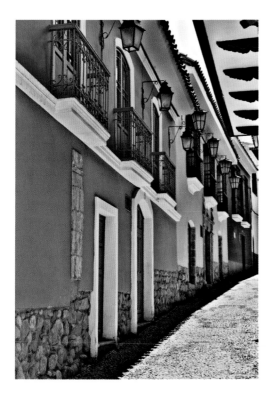

116 Calm, quiet, and full of creatives

Calle Jaen, La Paz, Bolivia

Longitude: 68.1° W
When to go: May to October

Home to a range of bars, shops, restaurants, and museums, Calle Jaen in La Paz is one of Bolivia's best-preserved colonial streets. Brightly plastered homes line the cobblestoned lane, and sandwiched in between are fabulous museums such as Museo del Litoral and Museo Casa de Murillo. The picturesque bohemian road is a meeting point for writers, poets, and artists to come together in the many cafés and gallery spaces in the area. With only pedestrian access, Calle Jaen offers a calm walkway to explore the city of La Paz.

117 Dalí's playground

Laguna Colorada, Bolivia

Longitude: 67.7° W
When to go: May to October

In the Altiplano, a wide plateau high up in the Andes, sits a salt lake that shines red-orange. Surrounded by rugged landscape and mountains, the lake provides a rich contrast to its harsh environment, reminiscent of a Salvador Dalí painting, which coincidentally is the name of a nearby desert. Algae and microorganisms in the water give the lake its dramatic hue, and islands of white borax deposits create an intense contrast with the water. Due to the area's high mineral content, many lakes on the Altipano are blessed with deep colors, but this is the only red one; others tend to be deep blues and greens, and there's a turquoise Laguna Verde. A rare species of flamingo is also found at the lake—so rare, in fact, that in 1924 it was thought that the Puna, or James's Flamingo, was extinct, but in 1957 it was discovered again, sharing a habitat with the Chilean flamingo.

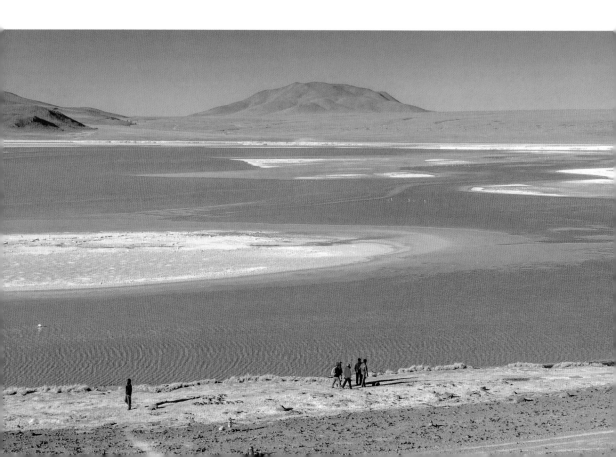

118 Not every town has a silver lining

Potosi, Bolivia

Longitude: 65.7° W
When to go: May to October

As one of the highest cities in the world, Potosi is nestled in the mountains at just over 13,000 ft/4,000 m above sea level. Once a small silver mining village and the richest city in the world, Potosi has been shaped by its past. In the city center, red-tile-roofed buildings line the streets and can be seen from the tower of La Compania de Jesus. And brightly painted homes surround the lively plazas.

119 Sky above and sky below

Salar de Uyuni, Bolivia

Longitude: 67.4° W
When to go: January to April for the best chance
of the reflection

Remnants of a dried-up prehistoric lake,
Salar de Uyuni covers more than 4,050 mi²/
10,500 km² and is the world's largest salt flat.
An awesome phenomenon, with wide,
desolate views of white stretching in every
direction, it becomes even more surreal at
certain times of the year. When nearby lakes
flood, a thin layer of water covers the flats,
creating the world's largest reflecting pool.
The landscape turns into a mirror of the pure
blue skies above and all of a sudden you're
walking in the air. It's possible to spend the
night at a salt hotel in the town of Uyuni.
Rooms, walls, and furniture are all made from
the mineral. Known for its healing properties,
the all-encompassing presence of salt creates
a calm, spa-like atmosphere.

120 Color treat

St. John's, Antigua and Barbuda

Longitude: 61.8° W
When to go: November to May

St. John's, a small bustling Caribbean town, is the soul of Antigua. The center of life for locals, St. John's is constantly buzzing. Markets along the harbor front are piled high with fruits and flowers while Heritage Quay and Redcliffe Quay are brightly colored shopping areas with many restored traditional buildings. For great views of the island head to the ruins of the eighteenth-century Fort James and Fort Barrington.

121 Crossing the divide

▼ Manaus, Amazonas, Brazil

Longitude: 60.0°W
When to go: June-September

A gateway into the Brazilian Amazon, Manaus is 6 mi/10 km away from Encontro das Águas, or "Meeting of the Waters," where the Rio Negro and Rio Solimões converge but don't merge. The Rio Negro waters are black, due to decaying plant matter, and the Rio Solimões are coffee colored. Different temperatures, speeds and density keep the two water flows separate, so when they run into the same channel, there is a divide that's visible from space.

122 Old world, new life

Ottleys Manor, St. Kitts

Longitude: 62.8° W
When to go: December to April

This eighteenth-century sugar plantation is home to a beautifully preserved Great House. The contrast of bright Caribbean skies against the sunshine yellow of the shutters is a study in warmth. Now it's a hotel, and you can wake up enjoying its old-world charm, along with incredible views of volcano Mount Liamuiga.

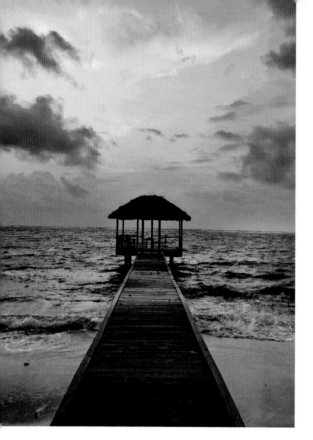

123 World's best sunrise?

◀ Petit St. Vincent, St. Vincent and the Grenadines

Longitude: 61.3° W
When to go: November to April

The southern tip of the Grenadines is home to the island of Petit St. Vincent that is teeming with magic at every step. But, the real showstopper happens in the early morning when the sky is painted with violet and mauve turning into fuchsia and magenta before slowly melting into citrus hues. And as the sun begins to rise from behind the clouds, the sea turns a deep shade of blue.

124 Reefs and royalty

Buccoo Reef, Trinidad and Tobago

Longitude: 61.2° W
When to go: January to May

The Buccoo Reef in Trinidad and Tobago was rated as the third most spectacular reef in the world by Jacques Cousteau. The vibrant underwater oasis is brimming with sea life. Located just beyond the reef is a shallow white sand tide pool, called The Nylon Pool by Princess Margaret in 1962. According to locals, the transparent waters will rejuvenate anyone who is lucky enough to swim there.

125 Art beneath the waves

Underwater Sculpture Park, Grenada

Longitude: 61.6° W
When to go: January to May

Submerged 16 ft/5 m below the water, a ring of children stand tall in the Underwater Sculpture Park in Grenada. The sculpture is one of many placed under the surface to help enhance the reefs in the area. Algae and coral cover these statues, creating a place for marine life to call home.

126 **Caribbean flavor**

Barbados

Longitude: 59.5° W
When to go: December to April

From Bridgetown to Speightstown to Silver Sands Beach, the colorful Caribbean island of Barbados is full of local flavor and culture. In Bridgetown, bright buildings line the streets and beaches of the UNESCO Heritage Site. Speightstown is home to Cobblers Cove Hotel, a stunning pastel-pink hotel surrounded by lush palm trees and dotted with baby-pink-striped umbrellas. Down the road, The Lobster Pot serves up the tastiest fresh seafood, while Little Bristol Beach Club offers the quintessential backdrop for sunset, as the sky turns from lapis to honey before the sun sinks below the sea.

127 Penguins and jam

Port Stanley, East Falkland Island, Falkland Islands

Longitude: 57.8° W
When to go: October to April

Approaching Port Stanley by boat, the rugged landscape and often-gray sky make the colorful town of Port Stanley really stand out. Once you disembark and stroll around, noticing the red mailboxes, brightly painted maritime houses, and friendly locals, there's a sense of small-town Britain, but also that you've stumbled into something pretty spectacular. With only a few thousand residents and its remote location, Port Stanley is a world in itself. Around the island, there are multiple spots to see penguins, and you can't leave before tasting the local Diddle-Dee Jam.

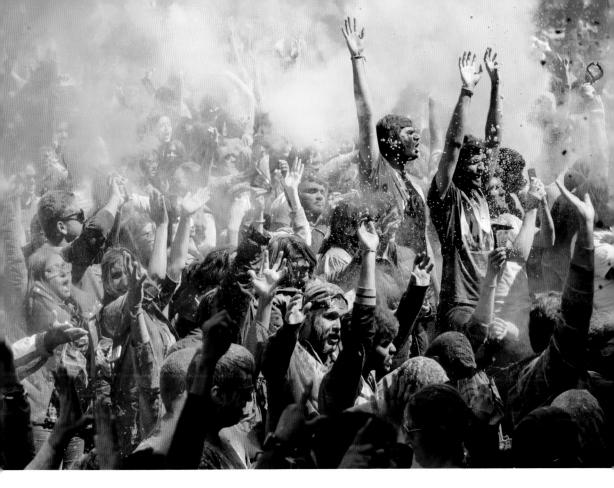

128 It's raining . . . a rainbow

▲ Phagwah, Guyana

Longitude: 58.9° W
When to go: March

Celebrate spring in Guyana with the happy, rainbow-filled Phagwah, or Holi, a Hindu Festival of Colors. Brought to the Guyanese by their Indian ancestors, the revelers dress in white and carry water guns filled with *abeer*, a colored powder, to cover friends and strangers with vibrant hues. Spring and all the colors are in the air.

129 Color in the hills

Loma San Jeronimo, Paraguay

Longitude: 58.4° W
When to go: April to September

A myriad of colorful homes can be found dotted along the hilly landscape of San Jeronimo. Loma, one of the oldest barrios of the city, sparkles as rays of sunshine reflect off brightly painted yellow and orange buildings, while eclectic mosaics mirroring the vibrant houses climb the city's staircases.

130 Let tango fill your soul

La Boca, Buenos Aires, Argentina

Longitude: 58.4° W
When to go: March to May

Buenos Aires' vibrant and bohemian neighborhood La Boca is the place to watch talented tango dancers on the cobblestones, pick up some souvenirs, or sit at one of the street restaurants and enjoy an Argentine steak and a delicious glass of Malbec. The direct translation of the area's name is "the mouth," as it's situated at the mouth of the River Riachuelo. El Caminito is the most colorful area—a slightly ramshackle pedestrianized street of rainbow houses, shops, and murals. Once a shipyard, the dockworkers living here constructed their homes from leftover materials such as planks, sheet metal, and corrugated iron, and covered them in whatever paint they could get their hands on. Often there wasn't enough of the same color to cover an entire house, so you'll see plenty of houses with a patchwork-style paint job. Close by is one of the most famous football stadiums in the world, *La Bombonera*. If you speak Spanish you'll know that translates as "a box of chocolates"—a reference to the shape of the stadium. When top team Boca Juniors aren't playing at home, the stadium is the place to catch global superstars performing live, which in the past have included Madonna and Elton John.

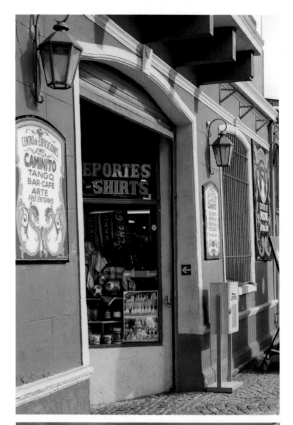

131 **Surprise, it's France!**

Saint-Pierre et Miquelon, France

Longitude: 56.3° W
When to go: July to October

Off the coast of Newfoundland, Canada's most eastern province, is an archipelago that belongs to France. Just a ninety-minute ferry ride from Newfoundland's town of Fortune, you'll still need to pack your voltage adapters and bring Euros. The ferry arrives on the island of Saint-Pierre, where the streets are as colorful as the tumultuous history of the islands. For many years it swung back and forth between French and British rule, until in 1816 it officially became French, and has remained so ever since. During the prohibition, it was a popular spot for smuggling alcohol into the United States, drawing interest from high profile criminals, including Al Capone who spent time at the—still running—Hotel Robert.

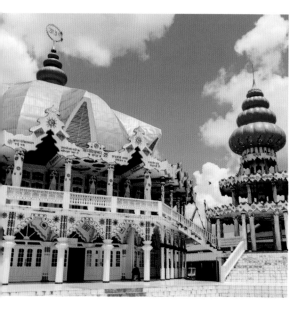

132 **Ringing in the changes**

Arya Dewaker Hindu Temple, Suriname

Longitude: 56.0° W
When to go: December 31

At noon on December 31 in the city of Paramaribo, Suriname, people pack the streets to start ringing in the New Year, or *Owru Yari*, which actually means "Old Year." Bold colors are everywhere—in the clothing, decorations, and vibrant fireworks—as people flock to celebrate around the temple of Arya Dewaker with its burnt-orange roof.

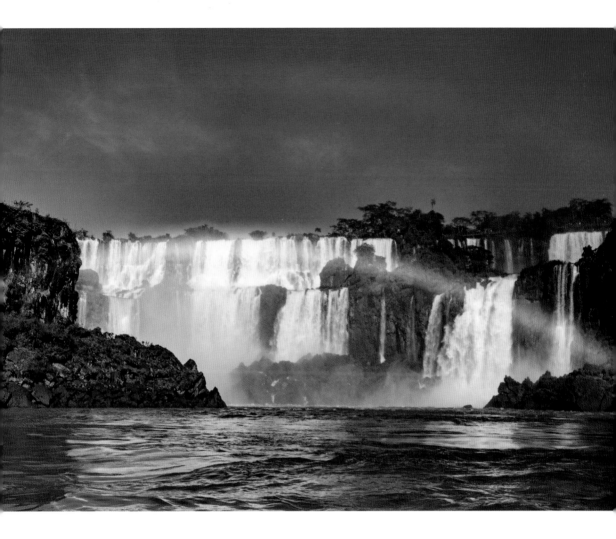

133 **Rainbows without the rain**

Iguazú Falls, border of Argentina and Brazil

Longitude: 54.4° W
When to go: All year

On sunny days when there is a strong flow of water, magic happens at Iguazú falls. The sun hits the water's mist in such a way that it creates a multitude of rainbows. From the higher viewing platform, you can stand above them, surrounded by the lush greens of the Amazon with colorful butterflies flitting through the delicate wildflowers around you, and you might just think this is nature hitting perfection. With 275 different falls, the highest 269 ft/82 m, Iguazú Falls is the largest waterfall system in the world. It spans the Argentinian and Brazilian borders and it's worth seeing it from both sides to get the full Iguazú experience.

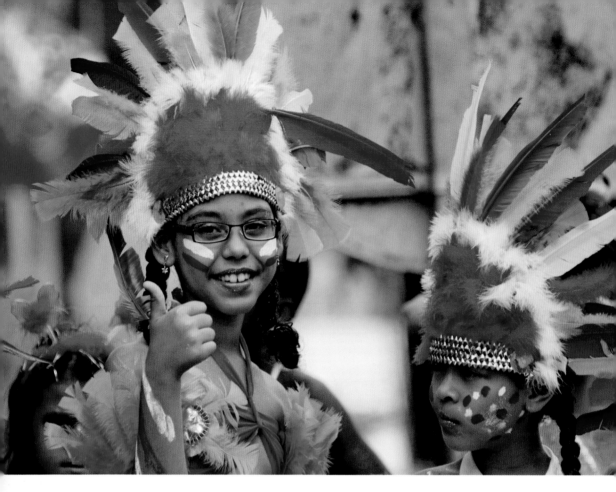

134 Brouhaha and Touloulous

▲ Carnival, French Guiana

Longitude: 53.1° W
When to go: January to March

The world's longest carnival lights up the
streets of French Guiana for more than three
months. With over-the-top street parades
and a never-ending party, the whole country
almost comes to a stop between January and
March. Each Saturday evening, touloulou
carnival queens, dressed in elegant dresses,
vibrant wigs, and intricate masks, lead the
dancing through the streets until dawn.

135 Hitting the sweet spot

St. John's, Newfoundland, Canada

Longitude: 52.7° W
When to go: All year

Jellybean Row might sound like a quaintly
named street, but it is in fact the term
given to the brightly painted houses and
businesses that are found all over the city of
St John's. The vibrant paint job began in the
1970s as a way to bring life to an aging
downtown, but residents loved the look and
so the style spread across neighborhoods,
splashing the entire town with color.

136 Professional paint job

▼ Narsaq, Greenland

Longitude: 46.1° W
When to go: June to September

The small Greenlandic town of Narsaq looks like it's constructed from rows of brightly colored Monopoly houses. Orange houses sit next to blues and greens and yellows. Historically, each color represented the profession of the person living there—so if you needed a doctor you'd know exactly where they lived.

137 Reus by name . . .

Barrio Reus al Norte, Montevideo, Uruguay

Longitude: 56.1° W
When to go: October to March

Named for, as well as designed and constructed by, Emilio Reus, a Spanish entrepreneur in the nineteenth century, Reus al Norte is a historic barrio in Montevideo, Uruguay. The modern architecture pops against the large urban background of the capital city, with a big splash of color. Pastel pink, sea-foam green, and lilac houses with pretty arched windows, contrasting doors, and small balconies overlooking the streets, can be found in the area.

138 A flickering trio

Flame Towers, Baku, Azerbaijan

Longitude: 49.8° E
When to go: Once the sun has set

Amid the cypress-lined boardwalks and bistro-filled streets of Baku, Azerbaijan, stand the iconic Flame Towers—a trio of skyscrapers called South, East, and West—constructed in 2007. Standing between 460 and 600 ft/140 and 182 m high, the towers were designed by renowned architectural firm HOK and, as the tallest of the three is the tallest building in the country, they can be seen from most vantage points of the capital city. Zoroastrianism, one of the world's oldest monotheistic religions, has left a deep mark in the history of Azerbaijan, known as the "region of eternal fires," and fire temples are still common across the country. This inspired the development's flickering design. But where does the color come into it? Visit during the day and you'll find the structures clad in illuminating orange- and blue-tinted glass; visit at night and you'll find the façades have been brought to life by more than ten thousand LED lights. Displaying the movement of fire and a kaleidoscope of colors, the screens are visible from the farthest points of Baku. Probably one of the best free light shows in the world.

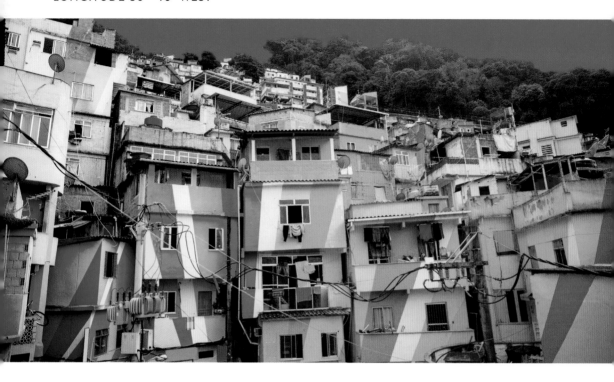

139 Color cascade

Praça Cantão, Santa Marta Favela, Rio de Janeiro, Brazil

Longitude: 43.2° W
When to go: All year

Perched on a steep slope overlooking Rio's famous beaches and coastline, Santa Marta is probably the city's most well-known favela: It was even featured in a Michael Jackson video. An artistically painted section in its Zona Sul is thanks to the local community working with two Dutch artists, Jeroen Koolhaas and Dre Urhahn. As part of a Favela Painting project in 2010, twenty-five locals received training and employment to complete the project in one month, painting over thirty-four houses and covering 1.7 ac/7,000 m² with a vibrant design that starts in a central public space and fans out in a wave of color over the neighboring homes.

140 Drink in the community spirit

Rocinha Favela, Rio de Janeiro, Brazil

Longitude: 43.2° W
When to go: December to March

Rio's largest favela is home to over one hundred thousand people who live in colorful houses stacked up on the mountain. Here, favelas are like towns within the big city, with their own schools, shops, and industries. Take a tour to learn about life here—proceeds support inspirational businesses within the communities.

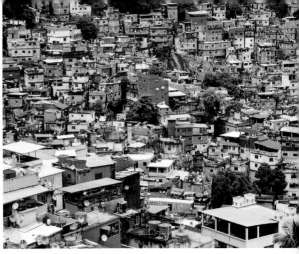

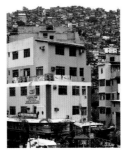

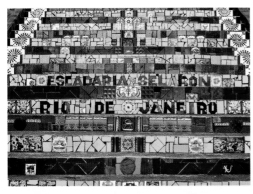

141 One step at a time

Lapa Steps, Rio de Janeiro, Brazil

Longitude: 43.2° W
When to go: December to March

It seems fitting that a colorful country like Brazil is home to one of the most vibrant staircases in the world. In 1990, Chilean artist Jorge Selarón began renovating the dilapidated steps outside his home, covering them with bright fragments of tiles. He focused on blue, green, and yellow to complement the country's flag. He described the steps as a "tribute to the Brazilian people" and it became a project that took over his life. There are over two hundred steps, covered in more than two thousand tiles, from over sixty countries—many of which were sent by people from all around the world.

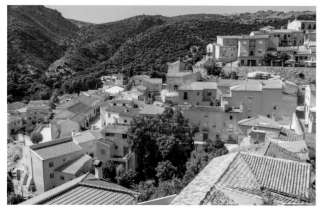

CHAPTER FOUR

40°–0°

WEST

142 Oh, beautiful

Olinda, Pernambuco, Brazil

Longitude: 34.8° W
When to go: All year, February or March
for Carnival

When the Portuguese arrived in Olinda and saw the sweeping ocean views and palm trees, legend says they exclaimed "*Ó, linda*," meaning "Oh, beautiful," and that's how this sixteenth-century colonial town got its name. With pastel buildings, red-tile roofs, beautiful churches, and a vibrant art scene, Olinda is picturesque from all angles. The city is especially bursting with life and color during Carnival—although it's not as well known outside of Brazil as Rio's, Brazilians consider it to be one of the best in the country. With no admission fees, the party takes to the streets and is truly for the people.

143 Jewel in the chain

Cabo Verde, Africa

Longitude: 3.0° W
When to go: November to June

Cabo Verde is an island playground for those seeking fun in the sun and Tolkien-esque adventures. With crystal blue waters, volcano hikes, windswept dunes, and pristine white-sand beaches, Cabo Verde is a chain of islands 310 mi/500 km west of the coast of Senegal. The archipelago is made up of ten islands, and the island of Santo Antão steals the show with its world class hikes through lush green valleys and gorges. Around Pico do Fogo, the highest peak of Cabo Verde and an active volcano, there are other-worldly hikes straight from Middle Earth.

144 The perfect mountain?

Mount Kirkjufell, Iceland

Longitude: 23.3° W
When to go: All year

Mount Kirkjufell, an iconic stop along the ring road in Iceland, changes with the seasons. Lush green moss covers it in the summertime. In autumn, it has an orange glow. And during the wintertime it's covered in blankets of stark white snow, glistening under the purples and greens of the Northern Lights.

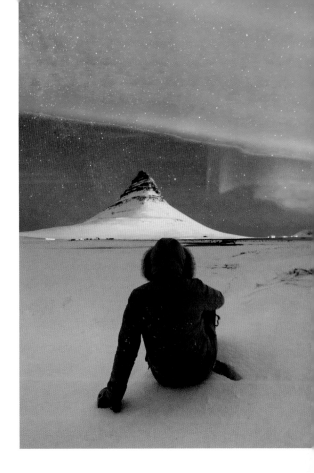

145 Take the lift

Cidade Alta, Salvador, Bahia, Brazil

Longitude: 38.5° W
When to go: July to February

A city filled with energy, Salvador was built on top of a precipice overlooking the harbour Baía de Todos os Santos. Until 1763, it was the capital of Brazil and was a major port throughout the years of the slave trade. The African influence in Salvador is everywhere, especially in Cidade Alta, Upper Town, which overflows with music and life. Get from here to the beach by a funicular or the Elevador Lacerda, a free-standing art deco elevator with sweeping views of the coast.

146 **Rose water**

Lac Rose, Senegal

Longitude: 17.2° E
When to go: November to June

Lac Rose, or Lake Retba as it is also known, is a pink lake in Senegal that's separated from the Atlantic Ocean by just a narrow row of dunes. For many years, it was the finish point of the Dakar rally, before it moved to South America. Wide and shallow, it is one of the few pink lakes that it's possible to swim in—but it's very salty. In the dry season (which is also when the color, caused by a pink algae, is at its most vibrant) the salt content reaches about forty percent, which is saltier than the Dead Sea, but makes it possible to float effortlessly. Salt workers, who extract tens of thousands of tons of salt each year from the lake, rub shea butter on their skin as a protectant and it's advised anyone entering the water do the same, so douse yourself in shea and dive in.

147 Follow the rainbow brick road

Seydisfjordur Church, Reykjavik, Iceland

Longitude: 21.9° W
When to go: August (for Pride celebrations)

Would Dorothy have wanted to head home if she'd been faced with a rainbow road instead of yellow bricks? Who knows. This path leading up to the Seydisfjordur Church in Iceland is in support of the LGBTQ community and plays a pivotal role in Reykjavik's annual Pride festival.

148 Take your minerals

Blue Lagoon, Iceland

Longitude: 22.4° W
When to go: Evenings during summer or winter

A black lava field and soft gray moss is the backdrop for the milky blue waters of Iceland's renowned Blue Lagoon. Located near Reykjavik, this otherworldly lagoon offers a tranquil setting to relax and experience the benefits of the mineral-rich water, which can relieve skin conditions such as psoriasis. Created accidentally when a nearby power plant was drilling in the area, the man-made lagoon is now one of the best spas in the world. The water, made blue by algae, is hot all year round—in winter you can try and spot the Northern Lights, while in summer, the midnight sun casts a soft golden glow along the dreamy lagoon.

149 Blue is the color

Essaouira, Morocco

Longitude: 9.7° W
When to go: March to October

While the majority of the buildings in this coastal city are white, all the accents are in a brilliant cobalt blue, from doors and shutters, to archways and steps. Even the city's fishing boats have followed the color theme. Hours can pass as you watch the boats bob in the harbor—seagulls flying above, fishermen mending nets—all with the backdrop of the perfectly proportioned harbor citadel behind. The streets of the town are filled with little shops and restaurants and the delicate scent of spice. Although it's a beach town, it's also the windiest city in Africa for most of the year, so the beach isn't one for sunbathers. However, nothing gets in the way of the epic beach football that is played on the wide, flat, sandy beach here on a daily basis. After exploring all this delightful town has to offer, enjoy a fish dinner—seafood doesn't get much fresher.

150 Work hard, play hard

▼ Village Underground, Lisbon, Portugal

Longitude: 9.1° W
When to go: All year

What can you do with a bunch of old shipping containers and derelict buses? Convert them into a place to work, eat, and party of course. Composed of fourteen brightly colored maritime containers and two retro buses, Village Underground Lisbon is a coworking space and arts hub for creative types, as well as a venue for cultural events. Don't worry, you can still visit if you're not looking to sit down with your laptop. There's a café serving coffee and food, a skate ramp for the thrill seekers, and parties in the evening for those who want to dance under the stars.

151 Past imperfect

Île de Gorée, Senegal

Longitude: 17.3° W
When to go: All year

Though it is now an idyllic island with colorful colonial buildings, a vibrant arts community, and a little beach for relaxation, Île de Gorée has a heartbreaking history. For over three hundred years it was a major outpost for the slave trade, passing through the hands of multiple European empires until 1848 when slavery was abolished in Senegal. Gorée today is a quiet and colorful island destination, the perfect place to visit and reflect on the past.

152 Modern fairytale

▲ Pena Palace, Sintra, Portugal

Longitude: 9.3° W
When to go: Spring and fall

Sitting on top of one of the highest hills in
Sintra, the Palacio Nacional da Pena is hard
to miss. But, it wasn't always this way. In
1996, Pena Palace was restored and the
exterior, which was fading, was repainted
to the original yellow, red, and blue colors
that once covered its walls.

153 Coasting along

Cliffs of Moher, Clare, Ireland

Longitude: 9.42° W
When to go: July

Green and blue are the order of the day at
Ireland's Cliffs of Moher. Every day in fact.
The sea cliffs run for about 9 mi/14 km and
reach a height of 700 ft/214 m. From them,
there are spectacular views of the Aran
Islands, the Maumturks, and the Twelve Pins
mountain ranges.

154 Perfect Porto

▼ Porto, Portugal

Longitude: 8.6° W
When to go: May to September

Named for Port wine, the city of Porto is filled with quirky, leaning houses covered in blue and white tiles and painted in bright, golden hues of yellow. Found in the neighborhood of Ribeira, a walkway winds its way through the homes, straight to the Douro River, where colorful boats carry barrels of wine to shore.

155 Breathe it in

▶ Cascais, Portugal

Longitude: 9.4° W
When to go: Early spring to late fall

As pretty as a seaside painting, Cascais is an idyllic coastal town in Portugal. Only forty minutes from Lisbon, the harbor village is a favored retreat for locals and tourists. More than just a beachtown, Cascais is built around a rocky coastline and scattered with epic viewpoints such as Buraco do Fojo. In town, houses painted in bold yellow and covered in traditional blue tiles line the small alleyways. Bright magenta flowers climb the walls and create canopies over the tiny, winding roads. Vibrant murals of turquoise and fuschia cover large buildings. You can't help but inhale color.

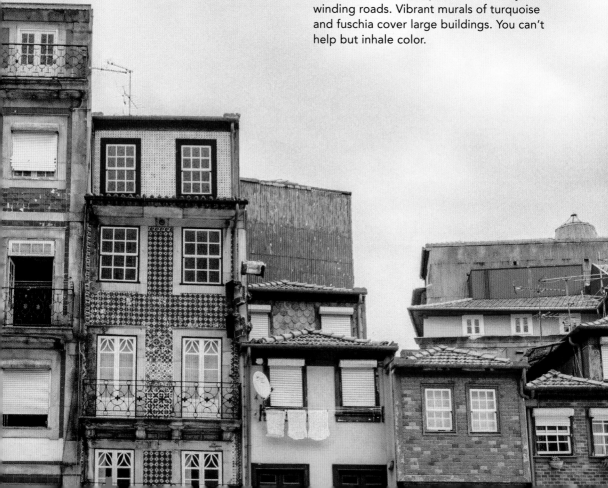

156 Pink by name . . .

Pink street, Lisbon, Portugal

Longitude: 9.1° W
When to go: March to October

Once the "Red Light District" in Lisbon, Rua Nova do Carvalho was the meeting point for sailors, criminals, and prostitutes for several decades. Now, the dilapidated, run-down buildings and warehouses have been turned into works of art and Pink Street has become the hotspot for cool cafés and bustling bars and nightclubs. The vibrant road, which was painted pink in 2011, stays open well after the bars in Bairro Alto close up. Known locally as Rua Cor-de-Rosa, the area is constantly buzzing with locals and tourists, no matter the night. Some of the bars on the bright pink street nod to their history by hanging fishing nets while yellow and red awnings line the streets and colorful table tops become the backdrop to a night out.

157 . . . pink by nature

Casa de Serralves, Porto, Portugal

Longitude: 8.7° W
When to go: May to June

Casa de Serralves is the perfect place for fans of modernist architecture. Designed by the architect José Marques da Silva, the curvaceous building is a smooth blend of neoclassical, romantic, and art deco styles with pink and blue hues. Simply lovely.

158 Shhh . . . don't tell

Le Jardin Secret, Marrakech, Morocco

Longitude: 7.9° W
When to go: March, in the morning

Nestled within the crowded souks of Marrakech, it's easy to miss this restored sixteenth-century *riad*. Featuring vivid green tiles and colorful interior walls, the garden has plants from all over the world including South Africa, Madagascar, Australia, and Latin America, as well as a reconstructed Islamic section. Drop by and feel the peace.

159 Beach beauty

Lagos, Portugal

Longitude: 8.6° W
When to go: Late April to mid-October

Jagged cliffs hug the coastline of Lagos in Portugal. And below those cliffs, an endless array of golden sand creates the perfect oasis for a relaxing afternoon. Powerful waves crash along the beaches and cliffs, creating coves and natural bridges that form some of the most beautiful landscapes in the world.

160 Lose yourself in the hustle and bustle

Souks of Marrakech, Morocco

Longitude: 7.9° W
When to go: March to May or September to November

Marrakech is a true feast for the senses, but nowhere is more vibrant than the city's souks. Traditionally, traveling merchants who arrived by donkey or camel would visit these areas of the city, selling their wares to locals. The souks grew and grew, with smaller souks merging with others to create the vast medina we see today. To make the most of the experience, start in Jemaa el Fna Square to enjoy tasty street food and watch the storytellers and snake charmers entertaining crowds. Then enter the labyrinth of the medina, made up of shadowy passages filled with stalls selling a vast array of items, including multicolored carpets, leather slippers, silk kaftans, scarves, spices, lanterns, and jewelery. There are plenty of workshops tucked away, too, including leather-makers, jewelers, and weavers. Even the best navigators are likely to get lost here, but that's all part of the experience. Be warned though, if you ask one of the locals for help, there's a chance they'll offer to show you the way, which may involve a stop at their friend's/brother's/long-lost cousin's shop. Our advice? Arrive with an open mind and your best haggling skills, and no doubt you'll leave with a few copper lanterns, several bags of aromatic spices, and some authentic gifts for your friends back home.

161 A garden fit for a fashionista

Jardins Majorelle, Marrakech, Morocco

Longitude: 7.9° W
When to go: March to May or September to November

It's impossible not to fall in love with the Jardins Majorelle with their exotic cacti, picturesque fountains, and colorful tiles. This urban oasis is the perfect spot to escape from the intensity of Marrakech. The 12 acre/48,500 m² gardens took French artist Jacques Majorelle forty years to create, and now boast more than three hundred plant species from five continents. They're often referred to as the Yves Saint Laurent gardens, as the legendary designer bought them in the 1980s after they fell into disrepair. They became his refuge from fame and a place for inspiration. After he passed away in 2008, his ashes were scattered in the gardens. Standing out in its Majorelle blue is the Berber Art Museum, which showcases an array of cultural artifacts including carpets, clothing, and musical instruments. In 2017, the Musée Yves Saint Laurent was opened, featuring several of his designs and serving as a reminder of his passion for Marrakech.

162 **Last view of home**

Cobh, Ireland

Longitude: 8.3° W
When to go: March to May for spring weather

The colorful seaside town of Cobh is Cork's magical city harbor. It was the last port of call for the *Titanic* in 1912 before the ship's unfortunate end and became an embarkation point during Ireland's mass emigrations—around 2.5 million Irish people emigrated to North America between 1848 and 1950.

163 **Rivers run red**

Rio Tinto, Huelva, Spain

Longitude: 6.9° W
When to go: March to November

The Río Tinto in southwestern Spain rises in the Sierra Morena mountains of Andalusia and for around 30 mi/50 km of its length it has a spectacular red coloring. This unique reddish-orange color is due to its highly acidic makeup, combined with high levels of iron and heavy metals. The surrounding area is rich in ores and has been mined for so many thousands of years that nobody is quite certain whether the river's color is due to this long history of mining or a result of the natural environment in this area.

164 Perfect palace

▼ La Casa de Pilatos, Seville, Spain

Longitude: 5.9° W
When to go: Avoid the summer season

This Italian Renaissance building serves as
a permanent residence to the Dukes of
Medinaceli but is also open to the public for
tours. Originally dating to the late fifteenth
century, the palace incorporates a mixture
of Mudéjar, Gothic, and Renaissance decor,
with beautiful azulejo tilework, frescoes,
and artesonados.

165 The right royal Portree

Portree, Isle of Skye, Scotland

Longitude: 6.2° W
When to go: June

The town of Portree is well known for its
picturesque landscape, sheltered harbor, and
history of Scottish residents departing for
America. But, most of all, it's known for the
quaint and colorful houses that line its
edges. Originally a fishing village, it earned
the Gaelic name *Port-an-Righ*, which means
"King's Port," after a visit from King James V.

166 Pearls come in blue

▲ Chefchaouen, Morocco

Longitude: 5.2° W
When to go: March to May or September to
November

Sky-colored walls dotted with bright carpets, flower pots, and intricate tiles are the highlight of this Moroccan gem. Various stories speculate on why Chefchaouen's originally white walls were painted, but whatever the reason, wandering around the blue-soaked buildings of Morocco's Blue Pearl is a drifter's dream.

167 Pleasure in the plaza

Plaza de España, Seville, Spain

Longitude: 5.9° W
When to go: March to May

Built in 1929 for the Ibero-American Exposition, you'll be amazed when you see Plaza de España's curved architecture, impressive fountains, and canal. Color lovers will adore the exquisite bridges, clad with blue and white, and the forty-eight detailed alcoves (one for each province of Spain), each with vibrant painted tiles.

168 The old and the new

Belfast, Northern Ireland

Longitude: 5.9° W
When to go: April to October

Once a bustling warehouse district, the Cathedral Quarter in Belfast is now known for its artsy vibes. Filled with pubs, restaurants, and galleries, there is almost always something going on. But, the real reason people flock to this area is to check out the street art that ranges from political to modern murals.

169 Merry in the marina

Puerto de Sotogrande, Cadiz, Spain

Longitude: 5.2º W
When to go: September

If sailing is your vibe, a stop at Puerto de Sotogrande is essential. With a vivid blue marina and the skyline to match, the port is a pitstop for those heading on an Atlantic crossing or preparing to sail in the Mediterranean Sea. Head into the countryside to see Los Alcornocales and the Guadiaro River Nature Site.

170 Old church, new life

Kaos Temple, Llanera, Asturias, Spain

Longitude: 5.9° W
When to go: All year

There's a lot of rain in northern Spain, so what could be better for one town's skating community than an indoor skate park? This amazing venue—known as Kaos Temple—is an old, neglected church that was falling into ruin until it was taken over by a local collective called the "Church Brigade." Through crowd-funding and a bit of sponsorship from Red Bull, they built skate ramps and employed artist Okuda San Miguel to transform the walls with his stunning colorful murals. Almost every flat surface is now covered in vibrant color. As the artist himself said, it's like his own personal Sistine Chapel.

171 Real-life Smurf land

Juzcar, Malaga, Spain

Longitude: 5.7° W
When to go: Fall, for nature at its best

Consisting of narrow, winding streets and bright blue walls, Juzcar is the perfect destination for culture, food, and outdoor adventures; an excellent place to while away an afternoon. The village was originally one of the "white villages of Andalusia" where buildings were traditionally whitewashed. However, in 2011, Sony España painted the entire village blue to celebrate the premiere of *The Smurfs* movie, which caused the area to surge in popularity. The village was filled with illustrator Pierre Culliford's cheeky cartoon characters to sit alongside the movie but these little blue friends have since moved on. At the end of the promotion, village residents were given an option to revert back to white and held a special referendum. It was decided that the village still retained its original Andalusian charm, only with a touch of color, and so remains a bold hue of beautiful blue.

172 Brazil on a hill

Kelburn Castle, Glasgow, Scotland

Longitude: 4.8° W
When to go: July

If you go down to the Scottish woods today, you're in for a big surprise. Nestled in the Kelburn country estate lies a colorfully painted castle. Kelburn Castle is one of Scotland's oldest castles and in 2007, it was found that the castle's concrete façade would need replacing. Owner Lord Glasgow invited four Brazilian graffiti artists to decorate the exterior. World-renowned street artists Nunca, Nina, and the Os Gêmeos twins flew in to add their touch to the listed building. The result is an eclectic mix of Scottish heritage and Brazilian carnival flair.

173 Hidden skills

Hidden Lane, Glasgow, Scotland

Longitude: 4.2° W
When to go: March to August

Right off Argyle Street in Glasgow's Finnieston neighborhood is a charming little lane painted in every color of the rainbow. A bit off the beaten path, the Hidden Lane is a community of artists, designers, and musicians working in about one hundred studios. Visitors can try their hand at learning a new skill in the row of arts and craft workshops. From handmade jewelry and quirky upholstered furniture to guitar lessons and yoga classes, the Hidden Lane is a one-stop spot for anything and everything, including a delightful tearoom.

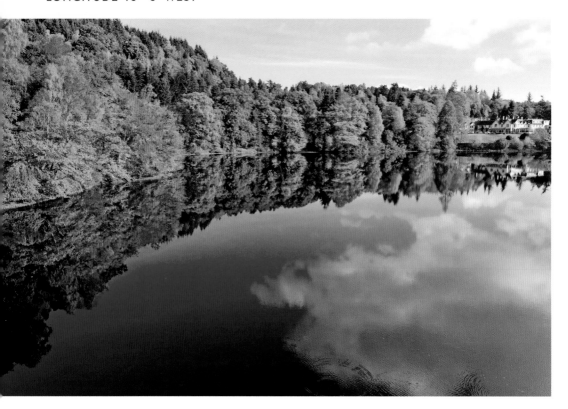

174 Magic in the woods

▲ Enchanted Forest, Pitlochry, Scotland

Longitude: 3.7° W
When to go: On a warm evening

Enjoy beautiful music and a vivid light show at Pitlochry's Faskally Wood after dark as the forest is illuminated with dazzling visuals set against an original music score. The colorful annual event known as "The Enchanted Forest" has received awards as the Best Cultural Event in Scotland.

175 Pretty as a port

Aberaeron, Wales

Longitude: 4.2° W
When to go: All year

Multicolored Georgian houses line the port of Aberaeron, a charming town on Cardigan Bay in west Wales. The tiny fishing village is home to tasty restaurants serving up fresh catch of the day. And when the sun sets, the golden hues create a glow along the mouth of the port, captivating passers by.

176 Patchwork hills

Lammermuir Hills, Haddington, Scotland

Longitude: 2.7° W
When to go: Late August for heather in bloom

The Lammermuir Hills look more like a patchwork blanket from above than a hillside. Hues of purple, browns, and greens drape over the range of hills in southern Scotland, forming a natural boundary between Lothian and the Borders and stretching for miles without any other form of landmark. Visit in late August and you'll find the breathtaking heather in full bloom, engulfing the hillside in shades of lilac, gray, violet, mauve, and even pink—but it only lasts for a few weeks.

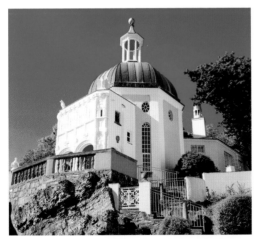

177 Be captured by its charm

Portmeirion, Gwynedd, Wales

Longitude: 4.1° W
When to go: July, but look out for special events

This enchanting Italianate village on the coast of North Wales was designed and built by Sir Clough Williams-Ellis between 1925 and 1975. Pastel-colored villas and piazzas give the village a Mediterranean air that has seen it take center stage in many films and TV shows, most famously the surreal UK TV series *The Prisoner*.

178 A street fit for wizards

Victoria Street, Edinburgh, Scotland

Longitude: 3.1° W
When to go: May to October

Edinburgh's very own Diagon Alley, Victoria Street was the inspiration behind the famous street in the Harry Potter novels. But, the vibrant buildings and cobblestones found their beginning in 1829, when the street was built by Thomas Hamilton. Once known as Bow Street, it was then named for Queen Victoria after she took the throne.

179 Jewel of a coast

Emerald Coast, Brittany, France

Longitude: 2.9° W
When to go: June to September

With its blue-green waters sparkling like a gemstone, Brittany's Côte d'Émeraude, or "Emerald Coast," is home to some of the most beautiful beaches in France. Given its name by French historian Eugene Herpin, the Emerald Coast is dotted with white-sand beaches reminiscent of a tropical paradise.

180 Burrows of fun

Llechwedd Slate Caverns, Blaenau Ffestiniog, Wales

Longitude: 3.9° W
When to go: June to September.

Head underground at Llechwedd Slate Caverns and you'll find a playground full of color among the cavernous ceilings and coves. The former slate mine descends 500 ft/150 m below ground and stretches for 25 mi/40 km beneath the mountain, where it plays host to brightly lit mountain-biking tracks, zip lines, and giant underground trampolines.

181 Everything goes with white

Mojacar, Spain

Longitude: 1.8° W
When to go: Spring to fall

Known for its classic Moorish architecture
and bohemian vibes, the hillside village of
Mojacar is a charming oasis in southern
Spain. Overlooking the sparkling
Mediterranean Sea and barren Sierra
Cabrera Mountains, the town is split into
two parts. The Mojacar Pueblo, rooted in
tradition, and the Mojacar Playa, the modern
expansion. And the real magic is located in
Mojacar Pueblo. White-washed houses line
the steep, winding streets and pops of
magenta bougainvillea hang over yellow and
blue doors, inviting passers-by to keep
exploring. Sweeping views of the green and
brown desert meeting the deep blue sea can
be seen from spectacular viewpoints. From
the Moorish fountain located at the foot of
the town to the detailed tiles that can be
seen decorating doorways and staircases to
the emblem of Almeria, the Indalo Man
marking buildings, Mojacar is a beautiful
coastal town brimming with history.

182 **Pine for more**

Oma Painted Forest, Kortezubi, near Bilbao, Spain

Longitude: 2.6° W
When to go: All year

Hidden on a walk through pine trees in the Urdaibai Biosphere Reserve is the Oma Painted Forest. Bright patterns and colors adorn the trunks of the trees and seen from a distance, they line up to create bigger shapes and patterns that change as you move through the woodland. It is all part of artist Agustín Ibarrola's desire to have you contemplate the relationship between man and nature.

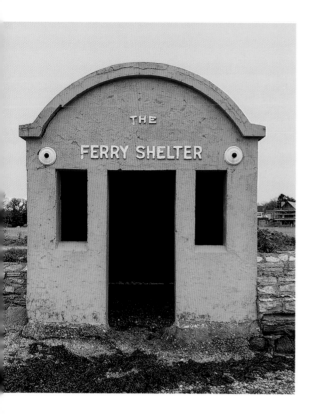

183 In perfect symmetry

The Hamble Ferry & Warsash Ferry Shelter, Southampton, England

Longitude: 1.3° W
When to go: Outside of rush hour

On a stretch of the River Hamble near Southampton, a ferry service has taken people from one side to the other between the villages of Warsash and Hamble for more than five hundred years. The tiny ferries that each carry a maximum of twelve passengers could be straight out of a Wes Anderson film: they are named *Claire* and *Emily*, and painted bright pink. On the Warsash side of the river, passengers can wait in a similarly charming pink ferry shelter. Built in the early 1900s, the shelter was originally where the nearby Bugle Pub stored kegs out of the rain.

184 Dancing in the street art

CHALE WOTE Street Art Festival, James Town, Accra, Ghana

Longitude: 0.1° W
When to go: August

A celebration of the arts, CHALE WOTE is a next level street festival that brings art, music, dance, and performance out of galleries and into the streets of James Town, Accra. By letting art loose in the streets, CHALE WOTE breaks the boundaries for people seeking art: it's already there and they are already a part of it.

185 Think pink

◀ Las Salinas of Torrevieja, Alicante, Spain

Longitude: 0.7° W
When to go: June to September

It's hard not to think pink when paying a visit to Las Salinas of Torrevieja. This pink-water lake is often filled with pink flamingos too. The natural park spreads across 3,450 ac/ 14 km² and can be home to up to two thousand flamingos during breeding season. But why is it pink? Due to exceptionally high salt levels in Las Salinas of Torrevieja, a micro-organism called archaea and a micro-seaweed called dunaliellas can thrive, and together they turn the water pink. Visitors to Las Salinas of Torrevieja can float in the water, which is much like the Dead Sea, and reap the benefits of the natural spa qualities.

186 The world's most talked about bathroom?

Sketch, London, England

Longitude: 0.1° W
When to go: All year

From a Michelin-star restaurant to a famous pink afternoon tea room to a dining room with a carpet inspired by moss, this London eatery has it all. But perhaps the thing that Sketch is most famous for is its egg-shaped toilets, where you can, quite literally, pee in a pod.

187 The family way

The Fruit Market, Humber Street, Hull, England

Longitude: 0.3° W
When to go: On a Saturday

Humber Street in Hull might look like a relatively normal street in an English town, but come the weekend, it turns into a lively mix of street art, food, and culture. The waterside area inherited "The Fruit Market" name due to a large number of family fruit businesses that were established in Humber Street in the early 1900s.

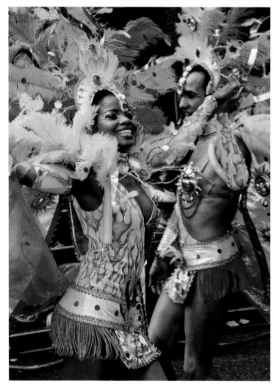

188 Join Europe's biggest street party

Notting Hill, London, England

Longitude: 0.2° W
When to go: End of August for Notting Hill Carnival

More than just the setting of a popular movie, Notting Hill is a favorite destination among locals and tourists alike. Its streets are full of color and quirky independent shops and bars all year round, but it is in August that people really flock to the area. Each year, the Notting Hill Carnival takes the stage as the biggest street festival in Europe. Two million people fill the streets over the course of the three-day weekend. As well as a hugely colorful procession full of floats and elaborate costumes, there are also steel pans, sound systems, and stages on every corner as music fills the air.

189 Epic floor show

◀ Alexandra Palace, London, England

Longitude: 0.1° W
When to go: All year, but check opening times

Sometimes art comes in the most unexpected of places, colliding with the oldest of buildings. Alexandra Palace—or "Ally Pally" as its affectionately known—was built in 1873 in north London. Having undergone an extensive renovation in 2018, the palace's East Court was in need of something special to celebrate. Graphic artists Art+Believe stepped in to design a piece of artwork to reflect the space. They created a hand-painted series of geometric floor pieces. The artwork covers four separate spaces to make one immersive piece: a vivid array of shapes set against the grand Victorian architecture.

190 Cool Camden

Camden Town, London, England

Longitude: 0.1° W
When to go: All year

A labyrinth of open-air markets is the focal point of Camden Town. From eateries and street vendors serving up food from around the globe to eclectic shopping, this part of north London is the place to be. But the real treats are the dynamic murals by popular street artists that line the side streets.

191 Where east meets art

Shoreditch, London, England

Longitude: 0.0° W
When to go: All year

In a city that's always buzzing, Shoreditch is the hotspot for street art. The area's artistic renaissance began in the 1990s when Shoreditch was the hub of the Young British Artists' scene, and while most of them have moved on, the street art continues to thrive. There are stunning murals to be found on walls, buildings, and railway hoardings throughout the area. Brick Lane and Great Eastern Street in particular are covered in works by a number of renowned street artists—although murals do frequently change—while on Rivington Street there's a Banksy that will be sticking around for a while.

192 Color is power

Colorful Crossing, Brighton, England

Longitude: 0.15° W
When to go: On a sunny day

Brighton-based artist Lois O'Hara believes in using colorful artwork to bring positivity and joy to the world. This rainbow crossing painted in front of King's Road Arches in 2018 took three days to complete and a total of 13 gallons/50 liters of paint. Inspired by her love of surfing when growing up, her artwork reflects the motion of the waves with curved lines and abstract shapes taking precedence. And her long-term mission? To color in the world.

193 **A pride of rainbows**

Brighton and Hove Pride, England

Longitude: 0.1° W
When to go: Early August

Brighton is to England's LGBTQ community what San Francisco is to the United States', and it has a Pride celebration to match. Thousands of revelers fill the streets with love and color for a joyous march through town that ends with a huge party in a park and smaller parties all over town. It even boasts a Pride Dog Show.

CHAPTER FIVE

0°–40°

EAST

194 **Living in a box**

La Muralla Roja, Calpe, Spain

Longitude: 0.0° E
When to go: June to August

Designed by Spanish architect Ricardo Bofill in 1968, La Muralla Roja is a postmodern apartment complex in Calpe inspired by the architecture of North African casbahs. "The Red Rampart," as the name translates, is a fabulous study of geometric forms with interlocking stairs, platforms, and bridges, making it feel like something out of an Escher drawing—only brought into wonderful, colourful life. Its jagged silhouette reflects the neighbouring rocky cliffs and the choice of colors—pink, red, blue, burgundy, and terracotta—complement and contrast with the landscape. The building has many apartments that are available as holiday lets, so get booking to make the most of the modernist aesthetic.

195 Neon dreams

▶ God's Own Junkyard, London, England

Longitude: 0.0° E
When to go: Weekends

Salvaged signs and glowing lights take up every inch of space in Walthamstow's own version of Vegas, God's Own Junkyard. The creator of the self-proclaimed junkyard, Chris Bracey was nicknamed the "Neon Man" when he first started working with neon making signs for Soho's clubs, and later creating props for Hollywood. Now, former props, disco balls, retro signs, and more line the floors and walls of the neon wonderland. There's also an on-site café, The Rolling Scones, which offers guests a chance to grab a beer or a sandwich and enjoy the pink glow of the neon.

196 Immersed in art

Eaton House Studio, Essex, UK

Longitude: 0.4° E
When to go: All year

Think pink and book a stay at Eaton House Studio, where the interior acts as an ever evolving art piece. Filled to the brim with quirky decor and eccentric touches, it's also completely covered in flamboyant pink.
The house is owned by best friends James Lloyd-Roberts and Amy Griffith, who spent four years transforming it.

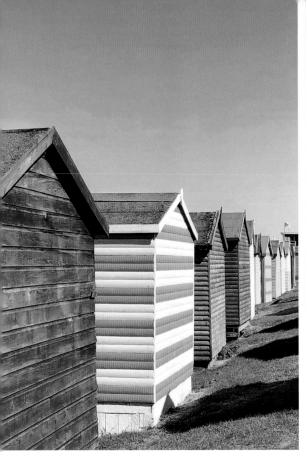

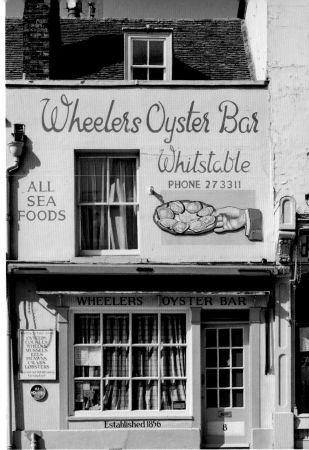

197 The town's your oyster

Whitstable, England

Longitude: 1.0° E
When to go: May to late September

Located a little over an hour from London, Whitstable is a quintessential English seaside town. It's famous for its fresh oysters and eclectic thrift stores, but the real treats are the pastel-painted shopfronts and bright beach huts.

198 Life is a rollercoaster

▶ Dreamland, Margate, England

Longitude: 1.3° E
When to go: April to September

Oh, we do like to be by the seaside! Dreamland Margate is an amusement park based on a traditional English seaside funfair and features a Grade II* listed rollercoaster as well as a roller disco, traditional arcades, and live music festivals. Grab your cotton candy and enjoy the retro vibes.

199 Is it a shrine? Is it a house? Is it pure glee?

A House for Essex, Manningtree, England

Longitude: 1.1° E
When to go: Whenever you can book

A house designed by Grayson Perry was always going to be a little wild. His House for Essex, which looks like a cross between a chapel and a gingerbread house, is based on the concept that it is a shrine built by a husband to his wife after the wife has a tragic accident. The building, clad in two thousand green and white tiles handmade by Perry, is full of little Perry-esque quirks.

200 City of roses

Toulouse, France

Longitude: 1.4° E
When to go: June to September

Nicknamed the Pink City for its unique architectural style, the city of Toulouse is rich in history, but known for its color. Built with mostly reddish-pink clay bricks and tiles, nearly all of the buildings have taken on a rosy glow.

201 Primary residence?

Richard Wood's Houses, Folkestone, England

Longitude: 1.1° E
When to go: June to August

While these tiny houses may look cute and pretty, their message is big: artist Richard Woods wanted to encourage people to think more carefully about the social implications of multiple-home ownership. The series of cartoonish, colorful bungalows were installed in unusual locations, including on the beach and on a floating platform in the harbor. The striking houses were built for an arts festival but were so popular that the local council decided to keep a couple forever.

202 Unfinished symphony

Sagrada Família, Barcelona, Spain

Longitude: 2.2° E
When to go: May to July and September to October

Like walking into a kaleidoscope, color lovers will adore the vibrant stained glass windows in Antoni Gaudí's unfinished Sagrada Família. The architect said that color was the expression of life, and you really feel it as you explore the inside. Construction started in 1882, and is still ongoing, with the latest date given for completion as 2026—the centenary of Gaudí's death. Climb up one of the towers for a great view of Barcelona, and visit at sunset to see the stained glass windows taken to another level.

203 **Bare bones**

Casa Batlló, Barcelona, Spain

Longitude: 2.1° E
When to go: September to October

With its curved façade, organic style, and skeletal qualities, it's no surprise that Casa Batlló is often referred to by locals as "*Casa del Ossos*" or "The House of Bones." Directly inspired by the sinuous shapes and colors found in plants and nature, Antoni Gaudí covered the building's exterior in thousands of pieces of lustrous glazed ceramics and glass. A must-visit for anyone's trip to Barcelona.

204 **Ready or not, here I come**

Walden 7, Barcelona, Spain

Longitude: 2.0° E
When to go: September to October

Situated on the site of a former concrete factory, Walden 7 is an apartment complex in Barcelona designed by Spanish architect Ricardo Bofill. Made up of eighteen towers and seven interior courtyards, the building was created with an enhanced quality of living in mind. And what is proven to improve mood? Color, of course. Just imagine a game of hide-and-seek here.

205 **Mosaic magic**

Palau de la Música, Barcelona, Spain

Longitude: 2.1° E
When to go: May to October

Designed by Lluís Domènech i Montaner, the Palau de la Música in Barcelona features ornate details throughout the interior of the building. There are two showstoppers inside the opera house—the central skylight, which lights up in the sunshine, and the tall pillars, covered in colorful and intricate mosaics.

206 **Urban parkland**

Park Güell, Barcelona, Spain

Longitude: 2.1° E
When to go: May to October

Designed by famous artist Antoni Gaudí, Park Güell was originally meant to be a private residential estate. However, the plans never quite worked out and the park was turned into a public space instead. With striking views of Barcelona and elaborate mosaics lining benches and structures in the Monumental Core, it's full of interest and intrigue—and possibly the most famous lizard in the world.

207 Step up to the rose house

La Maison Rose, Sacré-Cœur, Paris, France

Longitude: 2.3° E
When to go: For a spot of lunch

Make it to the top of Sacré-Cœur and you'll be treated to the charming village of Montmartre as a reward. Roam the cobbled streets and you'll find this pretty-in-pink maisonette, a French bistro, opened by Germaine Pichot in 1905. La Maison Rose was a hotspot for artists, including Picasso, Modigliani, and Edith Piaf.

208 Let it all hang out

Centre Pompidou, Paris, France

Longitude: 2.3° E
When to go: Avoid February, June, and September due to changing exhibitions

Centre Pompidou, designed by Renzo Piano and Richard Rogers, was the first major example of an "inside-out" building in architectural history. Look closely past the seemingly colorful exterior and you'll see the building's structure, mechanical systems, and circulation exposed in color-coded format. Head there for lunch, art, music, and more.

209 Palma chameleon

Palma, Mallorca

Longitude: 2.6° E
When to go: May to early October

Founded in Roman times, Palma de Mallorca is a treasure trove of history and beauty. The Gothic cathedral, which was first refurbished by Antoni Gaudí and then by painter Miquel Barceló, looms in the background of pastel-colored city streets, while bright green palm trees line the promenade, giving the city a true Mediterranean vibe.

210 Life's a beach

Balearic Sea, Mallorca

Longitude: 3.0° E
When to go: May to early October

A beach may be a beach, but when it's surrounded by fluorescent turquoise water, it's definitely something more. The Balearic Sea, which is part of the Mediterranean, is made up of crystal clear water that sparkles when the sun hits it and washes over untouched white sand beaches.

211 The geometric game

Memphis Basketball Court, Ezelsplein, Aalst, Belgium

Longitude: 4.0° E
When to go: While the kids are at school

This basketball court by Katrien Vanderlinden was designed to bring a colorful facelift to a rundown space between a school and a relief center for young refugees. The geometric design was based on a children's mathematical reasoning game known as "Logical Blocks" and is made up of irregular squares, rectangles, triangles, and circles.

212 **Fields of dreams**

Keukenhof, Netherlands

Longitude: 4.5° E
When to go: Mid-march to mid-May

Flowers bring happiness, and if you visit the gardens at Keukenhof in The Netherlands in April or May, you'll be able to harvest your quota of happiness for the year from the millions of flowers in bloom. Found just southwest of Amsterdam, in the normally quiet town of Lisse, Keukenhof receives around one million visitors in the three months it is open each year. In the fifteenth century the land was mainly hunting grounds, but the gardens also grew herbs for the Countess of Hainaut's castle; hence the name Keukenhof, which translates as "kitchen garden." In the nineteenth century, then owners Baron and Baroness Van Pallandt

hired the landscape architect Jan David Zocher and his son, Louis Paul Zocher, to redesign the grounds surrounding the castle. But it was in 1949, when a group of bulb growers came up with the idea to use the grounds to exhibit spring-flowering bulbs, that Keukenhof as we know it today was born. Today, the gardens and four pavilions are open to all (just stay on the paths) and show seven million tulips, hyacinths, daffodils, orchids, roses, carnations, irises, lilies, and more. A new theme is set each year, so expect to discover a new look on every visit as well as experiencing a feast for the eyes, nose, and ears.

213 Nothing square about these cubes

Kubuswoningen, Rotterdam, Netherlands

Longitude: 4.4° E
When to go: May to October

There's something slightly disconcerting about these tilted cube houses situated in the center of Rotterdam. Designed by Dutch architect Piet Blom, the design is a variant of the cube house that Blom previously designed in Helmond but in a slightly larger size. Known locally as "Blaakse Bos," the complex consists of thirty-eight cube-shaped houses, built between 1982 and 1984. Each house was built in the shape of a tilted cube on a pole, replicating the visual nature of a tree house and bursting with a zing of canary yellow at the top. The arrangement was initially inspired by Le Corbusier, who often designed with columns so that the space underneath remained public. The walls and windows of each building are angled at a precise 54.7°, providing spectacular views of the surrounding area. This does have the slight downside of meaning that only a quarter of the space inside is actually usable—oh well, you suffer for art!

214 A ceiling you could eat off

Markthal, Rotterdam, Netherlands

Longitude: 4.5° E
When to go: May to October

One of Rotterdam's most famous buildings, this huge indoor market hall is known for its extraordinary ceiling. It's so impressive, it has been nicknamed the Dutch Sistine Chapel. Artists Arno Coenen and Iris Roskam created it from over four thousand digitally printed panels that depict brightly colored fruits, vegetables, and flowers in a kaleidoscopic, larger-than-life artwork. Once you've finished looking up in this gourmet paradise, you'll find over one hundred food stalls, shops, and restaurants serving foods from around the world. Tuck into delicious Dutch cheese, Spanish tapas, and Italian ham on your culinary wanderings around the hall. Markthal is also home to more than two hundred apartments—perfect for foodies who can look down at the food stalls below for inspiration of what to cook for lunch.

215 Pretty as a picture

◀ Inntel Hotel, Zaandam, Netherlands

Longitude: 4.8° E
When to go: March to May

If you're looking for a place to stay near Amsterdam, there's nowhere quite as quirky and vibrant as the Inntel Hotel. Yes, this place really does exist. Designed by Dutch architects WAM, the iconic green wooden houses of the Zaan region were the inspiration behind the hotel's stacked house aesthetic. Made up of almost seventy individual houses spread over eleven floors, the structure includes various examples of typical Zaan architecture, ranging from a notary's residence to a worker's cottage. While most of the building is painted in four shades of the traditional green of Zaandam, one building on the top floor of the hotel is blue. Why? Because Claude Monet once lived in the city and painted a blue house with a blue fence. So the architects included this cultural reference. They envisaged the hotel as a temporary home for guests, a "home away from home" and a place to merge the past and the present. The impressive mix of design and heritage makes this an impactful place to visit, even if you're not staying the night.

216 Walk like a flamingo

Parc Ornithologique du Pont de Gau, Saintes-Maries-de-la-Mer, Camargue, France

Longitude: 4.6° E
When to go: All year, but flamingo numbers are best in winter

It comes as a surprise to many that there are flocks of flamingos to be found in France. But then, the Camargue is unlike many other places in Europe. Wide, watery, and flat, the area has huge skies that host spectacular sunsets and salty marshes that turn pink when the water level is low. Visit in winter for fabulous strutting courtship shows.

217 Natural sun worshippers

Sunflower Fields, Provence, France

Longitude: 6.2° E
When to go: July and August

Provence must be the region with the best colored crops. It has both lavender and sunflowers. Growing to be as tall as many grown-ups, a whole field of the bright yellow flowers is a beautiful sight. Known in French as "tournesol"—turn sun—the face of the flower slowly rotates throughout the day so it is always getting the full impact of the sun's rays. If you're taking photos, don't forget this is a working industry, so don't venture into the fields without permission.

218 The color purple

Lavender Fields, Provence, France

Longitude: 6.2° E
When to go: June to August

Every year in summer, the French region of Provence is transformed into a sea of vibrant lavender fields. Just driving around the region, you'll detect the delicate fragrance in the air before you see the huge swathes of dusky purple. It really is an incredible sight, and while other countries grow lavender, nowhere else produces it on this scale. One of the most famous views is in front of Sénanque Abbey near Gordes, where the indigo fields surround the twelfth-century building. The monks there plant and cultivate the lavender themselves. To see it at its best, visit in the morning when the sun illuminates the fields, showing off the lavender's mauve hue. The Provençal locals appreciate how special lavender is, throwing festivals in the plant's honor and creating soaps and perfumes from it. It's even an ingredient in the local cuisine, which includes lavender honey, lavender cake, and a delicious lavender sorbet.

219 Look up

Rue Philippe II, Luxembourg

Longitude: 6.1° E
When to go: June to August

As one of the most prestigious shopping streets in Luxembourg, rue Philippe II is a hive for locals and tourists alike who visit the road for its luxurious outlets. But, come in the summer months, and shopping is not all you'll find on the street. Every year art takes over with an aerial installation. The creative initiative was born from the street traders who grouped together with the neighboring Avenue de la Porte-Neuve, joining forces to enhance the pedestrian shopping area and create a friendly summer atmosphere.

220 Banks of charm

Old Town, Colmar, France

Longitude: 7.3° E
When to go: September or around Christmas for excellent markets

Stepping into Colmar's old town is like stepping back in time. The well-preserved town has undeniable charm; half-timbered houses, flower-covered balconies, corbelled turrets, and oriel windows give the place a sense of romance. While every house is painted in a pop of color, it's the combination of nature with the crystal-clear canals that really make this place spectacular.

221 It's a kind of magic

Lake Geneva, Switzerland

Longitude: 6.5° E
When to go: May to September

The crescent-shaped Lake Geneva is one of the largest lakes in Western Europe and is shared between France and Switzerland. Overlooked by the Alps, the aquamarine waters are quite spectacular and have inspired the likes of David Bowie, Freddie Mercury, and Vladimir Lenin, who have all resided on Lake Geneva's shores.

222 Mon Dieu, it's Menton

Menton, France

Longitude: 7.5°E
When to go: Summer or for the lemon festival in February

Menton is one of the French Riviera's most charming towns. It is quieter and less expensive than many of its glitzier neighbors, such as Nice and Monaco. The town is full of history, charming gardens, and fabulous seafood, but it is the view you get from taking a boat trip out to sea or wandering to the end of the quay that will stay with you: A cascade of colorful pink, orange, and yellow houses tumble down the hillside from the gray rocks of the Alps to the turquoise blue of the sea. Visit in February for the lemon festival held in Jardin Biovés.

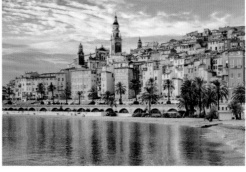

223 Sixth sense

▲ Hexa Grace, Auditorium Rainier III, Monaco

Longitude: 7.4° E
When to go: All year

If you wander around to the back of Monte Carlo's famed casino and look out to sea, you might find your attention somewhat sidetracked by the multicolored hexagonal roof appearing in front of you. Known as the Hexa Grace, this is the work of Hungarian-French Op art legend Victor Vasarely. The piece was made in 1979 from shiny colorful tiles chosen to reflect the colors of the sky, the sea, and the earth.

224 Swiss designed

Les Enfants Terribles, Geneva, Switzerland

Longitude: 6.1° E
When to go: June to August

Les Enfants Terribles is a cultural hotspot in Geneva, consisting of a boutique, an organic café, a workshop, a winery, and a hair salon. While the outside of the shop looks ready for children's TV, the interior is where the magic happens. Colorful eye candy fills every corner of this design boutique-cum-everything else imaginable.

225 **Brick by brick**

LEGO House, Billund, Denmark

Longitude: 9.1° E
When to go: June to August

Ever wondered where LEGO® was invented? Visit the Danish town of Billund and you'll soon know. The LEGO House, designed by Bjarke Ingels Group, is an immersive experience center focused on one thing and one thing only: LEGO. The building looks as if it could be made of LEGO. White bricks are stacked on top of one another, crowned with oversized 2x4 LEGO blocks in bright primary colors. Inside the building, there are more than twenty-five million actual LEGO bricks—that's a lot of playtime! Color was of huge importance to the design of the building and as well as a huge yellow entranceway, there are also four color-coded play areas that each symbolize a special aspect of play and learning. Red encourages creative skills, blue fosters cognitive skills, green helps with social skills, and yellow aids emotional development.

226 Don't look down

▼ Trolltunga, Røldal, Norway

Longitude: 6.7° E
When to go: Mid-June to September

Trolltunga is a rock formation about 3,600 ft/1,100 m above sea level that was created during the Ice Age. This breathtaking cliff juts out horizontally from the side of a mountain into free air, its granite gray contrasting with the blue of Lake Ringedalsvatnet below. Take care, there's no safety barrier.

227 Medieval magic

Mainz, Germany

Longitude: 8.2° E
When to go: April to October

Known for its old town, Mainz sits on the Rhine River and is filled with Romanesque half-timbered houses, medieval market squares, and the deep red Mainz Cathedral. The German city has a culture and history going back two thousand years and is home to colorful carnivals and many great wines.

228 Five towns, five colors

Cinque Terre, Italy

Longitude: 9.6° E
When to go: Mid-May to mid-September

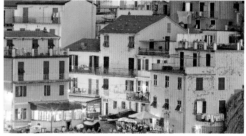

Five multicolored fishing villages known as Cinque Terre line the coast of the Italian Riviera. Built in medieval times, they seem to defy nature as they cling to the cliffsides. Cars were banned from the area more than ten years ago, and the villages are connected by a narrow trainline and winding footpaths. It is, understandably, a popular walk to cross from the first village to the last, traversing the intricate fields and gardens in between which are terraced into the hillsides. Hiking definitely gives the best views of the technicolor villages—but don't take your eyes of the path for too long, it's a steep cliff below you.

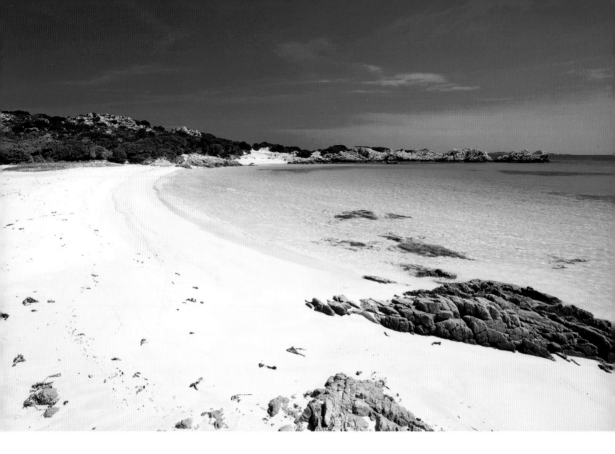

229 Don't make me blush

▲ Spiaggia Rosa, Budelli, Olbia-Tempio, Italy

Longitude: 9.3° E
When to go: Summer

Spiaggia Rosa is one of the few places on the planet to have pink sand. Yes, really, truly pink sand. The brilliantly blush color of this coastline in Budelli comes from a precise mixture of crushed fossils, crystals, coral, and dead marine creatures, which blend together to tint the sand a perfect shade of pink.

230 Glam it up in the Italian lakes

Grand Hotel Tremezzo, Lake Como, Italy

Longitude: 9.2° E
When to go: April to September

Five-star luxury awaits guests at the stylish Grand Hotel on the banks of Lake Como—one of Italy's most glamorous destinations. The bright yellow art nouveau palace boasts spectacular views and is home to period bedrooms, high-end restaurants, a private beach, and an incredible floating swimming pool on the lake.

231 Lights, camera, cake

Bar Luce, Milan, Italy

Longitude: 9.1° E
When to go: First thing in the morning
or early evening

Designed by film director Wes Anderson and situated in the incredible Fondazione Prada, Bar Luce recreates the atmosphere of a typical Milanese café with aperitifs and gelato. Anderson's much-loved movie sets have been brought to life in the café with decorative detail, soft pastels, swirling typography, and uniformed waiters.

232 Brilliant blue

Sidi Bou Said, Tunisia

Longitude: 10.3° E
When to go: All year

Sidi Bou Said's white-washed walls and brilliant blue doors are so perfect they could almost be from a film set. Add to their charm the architecturally stunning Palace Dar Nejma Ezzahra and the pristine coastal views, and you can see why this seaside town is considered such a gem.

233 Citrus sunsets

Florence, Italy

Longitude: 11.2° E
When to go: All year

From the golden hues encompassing the Renaissance buildings to the sun reflecting off the Arno, the sunsets in Firenze are unparalleled. Piazzale Michelangelo is the place to be for panoramic views as the sun paints the sky citrusy hues of orange, pink, and red and slowly sinks behind the Arno.

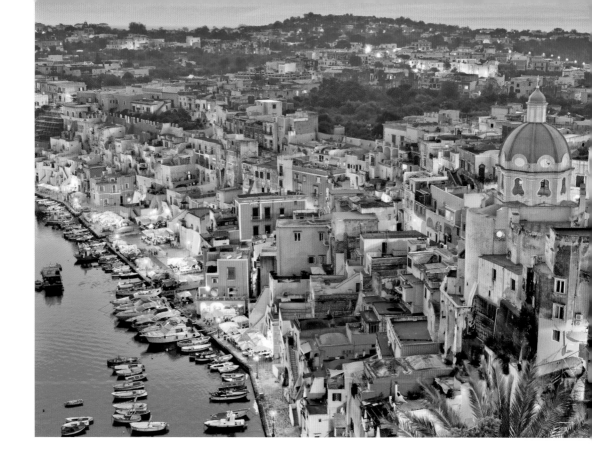

234 Flagrantly fantastic

Procida, Phlegraean Islands, Italy

Longitude: 14.0° E
When to go: March to June, as a day trip

Step off the boat to Procida and you'll be met with one of the best-kept secrets of southern Italy: a kaleidoscope of color from the pastel-hued houses, the fresh produce, and the perfectly presented blooms. Located just off the coast of Naples and only a short ferry ride from the city, Procida was created by the eruption of four volcanoes, now dormant and submerged. The island is so small that you could walk all of it in a couple of days. Corricella, the oldest fishing village in Procida, is every color lover's dream. Filled with dreamy coastal architecture, scintillating waters, and richly hued fishing boats, it's perfect and peaceful. *Il Postino* was filmed on the island, and many other artists and writers have been lured by its quiet simplicity and beauty.

235 Slam dunk funk

Carlo Carrà Park Basketball Court, Alessandria, Italy

Longitude: 8.6° E
When to go: April to June

This eye-popping basketball court, created by Sicilian muralist Gue, is a lesson in how to merge shapes and lines. Conceived as part of the urban regeneration and redevelopment of the city's Carlo Carrà park, the fluid court design plays with perceptions of space and shape. Plus, just look at that color palette.

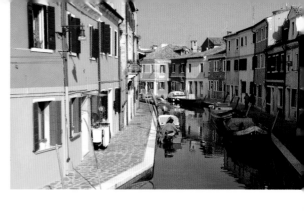

Murano Island, Venice, Italy

Longitude: 12.3° E
When to go: Alongside a visit to Venice

With its block color buildings and idyllic street canals, the island of Murano is utterly enchanting. Renowned for its long tradition of glass-making, color has always been a vital part of Murano's history. Glassmakers were forced to move here from Venice in 1291, to reduce the risk of fires. This isolation and concentration of so many glass artists in one place caused Murano to become a leader in the field. The island initially became famous for glass beads and mirrors. Aventurine glass was invented here, and for a while Murano was the main producer of glass in Europe. Later, the island became known for chandeliers. Today a visit to the Museo del Vetro will tell you the story of glass through the centuries and show you beautiful examples of modern-day glassware, something you can shop for locally throughout the island. The Church of Santa Maria and San Donato, built in the Romanesque style, has a colorful mosaic floor and supposedly houses the bones of a slain dragon.

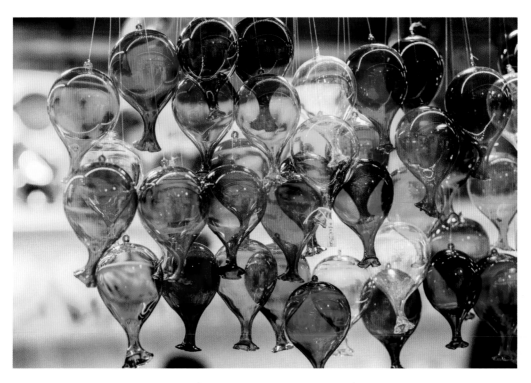

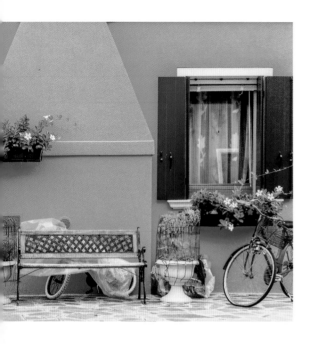

237 Permission to dazzle

Burano, Italy

Longitude: 12.4° E
When to go: All year

Once used to guide fishermen through the fog, the brightly painted homes of Burano are a draw for those escaping the crowds of Venice. Located only 6.5 km/4 mi away, the island is brimming with history. So much so that if a homeowner wants to repaint their home, they must get permission from the government first.

238 Movie magic

Palads Cinema, Copenhagen

Longitude: 12.5° E
When to go: All year

Originally opened in 1912, the Palads movie theater has undergone many changes over the years, the last in 1989 when it was painted in vivid pastel colors. It owes this look to Poul Gernes, a Danish artist who is the cofounder of the art school Eks-Skolen.

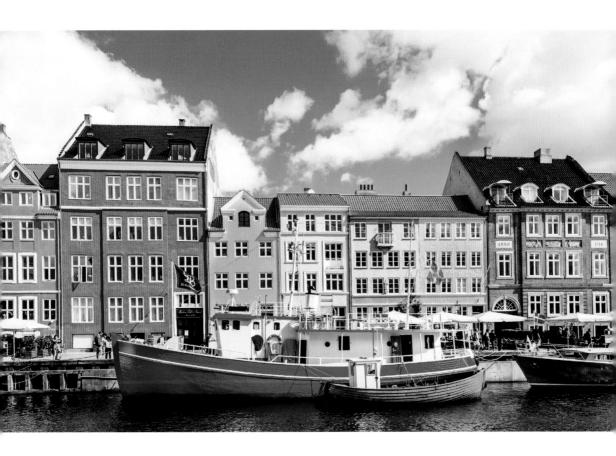

239 Sunny side of the street

▲ **Nyhavn Canal, Copenhagen, Denmark**

Longitude: 12.5° E
When to go: All year

Truly the historic center of Copenhagen, the Nyhavn Canal is a hot spot for tourists and locals alike. The sunny side of the canal is made up of pubs, bars, and restaurants, and has attracted colorful people to the city for years. Danish fairy-tale author Hans Christian Andersen lived in three of the vibrant houses during the 1800s.

240 Sounds of water

The Singing Fountain, Marianske Lazne, Czech Republic

Longitude: 12.7° E
When to go: At night

Located next to the iconic Hlavni Kolonada in the Czech Republic, The Singing Fountain is a circular pool that comes to life at night. Designed by architect Pavel Mikší, the complex sound, water, and light piece provides daily concerts that are dramatic, creative, and most importantly of all, colorful.

241 Dairy delights

▼ Pfunds Molkerei, Dresden, Germany

Longitude: 13.7° E
When to go: May to October

Quite possibly the world's most beautiful dairy, this Dresden cheese shop is decorated with hundreds of hand-painted Villeroy & Boch tiles. There are stunning details everywhere, including the vintage milk fountain where locals once filled up their bottles.

242 Train of thought

Urban Spree, Berlin, Germany

Longitude: 13.4° E
When to go: May, for the best spring vibes

Creativity is at the heart of Berlin and this dedicated artistic space, nestled in a disused train depot, is no exception. The gallery, bar, and shop showcase urban culture and street art through exhibitions, artist residencies, DIY workshops, and experimental on-site residencies. Who knows what you'll find on your visit?

243 **Art on the wall**

Berlin Wall, Germany

Longitude: 13.4° E
When to go: May to September

A monument to the fall of the Berlin Wall, the East Side Gallery is an open-air showroom that features 105 vibrant murals by artists from all over the world. The artworks were created in 1990, documenting a time of change after a monumental moment in history. Throughout the years, pieces of the wall have been moved over to create room for Berlin's expansion. Some pieces have been damaged by erosion or graffiti, but still the meaning behind the gallery stands.

244 **The big blue**

▲ Blue Grotto, Capri, Italy

Longitude: 14.2° E
When to go: April to mid-October

A few miles off the coast of Naples lies
Capri, a captivating Italian island in the
Mediterranean Sea. The island is home
to the Blue Grotto, which was once the
personal swimming area for Emperor
Tiberius. Shining crystal-clear azure water
casts a glowing blue light around the
natural cave.

245 **Island in the sun**

Salina, Sicily, Italy

Longitude: 14.8° E
When to go: May to September

One of Sicily's Aeolian Islands, Salina is home
to a colorful street of houses clad with
vibrant shutters. As you explore you'll find
shops selling *arancini* and *gelato*, along with
tomatoes laid out to dry under the sun.
Fancy an outing? Head to Hauner for a
sunset wine tasting.

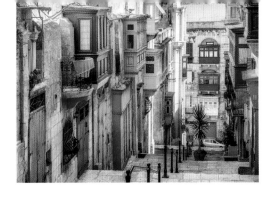

246 Baroque and pop

Valletta, Malta

Longitude: 14.5° E
When to go: Early spring to late fall

One of Europe's smallest capital cities, Valletta, a UNESCO World Heritage Site, is packed with history and stunning architecture. Baroque buildings line the streets of the sixteenth-century city. Colorful doors with matching balconies jut out of stone buildings, adding the perfect pop of color to the narrow streets.

247 Jump in

Blue Lagoon, Malta

Longitude: 14.3° E
When to go: Summer

Off the coast of Malta, a small island, Comino, is home to the Blue Lagoon. Its golden rocks, soft white sand, and cyan-colored water make it one of the most popular places to visit in Malta. Go on a sunny day to see the strongest colors.

248 The eyes have it

Fishing Boats, Marsaxlokk, Malta

Longitude: 14.5° E
When to go: April to June

The town of Marsaxlokk on the southeastern coast of Malta has a population of around four thousand people but boasts one of the largest populations of active fishermen. Visit the port here and you'll find a rainbow of colorful boats, also known as the Maltese luzzu. These traditional fishing boats date back to 800 BC when the ancient Phoenicians came to Malta. Painted in bright red, green, yellow, and blue, the boats feature the traditional eye of Osiris on both sides of the front bow.

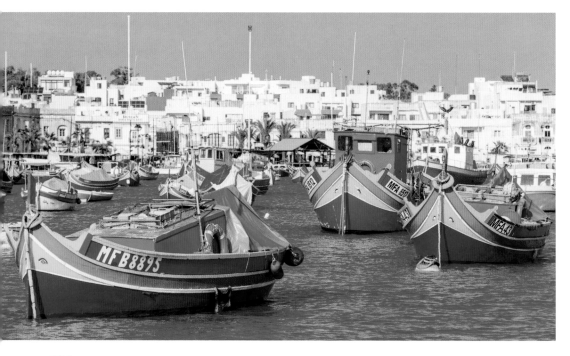

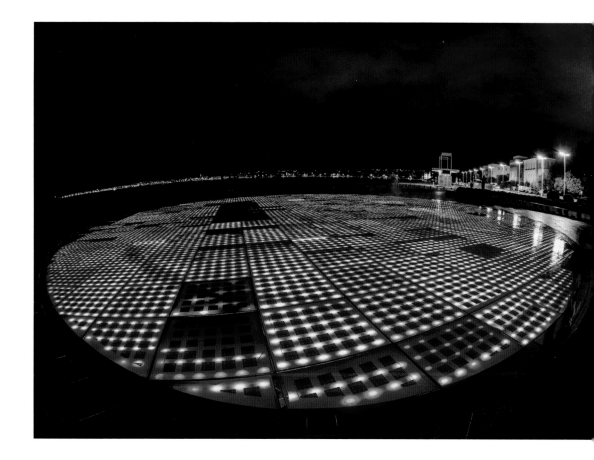

249 Sun salutations (after dark)

▲ Greeting to the Sun, Zadar, Croatia

Longitude: 15.2° E
When to go: May to June and September to October

Art meets nature meets renewable energy generation in this mesmerizing light show. The 70 ft/22 m glass circle covers a bank of photovoltaic panels that absorb the sun's energy by day and power an ever-changing light show by night (as well as the seafront's lights). The lights work in harmony with the neighboring Sea Organ, which turns the sea's wave power into musical sound.

250 Italian style

Cres Old Town, Cres Island, Croatia

Longitude: 14.3° E
When to go: September

The island town of Cres is often likened to a little Italian village thanks to its tiny streets and historical center. Known for its sixteenth-century Venetian Tower and Arsan Palace, the rest of the town consists of pastel-colored houses and an astonishingly blue sea. Get up early for more color-seeking at the markets held in the central square.

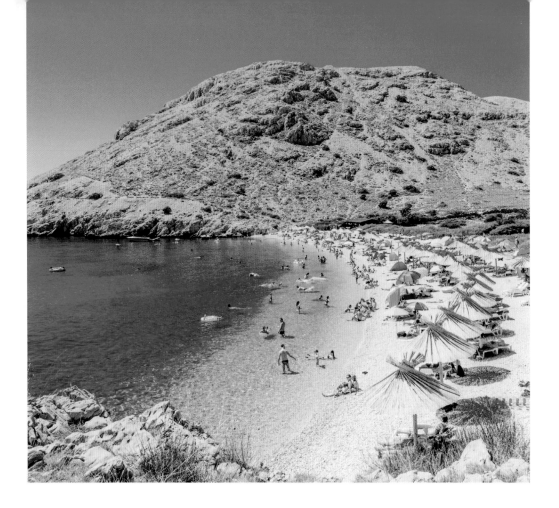

251 Heavenly hideaways

▲ Krk, Croatia

Longitude: 14.5° E
When to go: Summer

The largest island of Croatia, Krk is home to old towns, rural villages, and secluded swimming bays. Steep, winding roads wrap around the coast of the island, creating secret hideaways where you can take a dip. Dramatic inclines lead to rocky beaches dotted with colorful umbrellas all backed by the crystal clear Adriatic Sea.

252 Look before you leap

Krka National Park, Croatia

Longitude: 15.9° E
When to go: May to June and September to October

One of the most popular day trips from Split, Krka is famed for its incredible waterfalls, which cascade weightily from step to step. The colors vary from a deep turquoise to lurid green. After enjoying a wander along the main trail, cool off with a swim in the main waterfall.

253 **Fight night**

Metelkova, Ljubljana, Slovenia

Longitude: 14.5° E
When to go: April to October

Hidden away in the back streets of the sleepy old town of Ljubljana, Metelkova is anything but tired. As darkness envelops the city, the eclectic area comes to life. Metelkova, an urban squat in former Army barracks, is the center of underground music and art in Slovenia. Cracked-tile mosaics and mismatched murals line the walls. Rusty sculptures and noise machines cover the concrete area, drawing in students, artists, and backpackers to experience the nightlife of Ljubljana in the streets and late-night bars.

254 **Color block**

▼ Hundertwasserhaus, Vienna, Austria

Longitude: 16.4° E
When to go: April to May, September to October

Named as one of Vienna's most visited buildings, Hundertwasserhaus has become an integral part of Austria's cultural heritage. The unique apartment block was designed by Austrian artist Friedensreich Hundertwasser, who was passionate about creating living spaces that benefited the public. Every tenant of the Hundertwasserhaus has "window rights"—the opportunity to embellish the façade around the windows as they please. Public walls were designated spaces for children to draw on. The roof and balconies are covered in trees, creating a wonderful oasis around this very unique building.

255 **Bled of Heaven**

▲ Lake Bled, Slovenia

Longitude: 14.0° E
When to go: All year

Lake Bled in Slovenia is one of those magical places that feels like it has come straight from a fairy tale: A castle sits on a hillside; a tiny island with a stunning church stands in the middle of a sparkling turquoise lake; secluded swimming spots dot the shoreline; and hiking trails wind through the forest.

256 The original tile icon

Stephansdom, Vienna, Austria

Longitude: 16.4° E
When to go: April

For color with a dash of Gothic, you can't beat the eye-catching Stephansdom (or St. Stephen's Cathedral) in Vienna. The most important religious building in Vienna, the cathedral has borne witness to many important events in Habsburg and Austrian history and, thanks to its multicolored tile roof, has become one of the city's most recognizable landmarks. The ornately patterned 364 ft/110 m-long roof is covered in approximately 230,000 vividly glazed tiles. On the south side of the building, the tiles form a mosaic of a double-headed eagle, a symbol of the Holy Roman Empire. Inside, you'll find similarly intricate statues and frequently an art installation too.

257 That's Gamla Stan style

▲ Gamla Stan, Stockholm, Sweden

Longitude: 18.0° E
When to go: May to September for sun,
December to March for long nights

Gamla Stan, the oldest part of Stockholm, is one of the largest and most well-preserved medieval city centers in Europe. Packed with history and culture, medieval buildings line the cobblestoned streets, painted in various shades of gold, red, and orange, and dotted with original cellar vaults and frescoes. Stortorget, the central square, is the perfect place for a pit stop, while Prästgatan is thought to be one of the most beautiful streets in Sweden—and where a rune stone, believed to be about one thousand years old, is mysteriously embedded in a wall.

258 Petals at the palace

Rosendals Trädgård, Stockholm, Sweden

Longitude: 18.1° E
When to go: May to September

Situated just west of Stockholm's famous Rosendal Palace designed by Fredrik Blom, you'll find a hit of nature in the form of Rosendals Trädgård. The charming public gardens were designed to bring attention to biodynamic agriculture and to demonstrate different cultural effects on gardening throughout history. Time to be at one with nature.

259 Fantasy funland

▼ Gröna Lund, Stockholm, Sweden

Longitude: 18.0° E
When to go: May to September, at dusk

If you think that color stops at the architecture when it comes to Sweden, you'd be wrong. Gröna Lund, an amusement park on the seaward side of Djurgården Island, is filled with funfair charm. Visit at night for a chance to see all the attractions lit up in bright and gaudy lights.

260 Byzantine beauty

Hercegovačka Gračanica monastery, Trebinje, Bosnia and Herzegovina

Longitude: 18.3° E
When to go: April to July

While the exterior of this Serbian Orthodox monastery is impressive enough, the interior takes it to a whole other level. The church was built in Byzantine style and the beautiful paintings inside were heavily influenced by the Greek painter Stamatis Skliris. Step inside this magical monastery and explore every corner.

261 Charming outside and in

Cathedral of the Resurrection of Christ, Podgorica, Montenegro

Longitude: 19.2° E
When to go: March to June, or September to October

The Cathedral of the Resurrection of Christ in Montenegro is located in the new town of Podgorica. In a culmination of modern design and high-quality craftsmanship, the building is eccentric and charming: washed white-stone towers and golden crosses. It's not just the outside that's cool, though; the interior of the building is equally impressive. The church is heavily adorned with colorful frescoes depicting iconographic gold backgrounds, magnificent marble floors, mosaics, and opulent furnishings.

262 Salt for sale

Salt Market Square, Wroclaw Old Town, Poland

Longitude: 17.0° E
When to go: June to September

This central market square in Wroclaw's Old Town was once one of the largest markets in Europe and is lined with cute pastel-coloured houses. The original square was where salt was traded alongside leather, honey, and beeswax, but was largely destroyed by World War II and had to be rebuilt almost entirely in the 1950s.

263 Bath time

Gellert Baths, Budapest, Hungary

Longitude: 19.0° E
When to go: May to September

The stunningly intricate green-and-blue-tiled
walls of the Gellert Thermal Baths in Hungary
are a beautiful example of art nouveau style.
The waters here are deemed to have healing
properties, and in the thirteenth century,
Hungarian King Andrew II had a small
hospital erected at the foot of Gellert Hill,
where the mineral-rich thermal springs
offered ways to heal, clean, and calm.

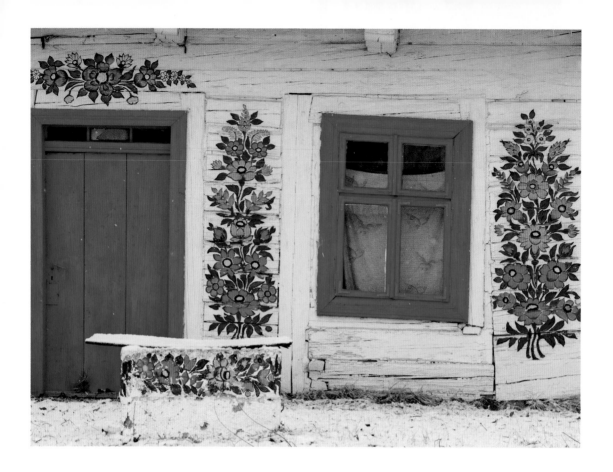

264 Blooming marvelous

▲ Zalipie, Poland

Longitude: 20.8° E
When to go: April to October

You don't have to walk far in the Polish village of Zalipie to discover a house painted with colorful folksy flowers. They are everywhere. It's a tradition that began in the late nineteenth century but is still alive and well today with local artists (traditionally women) taking part in regular competitions and exhibitions. The women create their own designs which cover houses, dog kennels, trees, benches, wells, and even animal troughs all over the village.

265 Paint blocks

▶ Zaspa, Gdańsk, Poland

Longitude: 18.6° E
When to go: June to July

The Gdańsk suburb of Zaspa has Europe's largest neighborhood collection of residential wall murals. The painting began in 1997 during a festival organized to celebrate the one thousandth anniversary of Gdańsk as a city. Ten walls were painted but the craze caught on and now the streets have amassed more than one hundred murals. These murals, some twelve stories high, document Poland's political history as well as other more abstract themes.

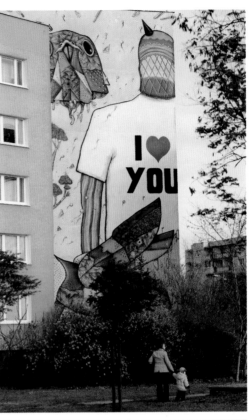

266 The little blue church

Blue Church, Bratislava, Slovakia

Longitude: 17.1° E
When to go: January to February

The Church of St. Elizabeth, more affectionately known as "The Little Blue Church," is a Hungarian Secessionist Catholic church in the old town of Bratislava. Constructed between 1909 and 1913, the one-nave church is typical of the Hungarian art nouveau style and was initially part of the neighboring high school, serving as its chapel. To match the baby blue façade, the church features a blue-glazed tile roof and a line of blue tiles around the walls. Not to be outdone, the interior is just as breathtaking, with blue mosaics, majolicas, and church pews.

267 Border patrol

Uvac Gorge, Serbia

Longitude: 19.9° E
When to go: All year

A snakelike river meanders through the Uvac Gorge in Serbia. Carved by nature, the Uvac Gorge consists of two opaque, emerald rivers, Zlatibor and Zlatar, surrounded by stunning mountains and a steep plateau. Acting as a natural border between Serbia and Bosnia and Herzegovina, the Gorge resembles a maze, wrapping around a dense green forest.

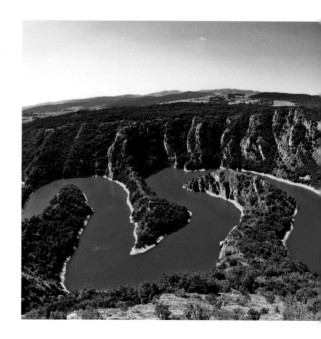

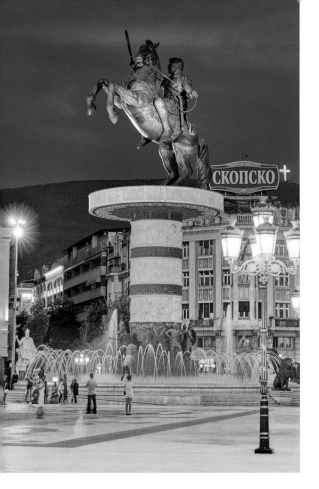

268 Sherbet fountain

Macedonia Square, Skopje, North Macedonia

Longitude: 21.4° E
When to go: At night

By day Macedonia Square might look like an average city square, but visit at night and you'll find it comes to life with a vibrant fountain and musical light show. It's the true heart of the city, where most major cultural and political events have taken place—including the declaration of Macedonia's independence from Yugoslavia. In the center of the square you'll find a colossal bronze sculpture of Alexander the Great on his horse. When it was installed in 2011, a huge crowd gathered to celebrate and sing.

269 History hotel

Hotel Moskva, Belgrade, Serbia

Longitude: 20.4° E
When to go: Early July

The grand ocher and green exterior of Hotel Moskva is one that changes with the light around it. A landmark of Belgrade, the hotel was built in the style of the Russian secession and has been under governmental protection since 1968. One of the oldest hotels operating in Serbia, it was inaugurated by King Petar I Karadjordjević in 1908.

270 Snuggle up

▲ Tulikino Cinema, Šamorín-Čilistov, Slovakia

Longitude: 17.3° E
When to go: All year

Everyone loves a visit to the cinema, don't they? There's nothing better than turning your phone off and tuning in. Although you might want to snap a picture of this movie theatre first. The Tulikino comes with a colorful twist. This one-hundred-seat theatre is made for getting cozy. In fact, *tulikino* translates from Slovakian as "snuggling cinema." Instead of seats there are brightly hued beanbags in modular cubicles.

271 Fit for a queen

Kadriorg Palace, Tallinn, Estonia

Longitude: 24.7° E
When to go: June to September

This eighteenth-century baroque palace was built for Catherine I of Russia by Peter the Great in Tallinn. The Estonian name for the palace means "Catherine's Valley." The palace became the main site for the Art Museum of Estonia in 1921 and holds a wide range of foreign art from the sixteenth to twentieth centuries.

272 **High table**

Table Mountain, South Africa

Longitude: 18.4° E
When to go: All year

The distinctive flat top of Table Mountain is a Cape Town icon recognized around the world. Panoramic views of the vibrant city below and the shimmering blue sea can be seen from the colorful cable cars that travel up and down the peaceful giant. Ascend into the sky through the Tablecloth, a fluffy white cloud that envelops the mountain at certain times of the day.

273 **Mother Nature's magic**

Namaqualand, Namibia and South Africa

Longitude: 19.3° E
When to go: August to September

Mostly a semi-arid land, Namaqualand spans the borders of Namibia and South Africa, and once a year after a short spring rainfall, the desert magically blooms with thousands of vivid wildflowers, transforming the harsh landscape into an artist's palette. Depending on which area of Namaqualand you visit, the blooms happen in different weeks during the spring season.

274 Time for a hike

Šar Mountains, Kosovo

Longitude: 20.8° E
When to go: May to June, September to October

Be at one with nature and head to the Šar
Mountains National Park (or Sharr Mountains)
in Kosovo for your natural color fix. Spanning
half the country, from central Kosovo to the
southern border with Macedonia, this
national park offers some of Kosovo's most
beautiful hiking routes, including the chance
to spot forty-five Serbian Orthodox
monasteries, dating from the twelfth to the
sixteenth century.

275 Books behind bars

National Library of Kosovo, Pristina, Kosovo

Longitude: 21.1° E
When to go: All year

Designed by Croatian architect Andrija
Mutnjaković, whether you love it or hate it,
the National Library of Kosovo is undeniably
an interesting building. Consisting of
ninety-nine irregularly sized domes sitting
atop different-sized cubes covered in large
metal latticework, it has a brutal quality that
some critics have called prison-like.

276 Looks good, works better

◀ Tirana, Albania

Longitude: 19.8° E
When to go: All year

Had you visited Tirana in the 1990s, you'd be
forgiven for thinking that Albania's capital
was a rather gray and rundown place, full of
communist-era apartments in black, gray, or
white. Edi Rama, an artist, politician, and
writer, became mayor of Tirana in 2001 and
decided to inject color into the architecture
by repainting existing buildings in bright and
bold hues. The rainbow building located
near the Blloku area is one of the most
successful transformations and has become
one of the most visited buildings. Tirana is
proof of the benefits of color: since the
addition of the urban art, citizens are
spending more time outside and there's less
litter and lower crime rates in the city.

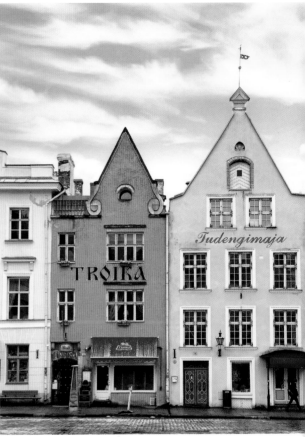

277 Writing's on the wall

Tallinn Old Town, Estonia

Longitude: 24.7° E
When to go: All year

Colorful medieval buildings create a maze of streets in the Old Town of Tallinn. Views of red roofs and church towers dot the skyline from the Kohtuotsa viewing platform. But, the best part is when the pink "The Times We Had" wall perfectly matches the pastel hues of sunset.

278 Freedom of expression

Bo-Kaap, Cape Town, South Africa

Longitude: 18.4° E
When to go: October to April, to avoid the rain

A neighborhood in Cape Town that is impossible to miss, the bright cobblestoned streets of the Bo-Kaap weren't always this way. The houses were originally accommodation for slaves brought to the Cape from other parts of Africa, Malaysia, and Indonesia. While the houses were leased, they had to remain painted white. So when slavery was abolished in 1834 and the residents were able to purchase their homes, they painted them in bright colors as an expression of their freedom.

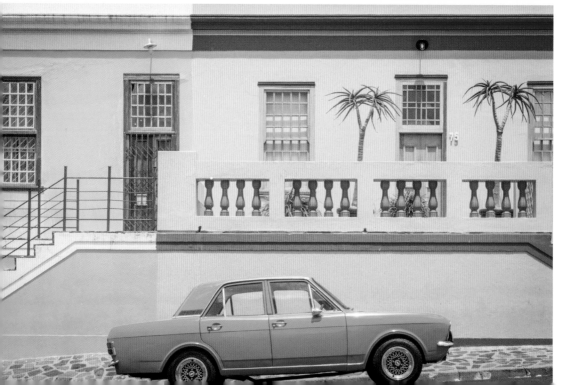

279 Have a whale of a time

St. James Beach, Cape Town, South Africa

Longitude: 18.4° E
When to go: All year

As if brightly painted Victorian bathing boxes weren't pretty enough, these ones on St. James Beach in Cape Town have a mountain backdrop behind them, creating a perfect summer vacation postcard. Decorated in contrasting primary colors, the wooden bathing boxes are a landmark sight and open to the public for changing into and out of

swimwear. Though it's one of the smaller beaches on the False Bay coastline, with its sheltered location, lively rock pools, and calm tidal pool, St. James Beach is a popular spot for families. From June to November, head up to the nearby Boyes Drive for a great spot for some clifftop whale watching.

280 Blue Danube

Danube Delta, Tulcea County, Romania

Longitude: 28.7° E
When to go: Mid-May to September

The Danube River passes through ten countries and four continents before it empties into the sea, but it is in Romania, at its delta, where the river arguably takes its most beautiful form with lagoons full of birdlife and wide meandering watercourses. It's a beauty that is laced through with history as various peoples and empires have laid claim to its riches: the Dacians, the Romans, the Goths, the Ottoman Empire, the Russians, and the Romanians. "Blue" is the word here, from the cobalt water to the azure sky; even the houses are trimmed in an aqua shade.

281 Nice place for a vampire

▶ Sighişoara, Transylvania, Romania

Longitude: 24.7° E
When to go: April

The Transylvanian town of Sighişoara could be straight out of a colorful fairy tale. Perhaps not something you'd expect from the birthplace of Vlad the Impaler, otherwise known as Dracula. However, Sighişoara is often considered to be the most beautiful and well-preserved inhabited citadel in Europe thanks to its authentic medieval architecture. The houses inside the citadel have all the features of a craftsman's town. Every building is brightly painted, especially in Piaţa Cetăţii, where markets, craft fairs, public executions, impalings, and witch trials were held.

282 Earn your stripes

Saint Kotryna Church, Vilnius, Lithuania

Longitude: 25.2° E
When to go: In the evening to catch a concert

Saint Kotryna Church (or the church of Saint Catherine) was the first church to be extensively restored once Lithuania regained its independence. The decoration of choice? Pink and white candy cane stripes, of course. No longer used as a church, the building now plays host to concerts and performances.

283 Space travel

Colorful Mansion Hotel, Ahtopol, Bulgaria

Longitude: 27.9° E
When to go: June to August

More air and more space was the motto of the owners and the architect behind the Colorful Mansion in Ahtopol. With a brightly-colored exterior, terraces facing the Black Sea, and a casual but bold interior, this hotel has become the budget place to stay in Bulgaria.

284 Blue onions, anyone?

Church of Pardaugava (Holy Trinity), Riga, Latvia

Longitude: 24.0° E
When to go: July

This striking Eastern Orthodox church in Riga dates back to 1893 and was designed in a Russian baroque style. It's not hard to spot it among the more neutral architecture in the rest of Riga—you'll be sure to see its red bell tower and blue onion domes rising up from a distance.

285 Dusk delight

▼ Cultural Centre Valve, Oulu, Finland

Longitude: 25.4° E
When to go: January for the Northern Lights

Stop by the Cultural Centre Valve in Finland as the sun is setting and you'll find it almost blending into the horizon. Located in the Pokkinen neighborhood in Oulu, the dusty pink three-story cultural center has two theatre stages, a cinema, galleries, and workshops for creatives to enjoy.

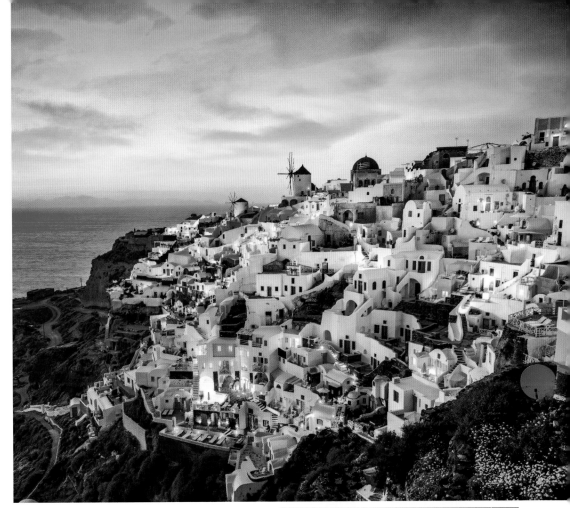

286 World's best sunset?

Village of Oia, Santorini, Greece

Longitude: 25.3° E
When to go: April to October

Expect pops of pink, burnt orange, and blood red laced between the cobalt-blue domed buildings as you watch the sun set in the coastal hillside town of Santorini. The stunning village features two types of dwelling—the cave houses dug into the volcanic rock for ship crews and the captain's houses belonging to the affluent class of ship owners. While every part of the winding village is a treat for the eyes, it's the remarkable sunsets that are unforgettable. If you're looking for a sense of enlightenment, this is the place to come.

287 Art for conservation's sake

Oktyabrskaya Street, Minsk, Belarus

Longitude: 27.5° E
When to go: July

Had you visited Oktyabrskaya Street in Belarus in the late twentieth century, you would have found nothing but factories and a bleak landscape, typical of Soviet architecture. However, today this former industrial area of Minsk has become a center of creativity. Still home to the one machine-making factory named after the 1917 October Revolution, MZOR, the area has not lost all of its industrial roots. But thanks to street artists and a new wave of architects and designers, the road now also offers fun and inspiration for when the day's work is done. The street art renovation of the area began in 2014 when a group of Brazilian street artists came to Minsk to paint alongside Belarusian artists on the street. To celebrate the creations, the embassy of Brazil in Minsk organized an international street art festival titled Vulica Brazil. The street includes one of the biggest murals in the world by Brazilian artist Ramon Martins. The collage features endangered animals of Belarus and covers more than 32,000 ft²/3,000 m².

288 Je t'adore

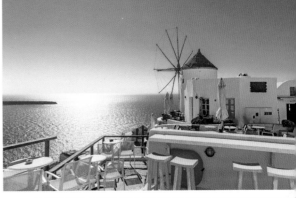

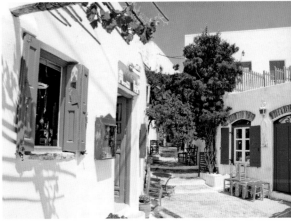

The Amorgos Islands, Greece

Longitude: 25.8° E
When to go: All year

Located near Naxos and Ios, on the southern side of the Cyclades archipelago, Amorgos is one of the most picturesque Greek islands. Built at the center of the island and surrounded by rocky hills, the labyrinth-like village of Chora is perfect for exploring. Square, white-washed houses featuring brightly colored doors and window shutters pop against the azure sky. Set on traditional narrow Lilliputian whitewashed alleys, with bougainvillea trees and scenic squares, these houses give Amorgos a charm all of its own.

289 Where there's a will . . .

Ciuflea Monastery, Chisinau, Moldova

Longitude: 28.8° E
When to go: All year

No, this isn't Cinderella's castle, although you'd be forgiven for thinking so, what with the monastery's powder blue and gold turrets. The Ciuflea Monastery was built between 1854 and 1858. It is the legacy of wealthy merchant brothers Teodor and Anastasie Ciufli. The former died in 1854 and left instructions for the monastery to be built in his will, his brother duly carried out the project. Both are now buried under its consecrated ground.

290 Out of this world (almost)

Honningsvåg, Finnmark, Norway

Longitude: 25.9° E
When to go: September and October

Autumn along Norway's coast is known as the season of color. Think reds, yellows, and oranges against beautiful blue skies and white snow on the mountaintops. Head to the northernmost city in Norway and you'll find Honningsvåg—a tiny city that features vivid houses and primary-colored fishing boats set against an occasionally snow-covered hillside. The city is the gateway to the North Cape; the northernmost point on the European mainland. While travelers once had to climb up the 1,000-ft/307-m-high cliff to get there, it is now accessible by bus—but it is still probably the place that feels most like the edge of the world anywhere. Honningsvåg has the vaulted position of being the smallest city in Norway—with just 2,500 inhabitants.

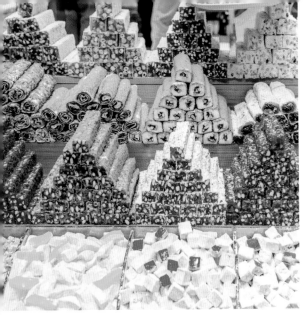

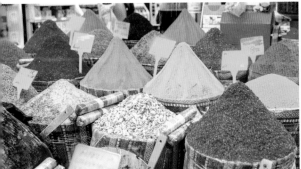

291 Spice, spice, baby

Spice Bazaar (Mısır Çarşısı), Istanbul, Turkey

Longitude: 28.9° E
When to go: April to May, September to November

Nowhere else in the world smells quite like Istanbul's Spice Bazaar—a huge space that is filled to the brim with beautifully rich and vibrant spices, and their aromas. Vividly-colored spices, jewel-like Turkish delight, dried fruits and nuts, herbs, olives, honey, oils, and essences of the finest quality are all on display. Look out for the maroon-colored spice among the mounds of color—the deep and fragrant sumac is made from the berries of the wild Rhus coriaria bush.

292 Shop till you drop

Grand Bazaar, Istanbul, Turkey

Longitude: 28.9° E
When to go: All year

Color magpies beware. The Grand Bazaar in Istanbul requires serious restraint. As one of the largest and oldest covered markets in the world (there are sixty-one covered streets in total), the original core of the bazaar was completed by Mehmet the Conqueror in 1461. The market includes row upon row of brightly-hued wares. Best practise your haggling skills.

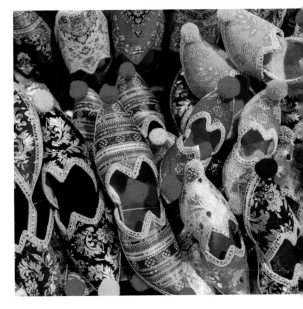

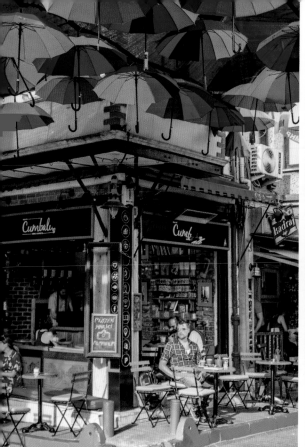

293 Hill walking for pleasure

Balat, Faith, Istanbul, Turkey

Longitude: 28.9° E
When to go: April to May and September to mid-November

With narrow ascending streets lined with tightly packed colorful houses, Istanbul's charming neighborhood of Balat is a little off the beaten path but well worth a visit. Located on the European side of Istanbul, on the shore of the Golden Horn, it used to be known as the Jewish Quarter. In 1492 when the Alhambra Decree came to life in Spain, anyone not practicing Christianity had to convert or leave. Sultan Bayezid II of the Ottoman Empire sent ships to Spain and granted Ottoman citizenship to Muslim and Jewish people fleeing the decree. Balat became the place where many Jewish people settled. Wandering the cobblestoned streets, viewing the brightly painted houses, tasting the food, and visiting the bustling market are the best ways to see the neighborhood. The Ahrida Synagogue is available for tours as well, if you book in advance.

294 The white stuff

Pamukkale, Denizli, Turkey

Longitude: 29.1° E
When to go: April to May and September to November

Pamukkale, meaning "cotton castle" in Turkish, is a natural beauty spot in Denizli in the southwestern area of Turkey. Often referred to as the "White Marvel," the site is known for its mineral-rich thermal waters flowing down gleaming white travertine terraces. These unique formations are caused by limestone deposited by the mineral springs, through a process of rapid precipitation of carbonate minerals. The geological sensation receives over two million visitors annually, making it Turkey's single most visited attraction. Artificial pools have been built next to the site allowing visitors to bathe in the mineral-rich waters just as the Romans did. Alongside the surreal travertines, you'll find ruins of bath houses, a well-preserved theater, and a necropolis with sarcophagi that stretch for 1.2 mi/2 km. There's over two thousand years of history to explore here.

295 One man and his paintbrush

◀ Rainbow Steps, Istanbul, Turkey

Longitude: 28.9° E
When to go: April to May and September to November

In 2013, Hüseyin Çetinel, a retired man in Istanbul, spent several days painting a dull gray staircase with fun rainbow colors. People assumed it had a political or LGBTQ message, but the artist said: "I didn't do it for a group or as a form of activism. I did it to make people smile." When the local municipality heard about it, it repainted the stairs gray, which caused a huge stir and #resiststeps started trending on Twitter. Within days, not only were the original stairs repainted in rainbow colors, but the guerrilla street art project spread all across Turkey.

296 Gold medal for opulence

Peterhof Palace, St. Petersburg, Russia

Longitude: 29.9° E
When to go: April to September

Peterhof Palace was built by Peter the Great, and decorated to extreme extravagance by his gold-loving daughter Elizabeth. Her lavish interiors feature an abundance of gold leaf, carved ceilings, and ornate detailing. Outside, the buttercup yellow façade of the palace overlooks an expanse of gardens, built to mimic the Palace of Versailles.

297 Ancient wonder

Pyramids of Giza, Egypt

Longitude: 31.1° E
When to go: October to April

The last remaining wonder of the ancient world, the Pyramids of Giza stand tall over Egypt's desert. The awe-inspiring golden structures were originally covered in shiny white limestone but over the years this got removed and reused in other buildings. Scientists estimate that the Great Pyramid took twenty thousand slaves twenty-three years to build. Now that's a building project.

298 Sweetness and light

Chesme Church, St. Petersburg, Russia

Longitude: 30.3° E
When to go: Mid-June to September

The Chesme Church, also referred to as Church of Saint John the Baptist at Chesme Palace, is a small Russian Orthodox church built in 1780 by Yury Felten, who was court architect to Catherine the Great. Painted in baby pink and white, the inspiration for this gothic style church was the exotic nature of Turkish architecture but it also referenced Catherine's love for England. The vertical stripes on the building lend to it often being referred to as a candy cane. This gothic-revival style introduced by Catherine became so popular in Russia that it can be seen on many other historical landmarks too.

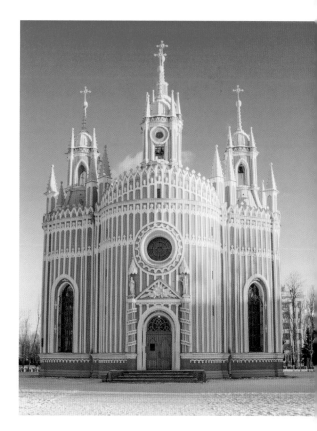

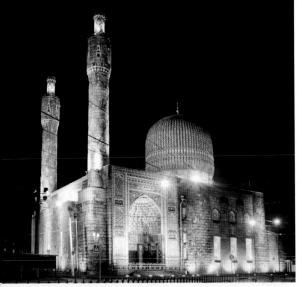

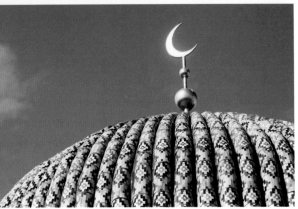

299 Great and good

St. Petersburg Mosque, St. Petersburg, Russia

Longitude: 30.3° E
When to go: Mid-June to September

The Great Mosque of St. Petersburg is the biggest mosque in the European part of Russia—and it's impressive in both scale and design. The building was constructed in honor of the Emir of Bukhara, as a result of Central Asia joining Russia. When built, the mosque was the largest religious landmark in Russia and could fit up to five thousand worshippers. The design was based on the tomb of Tamerlane in Samarkand. Decorated in beautifully tiled mosaics, the blue façades are also adorned with sayings from the Koran.

300 Fairy-tale tracks

Tunnel of Love, Klevan, Ukraine

Longitude: 26.0° E
When to go: May to September

In spring and summer, as leaves bud and flourish, this working railway track transforms into an extraordinary natural tunnel. Still used by a train three times a day, it is otherwise empty and ready for a soulful wander. Legend says that couples walking through will have wishes granted if their love is sincere.

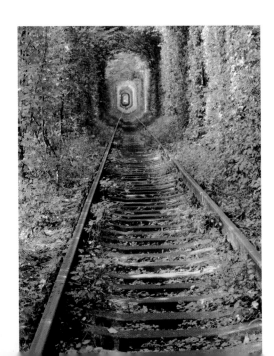

301 What's in a name?

Church of the Savior on Spilled Blood, St Petersburg, Russia

Longitude: 30.3° E
When to go: April to September

St. Petersburg's rich religious history has created many beautiful churches. But if you only see one, make sure it's the Church of the Savior on Spilled Blood. If the name seems extravagant, that's nothing compared to the church itself. Its unique turreted design looks more like a fairy-tale palace than a church, with a pink-hued façade topped by blue swirled domes and decorated in dazzling semiprecious stones. If possible, the interior is even glitzier, with every surface covered in intricate paintings and enormous mosaics.

302 A palace for every season

The State Hermitage Museum, St. Petersburg, Russia

Longitude: 30.3° E
When to go: June to September

St. Petersburg's State Hermitage Museum is one of the largest art museums in the world, second only to the Louvre. Made up of several buildings along the river, it houses over three million artifacts and artworks. But among its many treasures, it is the glorious Winter Palace that might be the fairest of them all. Built between 1754 and 1762, as the winter palace for the tsars, the exquisite green and white baroque masterpiece has 1,786 doors, 1,945 windows, and more than 1,000 rooms and halls.

303 It's the station, not the journey

Moscow, Russia

Longitude: 37.6° E
When to go: All year

Moscow's metro is famed for its luxuriously designed stations, particularly those on the Circle Line. Constructed shortly after WWII, the decorations glorify the country's military might. Each underground work of architectural fancy is completely unique and brimming with Soviet symbolism.

304 **Put it all on red**

Red Square, Moscow, Russia

Longitude: 37.6° E
When to go: All year

Separating the Kremlin from the historic
merchant quarter of Kitai-gorod, the Red
Square is one of the most iconic landmarks in
Moscow. The crimson-walled fortress of the
Kremlin dominates one side of the square;
once the royal citadel, it is now the official
residence of the Russian prime minister.

305 **Russia's Holy Trinity**

The Trinity Lavra of St. Sergius, Sergiyev Posad, Russia

Longitude: 38.1° E
When to go: April to August

Russian Orthodox churches are known for
their bright colors and numerous domes.
Several shining examples can be found at the
enormous Trinity Lavra of St. Sergius
monastery, which is considered the spiritual
heart of the Orthodox church. A sprawling
ensemble of brightly painted buildings are
housed within the monastery's fortified walls,
which are topped with a distinctive leaf-
green roof. Still a working Orthodox
monastery, the Trinity Lavra of St. Sergius
has become an important pilgrimage site.

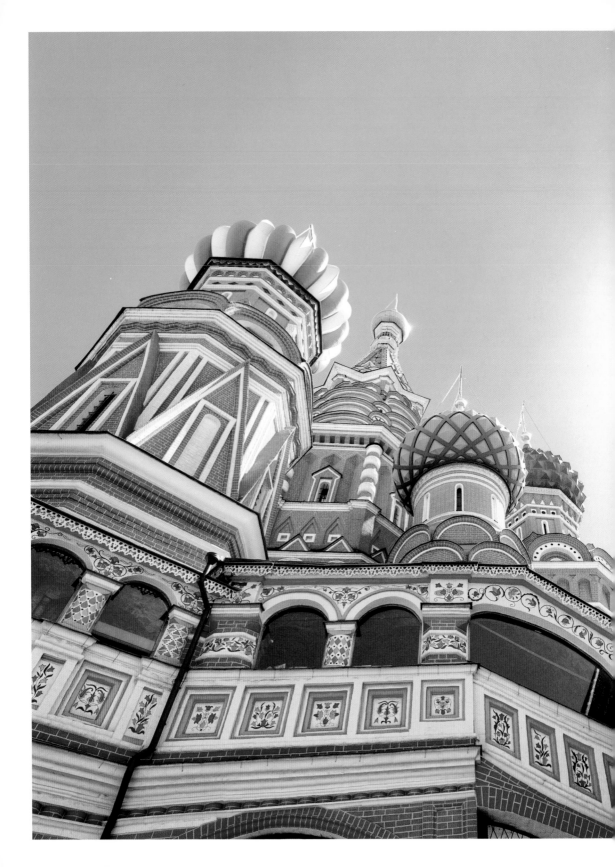

306 If Disney created cathedrals

St. Basil's Cathedral, Moscow, Russia

Longitude: 37.6° E
When to go: April to September

When you think of Moscow, no doubt you think of St. Basil's Cathedral. It's one of the most iconic buildings in Russia and with its playfully decorated onion domes, it looks like it's been plucked straight out of the pages of a fairy tale. Ivan the Terrible commissioned the church in 1552, and it was completed around ten years later. There's a legend that you'll still hear on tours today that Ivan the Terrible was so impressed by the cathedral's beauty that he ordered the architects be blinded so they could never build anything as incredible again. Amazingly, the building has survived throughout the country's turbulent history. As for the design, it wasn't always this colorful. Originally it was white with golden domes. Unlike many vast and airy cathedrals, St. Basil's is a cluster of buildings, consisting of one central church surrounded by nine smaller, more intimate chapels. After visiting during the daytime, return again at night to see the building stunningly illuminated.

307 Russia's own lake district

▼ Karelia, Russia

Longitude: 32.9° E
When to go: September and October

Tucked between the border with Finland and the White Sea, Karelia is an autonomous republic known for its verdant Baltic landscapes. The region boasts over sixty thousand lakes—one for every ten inhabitants—and forests cover around 85 percent of the land. During the fall these forests turn a vivid golden. It's easy to see why the region has inspired countless Russian artists. Head to Kivach Nature Reserve to truly appreciate Karelia's beauty.

308 The only crowdfunded cathedral?

St Volodymyr's Cathedral, Kiev, Ukraine

Longitude: 30.5° E
When to go: June to August

In the nineteenth century, St Volodymyr's Cathedral was funded by donations from citizens from all over the Russian Empire to mark nine hundred years of Orthodox Christianity. Its canary yellow exterior and seven blue domes is a masterpiece of Byzantine style, but the colorful interior is just as admirable, with mosaics and frescoes executed by artists from Venice.

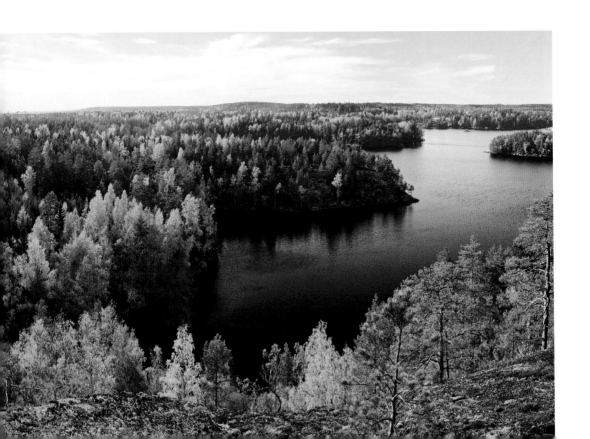

309 **Rebuilding history**

St. Michael's Golden-Domed Monastery, Kiev, Ukraine

Longitude: 30.52° E
When to go: June to August

The striking architecture, glittering gold domes, and decadent interior of this functioning monastery in Kiev brings in tourists from far and wide. Built in the 1990s, it is a reconstruction of the destroyed St. Michael's Cathedral, which was pulled down by the Soviet regime in the 1930s for having "no historical value."

310 **Red-light district**

Red Canyon, Israel

Longitude: 34.8° E
When to go: April, May, September, October

Named for the moment when the sunlight hits the reddish rocks, lighting up a deep, intense red, the Red Canyon in the Eilat Mountains is one of the most beautiful hiking areas in Israel. The breathtaking canyon is reminiscent of the planet Mars because of its deep red rock and soil.

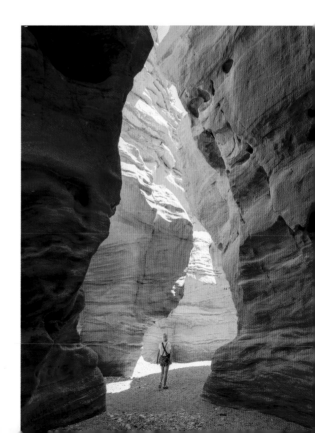

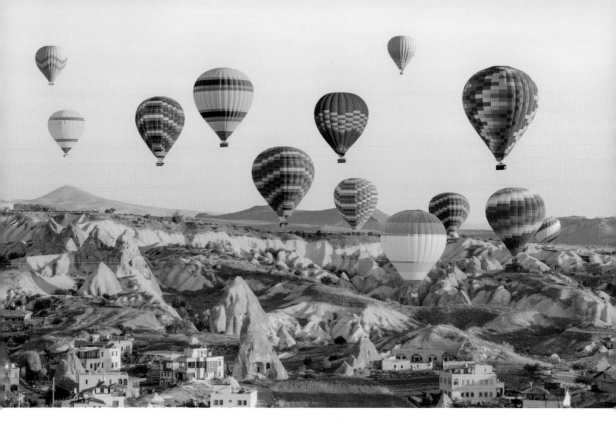

311 Scene from above

▲ Cappadocia, Turkey

Longitude: 34.8° E
When to go: April to June and September to October

Each morning in Cappadocia the skies fill with colorful hot-air balloons as tourists venture upward for breathtaking sunrise views over the region's surreal "fairy chimneys" (spiky rock formations that pepper the landscape). In Roman times, many of the chimneys were turned into homes and churches, adding to the town's fairy-like charms. It's an amazing sight as around one hundred balloons of differing colors and designs peacefully float in a pale blue sky over the orange land.

312 Stairway to heaven

▶ Mar Mikhael steps, Lebanon, Beirut

Longitude: 35.7° E
When to go: July to September

Beirut has a long and difficult economic and political history, but in response there has been a swelling of creativity. A group of Lebanese artists and changemakers, Dihzahyners, are transforming the urban scenery of Beirut by painting stairways in vivid colors and patterns. The old stairs of Mar Mikhael and Jeitawi have seen the city change around them and every step has a story. Dihzahyners aim to embrace this. The ongoing project, titled Paint Up, sees many of the city's stairways painted in geometric patterns.

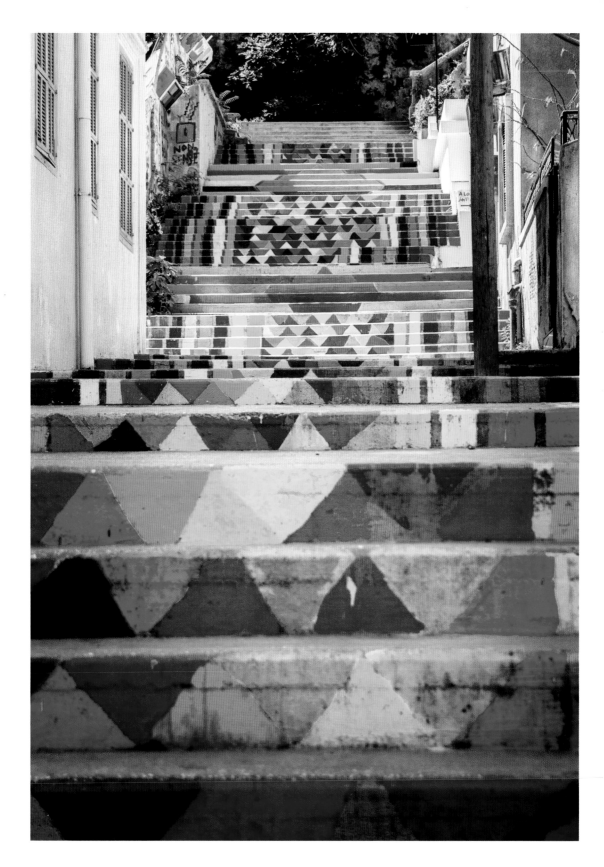

313 Ain't no party like a flamingo party

▲ Flamingos, Lake Manyara, Lake Manyara National Park, Tanzania

Longitude: 35.8° E
When to go: Wet season, April to May

A trek to Lake Manyara can reward you with a view of thousands of flamingos—a moving landscape of pink feathers. The exotic birds congregate here during the wet season when the lake covers more than 60 percent of the land inside the park. If you're really lucky you'll witness the sky turn pink when a flock takes flight.

314 Slow down and live a little

Kato-Drys, Cyprus

Longitude: 33.3° E
When to go: March to June and October to December

With its colorful shutters and old stone buildings, Kato-Drys is one of the most photogenic villages in Cyprus. Enjoy a slower pace of life and a feeling that you've gone back in time, as you watch ladies practicing weaving and lacework, and men playing dominoes and chess on the street.

315 Enchanted gardens

Euphoria Art Land, Pyrgos, Cyprus

Longitude: 33.4° E
When to go: May to October

Artist Anthos Myrianthous had a dream. He wanted to create a place where visitors could explore works of art and be inspired by nature at the same time. Helped by volunteers, it took him six years to fulfill this ambition by creating the Euphoria Art Land in Pyrgos, Limassol. Reminiscent of the creations of Antoni Gaudí in Barcelona, the venue celebrates color, handmade artwork, and traditional techniques. Three tiny buildings are engulfed by colorful tiled "roots," while extensive mosaics stretch from the houses to the outside fencing. Curious travelers can book to stay in the houses and wake up to the enchanting scenery. Profits from the project are all donated to supporting underprivileged children, providing them with education options and support.

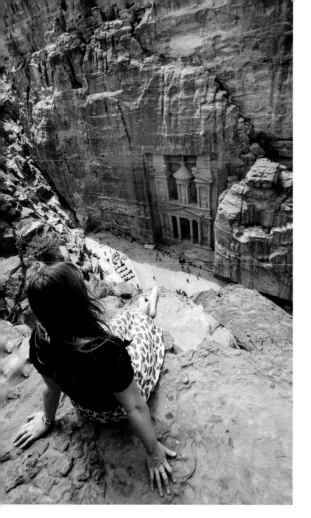

316 A head for heights

Petra, Jordan

Longitude: 35.4° E
When to go: March to May and September to November

As you wander through El Siq, a narrow gorge with 250-ft/80-m cliffs rising up on each side, it's impossible not to feel small. This is the dramatic path that leads to the two-thousand-year-old rose city of Petra, home to caves, temples, and tombs carved out of the sandstone rock by the Nabateans in 300 BC. The highlight for many is the detailed façade of The Treasury, best seen from the vertigo-inducing trail above.

317 Get a high from a low

Dead Sea, Israel

Longitude: 35.4° E
When to go: April, May, September, October

Known as one of the saltiest bodies of water and the lowest sea on earth, the Dead Sea is a stunning natural wonder. The rich blue water seems to change color along the beach and out into the open sea. Beautiful to look at, it also leaves visitors with rejuvenated soft, smooth skin.

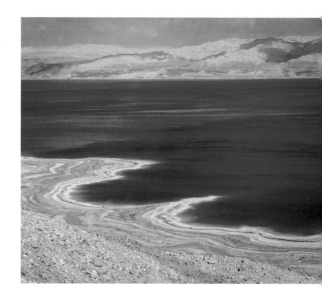

318 Desert island dreams

Bazaruto Archipelago, Mozambique

Longitude: 35.4° E
When to go: July to September

With their striking blue waters and pristine beaches, the five islands of the Bazaruto Archipelago wouldn't be such a bad place to find yourself abandoned on a desert island. Mozambique's unspoiled paradise in the Indian Ocean has even more treasure below the surface of its waters with a vast array of luminescent coral and wildlife, including mystical and endangered dugongs.

319 Walls of meaning

▲ Nairobi, Kenya

Longitude: 36.8° E
When to go: January to February and July to October

A growing revolutionary machine, Nairobi's street art acts as a colorful political message to bring about peace and change. Multiple movements, starting with the Ma-Vulture action against political corruption in 2012, to the Peace Train and Kibera Walls for Peace youth project, have fostered a generation of artistic talent and motivational change.

320 Safety never looked so good

▶ Le Gare Intersection, Addis Ababa, Ethiopia

Longitude: 38.7° E
When to go: All year

Pedestrians chancing upon Le Gare intersection in Addis Ababa can't help but be charmed by the colorful designs painted on the road. Bright yellows and blues clash with reds and greens in a modern mosaic of geometric design. However, these designs are about far more than just looking good; they are an integral part of Addis Ababa's road safety strategy. The paint has been used—alongside planters—to alter the traffic lanes and reduce the distances pedestrians have to negotiate as they cross the road from a terrifying 165 ft/50 m to shorter stretches of less than 30 ft/10 m at a time.

321 Paradise found

Zanzibar, Tanzania

Longitude: 39.3° E
When to go: June to October or December
to February

Powdery, white sand beaches, dotted with
tall, sweeping, green palm trees, and
crystal-clear turquoise water surround the
tropical paradise of Zanzibar. Located just off
the coast of Tanzania, the gorgeous island is
a unique mix of culture and pure relaxation.
The Darajani Market is where locals can be
found hustling all day long weaving between
colorful fruit and spice stands. In Stone
Town, Arabic, Indian, African, and European
cultures come together to create a vibrant
community in the labyrinth of winding streets
and alleyways. But perhaps the most
beautiful places in Zanzibar can be found in
nature. The Rock restaurant, a combination
of stunning nature and the cleverness of a
local, sits on a tiny rock in the middle of the
sparkling aquamarine water. During low tide,
it's easy to walk there, but at high tide, a
boat is the only way across. Back on land, the
Jozani Forest is brimming with every color of
the rainbow. Red colobus monkeys, which
can only be found in Zanzibar, swing through
the canopy of green trees. Over fifty species
of technicolor butterflies flutter around the
forest and birds of all types and colors fly
through the air.

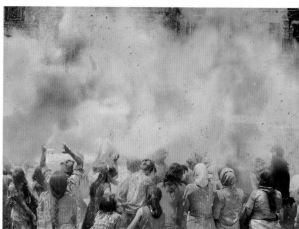

CHAPTER SIX

40°–80°

EAST

322 Take to the healing waters

▶ Orbeliani Baths, Tbilisi, Georgia

Longitude: 44.8° E
When to go: May, June, or September

The blue-tiled façade of this bathhouse will stop you in your tracks before you've even realized there's a curative, thermal spa behind the doors. Tbilisi, which translates from the Georgian as "warm place," is famous for its thermal spas fed by natural sulphuric-smelling springs—watch out for the smell of eggs. According to legend, King Vakhtang Gorgasali came across the springs and was so impressed that he built Tbilisi around them. The springs acted as a natural source of hot water where people could wash and reap the healing benefits—the waters are said to help treat eczema, arthritic pain, and digestive problems. Often called "the colourful baths" due to the radiant mosaics that adorn the exterior, the intricate detailing and blue color is typical of Iranian architecture. Orbeliani Baths dates back to the seventeenth century but was transformed into more of an "Eastern" style in the nineteenth century.

323 Meet the mountain people

Stepanakert, Republic of Artsakh, Azerbaijan

Longitude: 46.7° E
When to go: April to June

The terracotta-hued Tatik u Papik statue, which translates as "Grandma and Grandpa," is a great example of Soviet style monuments. Completed in 1967 by Soviet-Armenian architect Sargis Baghdasaryan, it depicts an old man and woman representing the mountain people of Karabakh. It's also known as "We Are Our Mountains." The statue sits on the border with Armenia and serves as a reminder of the area's previous troubles. Come for the history and stay for the view.

324 Cross through the valley of needles

Tsingy de Bemaraha National Park, Madagascar

Longitude: 44.8° E
When to go: April to November

Translated into English as "Where one cannot walk barefoot," Tsingy de Bemaraha National Park in Madagascar is filled with thousands of impenetrable limestone needles that jut out of the earth. The impressive pinnacles surround the Manambolo Gorge, where hanging bridges create a daring pathway through the dark gray formations.

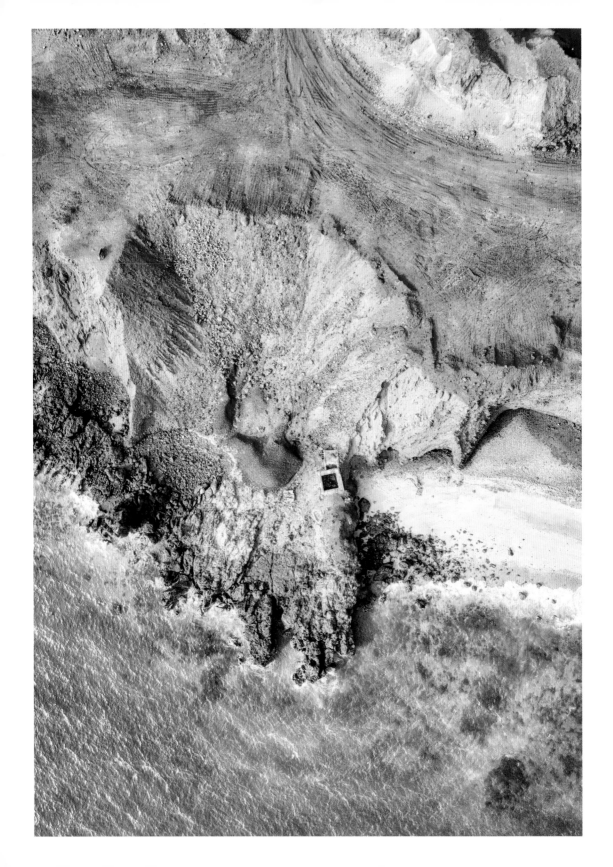

325 Red on the beach

◀ Red Beach, Hormuz Island, Iran

Longitude: 56.4° E
When to go: Spring and fall to avoid the extremes of heat or cold

The interior of this 6-mile/10-km-wide island off the south coast of Iran is a zigzag of red, purple, yellow, blue, and silver mountains. The carmine cliffs of Red Beach turn the sea into something from a horror movie, as red surf laps at the sands that condense all this magnificent geology into one concentrated rush.

326 A melting pot full of domes

Temple of All Religions, Kazan, Russia

Longitude: 48.9° E
When to go: May to August

It seems apt that Kazan's name translates as "cooking pot" from the Tatar. The colorful eclecticism of this fascinating city all comes together under one roof at the Temple of All Religions. A wonderland of colorful domes and tiered towers, the temple looks like a pick-and-mix of religious buildings from around the world, which is exactly what it is. It was established by philanthropist Ildar Khanov in 1992, to stand as a symbol of religious unity.

327 More than O-cay

Bird Island, Seychelles

Longitude: 55.2° E
When to go: All year

Home to thousands of tropical birds, giant land tortoises, and more, Bird Island is an oasis. Covered in stark white beaches, the island appears to be floating in emerald water. Formed on a coral cay three thousand years ago, the 250 ac/1 km² island's oldest reef dates back over seven thousand years.

328 Gorge-ous

Noravank Gorge, Armenia

Longitude: 45.2° E
When to go: May to June or September to October

Nestled on the ledge of a narrow, winding gorge above the Amaghu River is the Noravank Monastery. Small, but beautiful, it contrasts with the intense red rock cliffs and jade forest of the Noravank Gorge. The Gorge is also home to the wild yellow rose, which dots the hills, creating a brilliant sea of yellow.

329 If candy grew like flowers

Dubai Miracle Garden, Dubai, United Arab Emirates

Longitude: 55.2° E
When to go: November to May

Winner of multiple Guinness Book of World Record titles, including largest vertical garden, the Dubai Miracle Garden is unlike anywhere else on earth. Planted with 150 million flowers in different 3D shapes and scenes, wandering here feels a bit like you've invaded someone else's very kitsch daydream. Designs change every year and range from houses, arches, and butterflies to umbrella skies, airplanes, and beloved characters. It's not just the sight of hundreds of colorful flowers you experience, but the scent is amazing, too. If candy grew like flowers, this is how it would grow.

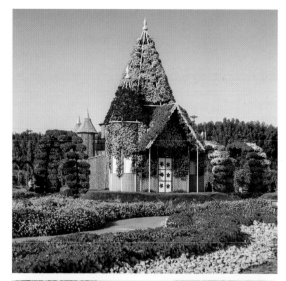

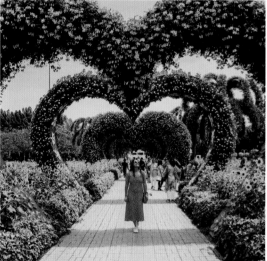

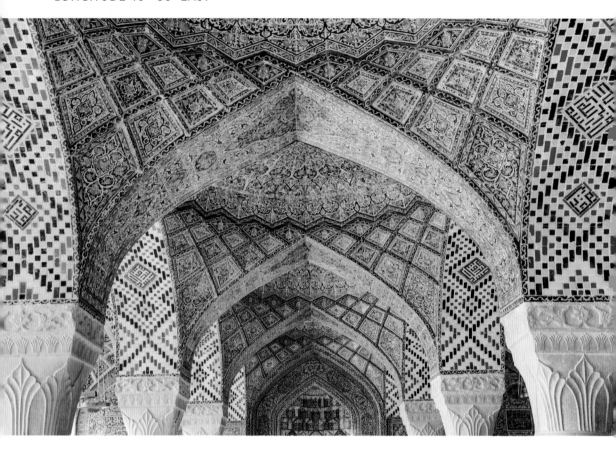

330 The pink pilgrimage

Nasir al-Mulk Mosque, Shiraz, Iran

Longitude: 52.5° E
When to go: March to May, September to November

When it comes to colorful buildings, the Nasir al-Mulk Mosque in the Gawd-i Arabān quarter of Shiraz really is on another level. The traditional mosque is often dubbed "The Pink Mosque" due to the abundance of pink-colored tiles blanketing its ceiling. Designed by Iranian architects Mohammad Hasan-e-Memār and Mohammad Rezā Kāshi-Sāz-e-Širāzi, the vision for the mosque was to create a place of worship that resembled the relationship between heaven and earth, and between light and color. Mission achieved. Catch the mosque in the morning sun and you'll be treated to one of the most beautiful natural light shows in the world thanks to the plethora of dazzling stained glass windows in the building, it's like stepping inside a kaleidoscope. The mosque also features thousands of painted tiles on the ceiling and rich Persian rugs on the floor.

331 Wonderful Wahiba

Wahiba Sands, Oman

Longitude: 58.5° E
When to go: November to March

The mixed geography of the Wahiba Sands creates a rainbow of color in Oman. From orange rolling dunes that can rise up to 300 ft/90 m, to treacherous salt flats that reflect the sky, to the arid landscape dotted with palm trees, this place is a dreamland. Sand dune safaris take guests on a stomach-flipping, adrenaline-inducing ride through the towering dunes to tourist camps that have popped up in the middle of the vast desert. At night, darkness descends, and the glow of thousands of stars and constellations light up the dark blue sky, something only to be seen in the middle of nowhere.

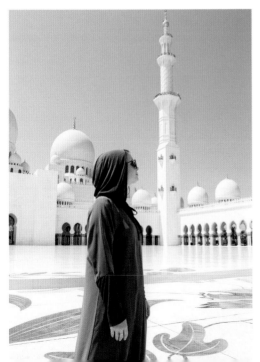

332 Moor than a mosque

Sheikh Zayed Grand Mosque, Abu Dhabi, U.A.E.

Longitude: 54.3° E
When to go: November to April

The Moorish architecture of Abu Dhabi's Grand Mosque is stunning, with its sparkling white stone, picturesque archways, beautiful domes, and Arabic minarets. Inside you'll find one of the world's largest chandeliers and the largest handmade carpet. It's free to visit, but dress respectfully.

333 Seven is the magic number

Earth of Seven Colors, Mauritius

Longitude: 57.5° E
When to go: May to December

When you think of Mauritius you probably think of paradise beaches and honeymoon resorts, but there's a wild side to this island too. The seven-colored earth is a natural phenomenon created over several millennia by the decomposition of volcanic lava into clay minerals. Over time water-soluble elements, such as silicon dioxide, have been washed out of the sand, leaving the stunning natural colors created by iron (which gives the red and brown hues) and aluminium oxides (which form the bluer shades). It's incredible to see the undulating dune-like earth in shades of red, brown, violet, green, blue, purple, and yellow, and despite changes in the weather, the landscape never erodes or changes. Even if you mixed all of the different colors together they would separate again, because the iron and aluminium particles naturally repel each other. While you can't walk directly on the sand, there are plenty of viewpoints around the perimeter of the site. The vividness of the colors depends on the brightness and position of the sun, but generally the best times to visit are at sunrise and sunset.

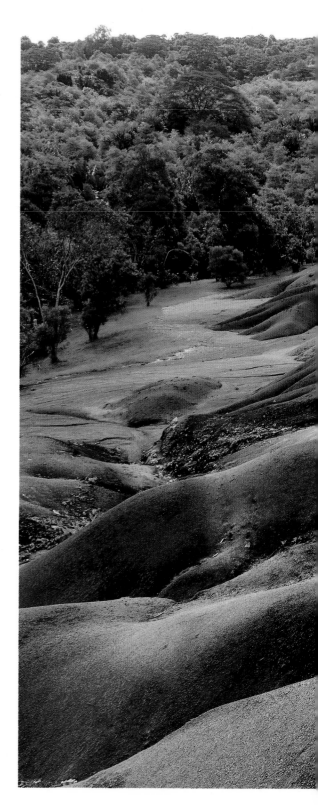

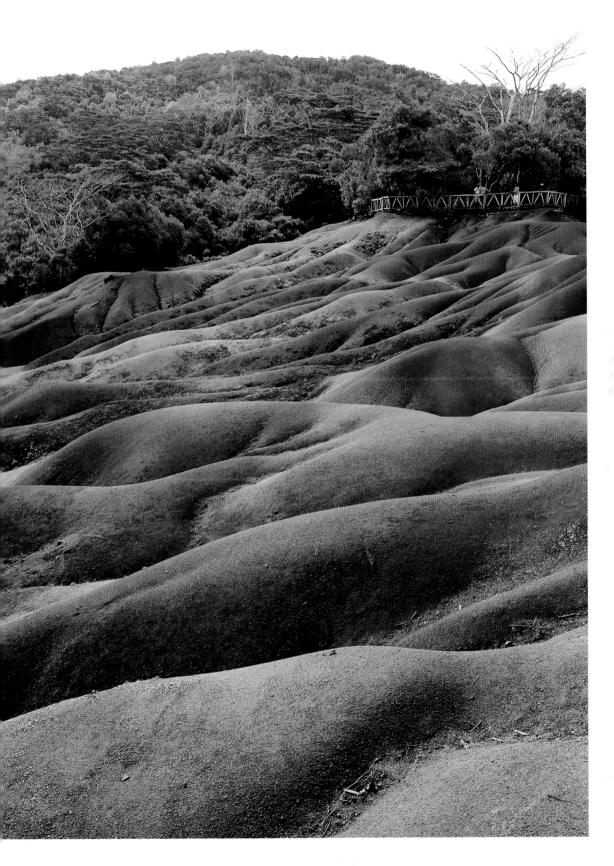

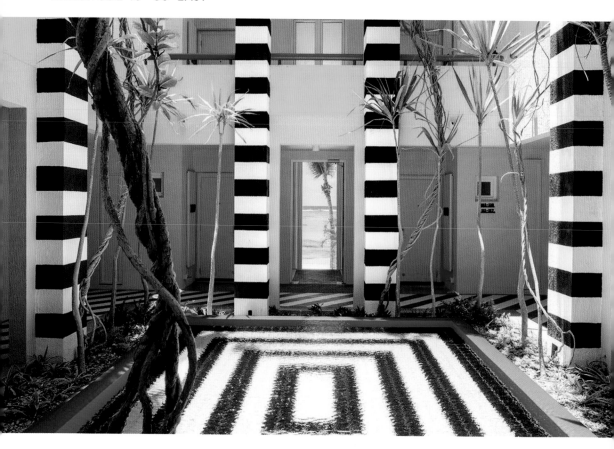

334 Walala-wala-woo

SALT of Palmar Hotel, Mauritius

Longitude: 57.7° E
When to go: October to February

Presenting a happy and hip vibe was of
utmost importance to the SALT of Palmar
hotel in Mauritius, so it was a no-brainer to
get French artist Camille Walala involved in
the design process. Inspired by Mauritius's
bright blue skies, pink sunsets, green
sugarcane fields, and the explosion of colors
used to decorate neighboring houses, Walala
collaborated with local architecture studio
JFA to cross the soulful local style with her

own bold aesthetic. SALT of Palmar is the
first eco-hotel on Mauritius and alongside its
vibrant interiors it also features locally
sourced organic food, a salt therapy room,
a rooftop bar, and skills-swap experiences.
Race you to the plane.

335 A new hour, a new gold

Jaisalmer, Rajasthan, India

Longitude: 70.6° E
When to go: November to March for the most comfortable temperatures

Jaisalmer is known as the Golden City, thanks to its uniform yellow sandstone buildings. The great Thar Desert in Rajasthan is one of the largest sandy stretches in the world. Dominated by undulating sand dunes, and with the sand varying in hue from vibrant yellow in the day, to deep golden or rich amber at sunrise and sunset, it's surprisingly colorful for a monochrome landscape.

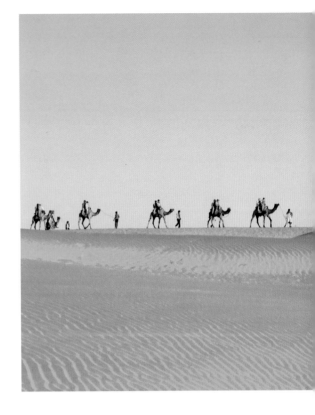

336 Wood you believe it?

Zenkov Cathedral, Almaty, Kazakhstan

Longitude: 76.9° E
When to go: April, May, September and October

The Zenkov Cathedral is a Russian Orthodox cathedral located in Panfilov Park. Built in 1907, the cathedral was constructed out of wood—allegedly without using nails. It's one of the tallest wooden buildings in the world and thanks to its design—including a seismic basket—it has successfully withstood earthquakes while nearby buildings have been flattened.

337 Chill out in the blue

Jodhpur, Rajasthan, India

Longitude: 73.0° E
When to go: October to March

Known as the Blue City, the walled city of Jodhpur is one of the most colorful places in all of India, thanks to its distinctive old town center. Almost all the buildings in this part of the city are painted a matching shade of pastel blue. The winding medieval streets of the old city are a photographer's dream, lined with crumbling blue-washed walls that brilliantly contrast with the desert surrounding the ancient city. No one can quite agree on why Jodhpur was painted blue. Some say that blue is an auspicious color for the Brahmin community, so they painted their houses blue to differentiate themselves from other Hindu castes. Others argue that it's simply to repel the desert heat, while still others say it's because the color is associated with Lord Shiva. According to legend, Lord Shiva turned blue after drinking a deadly poison called Halahala. It's been suggested that Shiva's followers painted their homes blue in his honor. A newer theory suggests that the blue tint of Jodhpur's houses may come from copper sulphate added into the whitewash to deter termites. Whatever the reason, the resulting blue city is an impressive sight to behold. Head to Mehrangarh Fort for the best views of the city.

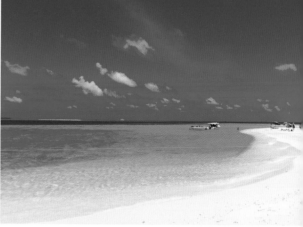

338 The sky's not the limit

Maafushi, Maldives

Longitude: 73.4° E
When to go: January and February

From the eye-catching, deep orange sunsets on the Western side of the island to the candy-colored houses in town, one thing's for certain: Maafushi is teeming with color. Forget your ideas that the Maldives islands are all about overwater bungalows and clear blue water—there's plenty more to explore here. And when you've finished your wander around town—dress respectfully, this is a Muslim island so keep your swimwear for the beach—the water is where to explore next. Head to one of the nearby reefs with snorkel to hand and you're sure to see all manner of color swimming around, and maybe even a dolphin or two.

339 Where camels dress to impress

▼ Pushkar, Rajasthan, India

Longitude: 74.5° E
When to go: Around November (the fair dates vary every year)

Every year, over a million visitors descend upon the tiny rural town of Pushkar in the Rajasthan Desert for the annual Pushkar Camel Fair. This five-day festival is one of the largest camel gatherings in the world and as with all Indian cultural events, color is king. Many camels come dressed to impress, adorned with colorful accessories, woven shawls, and dazzling jewelry.

340 After the rain, the flowers

Kaas Plateau, Satara, Maharashtra, India

Longitude: 73.8° E
When to go: Mid-August to October. The flowering begins during the monsoon, which varies each year

Every summer, the Kaas Plateau erupts into a sea of colorful flowers. The grasslands topping the plateau are a biodiversity hotspot and during the summer monsoon season, rolling fields of flowers create a glorious rainbow of more than 850 species of flowering plants.

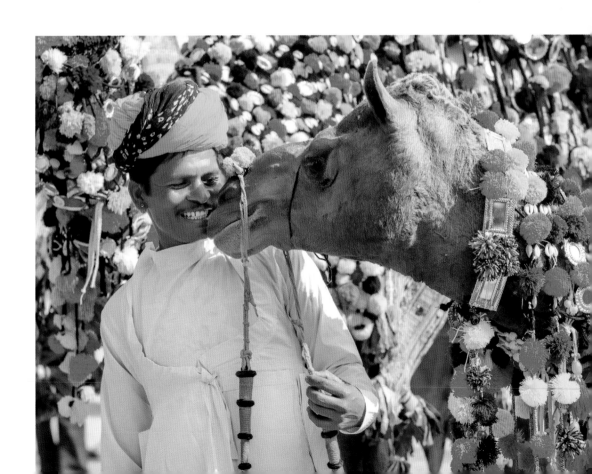

341 Dance like you mean it

Kannur, Kerala, India

Longitude: 75.3° E
When to go: December to April

India is known for its manifold religious festivals, which are often overwhelmingly colorful affairs. One of the most flamboyant, and fascinating, is Theyyam in Kerala. At Theyyam festivals, participants worship via the means of dance. Its an artform that predates Hinduism and is closely linked to nature with trees, plants, and animals worshipped alongside Hindu gods. Dancers wear elaborate bright red costumes, with huge headdresses, patterned skirts, and sometimes wing-like shoulder extensions. Their faces are painted a bright orange with intricate patterns etched in red. The spectacular shows are all accompanied by frenzied drumming. There are over four hundred types of Theyyam, each dedicated to a different god or hero. The festival is celebrated across Kerala, but the towns of Kannur and Bekal make good bases to catch different versions of this incredible ritual.

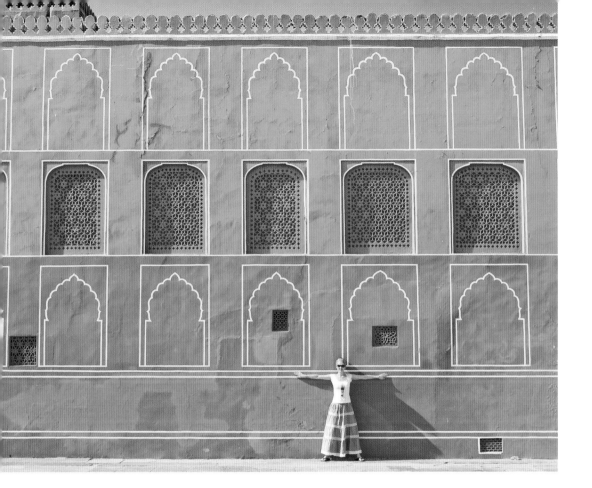

342 Take pleasure in the rain

▲ City Palace, Jaipur, Rajasthan, India

Longitude: 75.7° E
When to go: October to March for better weather

Nicknamed the Pink City because of the abundance of rose-painted walls and buildings, Jaipur's City Palace is an opulent gem in the center of the city. A complex of gardens, courtyards, museums, and other buildings, the Palace is lavishly designed, with intricate brickwork, gates, and a gorgeous "blue room"—sheltered but with open doorways to enjoy the monsoon rains.

343 Spice up your life

Pampore, Kashmir, India

Longitude: 74.9° E
When to go: End of October to mid-November

Think of saffron, and you're probably picturing that deep, red-tinged orange shade. The spice, however, is the harvested stamens of violet crocus flowers. Every fall, the fields around the town of Pampore in Kashmir turn bright purple as the crocuses flower. It is one of the few places in the world where the plants grow, and saffron from here is considered the world's finest.

344 Reclaim
the colonial streets

Lodhi Colony, New Delhi, India

Longitude: 77.2° E
When to go: All year, but during February and
March for the Lodhi art festival

The Lodhi Colony was built toward the end
of the British Empire's rule as housing for
government employees. Recently, nonprofit
foundation St+Art India brought together
street artists from India and around the world
to reclaim the pastel walls of the neat
colonial architecture with enormous murals,
creating India's first ever public art district.

345 Roll out the
red carpet

Red Fort, Agra, Uttar Pradesh, India

Longitude: 78.0° E
When to go: November to March

Built in the sixteenth century, the Red Fort is
one of the most historical and impressive
structures in Agra. Carved from local red
sandstone, hence the striking color, the
walled city was the royal residence of the
Mughal emperors until 1638, when the
capital was shifted to Delhi.

346 They call it mellow yellow

Maniknagar, Bangladesh

Longitude: 77.1° E
When to go: December to February

In the farmlands all over Bangladesh, mustard fields are a common site, as the seeds are one of the country's biggest crops. Around 926 mi²/2,400 km² of land are given over to mustard cultivation, and during the dry winter season the countryside becomes carpeted with the bright yellow flowers as farmers get ready to begin the harvest.

Although you can see the mustard fields all over Bangladesh, the districts of Maniknagar and Munshiganj are the closest to the capital city of Dhaka. A short drive will land you in a rolling sea of yellow, where you can catch a glimpse of country life in Bangladesh and experience the country at its most colorful.

347 Throw color to the winds

Holi Festival, India

Longitude: 77.6° E
When to go: Usually in March, on the last full moon of the lunar month

Hindus across the world mark the start of spring and celebrate new beginnings with Holi, the most colorful festival on earth. Crowds gather to throw brightly colored powders (symbolizing everything from love to fertility) over one another all over India and Nepal, but the ghats of Mathura are well known for their lavish and joyful celebrations. Boundaries are broken down as young and old, men and women, and people from all castes and creeds fill the streets and douse each other with color. It's a sight so eye-catching that brands ranging from Sony to British Airways have used this ancient festival that dates back to the fourth century in recent ad campaigns.

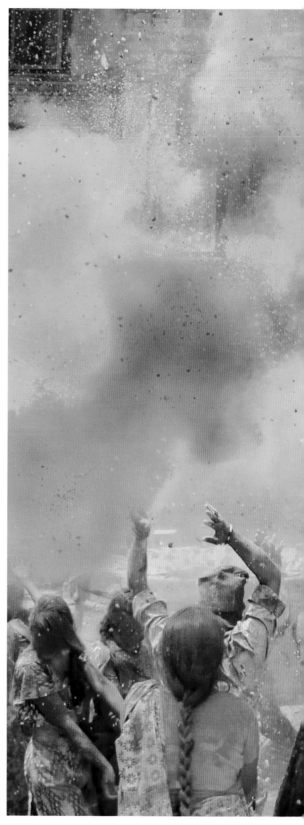

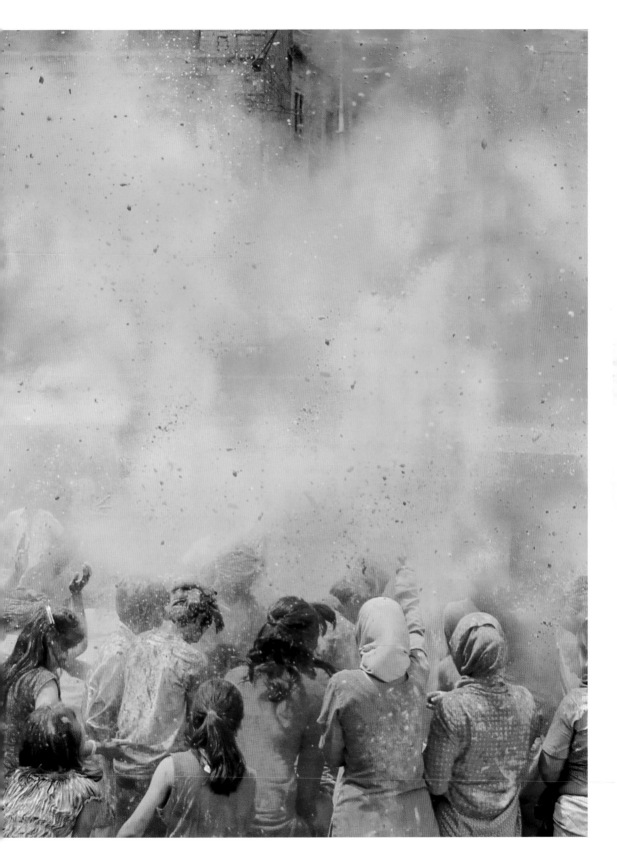

348 Big fat Hindu wedding

▲ Madurai, Tamil Nadu, India

Longitude: 78.1° E
When to go: October to March for comfortable temperatures. Arrive early to beat the crowds.

The Meenakshi Amman Temple in Madurai is one of South India's most famous landmarks. Dedicated to the Hindu goddess Meenakshi, legend has it that the temple was built on the very site where Lord Shiva married Meenakshi, in what Hindus believe to be the biggest event in the earth's history. The impressive architecture features fourteen pyramid-like towers completely covered in statues and brightly painted stucco images, which retell the legends from Hindu texts.

349 Natural born showstoppers

North Chamoli, Uttarakhand, India

Longitude: 79.6° E
When to go: June to October

In the mountainous north of India, at the border with Tibet, the Valley of Flowers National Park puts on a stunning natural display of color. This high-altitude Himalayan valley is known for its charming meadows of alpine flowers surrounded by snow-capped mountains and crisscrossed with rushing streams. During summer, the fields of perfumed wildflowers create a vibrant carpet of color.

350 White by name, bright by nature

Ville Blanche, Pondicherry, Tamil Nadu, India

Longitude: 79.8° E
When to go: October to March

Although it's still named Ville Blanche, or White Town, Pondicherry's historic French Quarter is anything but. The name is a leftover from colonial segregation, but today, bright colors reign in this quiet, leafy area of the city, with many of the walls painted in striking shades of orange, yellow, and pink. The addition of street art, murals, and bunting have reclaimed the neighborhood in as colorful a fashion as possible.

351 How bazaar!

Chudi Bazaar, Hyderabad, Telangana, India

Longitude: 78.4° E
When to go: 11am to 11pm daily, with evenings being the best time

India's markets are always a colorful affair, but perhaps none more so than the Chudi Bazaar (or Laad Bazaar) in Hyderabad. This dazzling market specializes in one thing only: bangles. On either side of the streets you'll find shops piled high with stacks of glinting bangles, in every style and color imaginable.

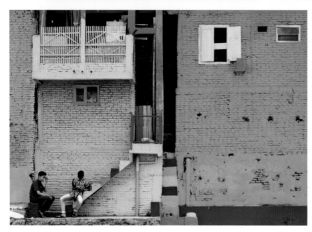

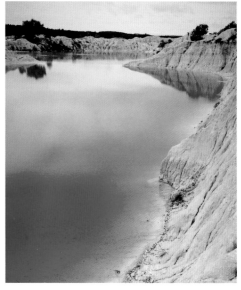

CHAPTER SEVEN

80°–120°

EAST

352 A new take on the old town

Galle, Sri Lanka

Longitude: 80.2° E
When to go: December to February

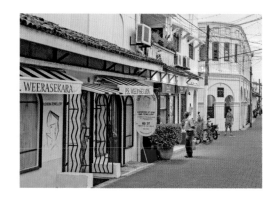

Founded by the Portuguese in the sixteenth century, the fortified old town of Galle on Sri Lanka's coast was later expanded by the Dutch, and then later still by the British. As a result, the town is filled with distinctively European architecture. Many southeast Asian influences are still incorporated, creating an east-meets-west fusion. Today, visitors will find a neighborhood brimming with trendy restaurants and boutique shops. These are all housed within cheerfully painted colonial buildings, with their terracotta roof tiles and plant-filled verandahs. Down at the shoreline you can also find brightly colored fishing boats. After Sri Lanka was devastated by the tsunami in 2004, people and organizations from around the world funded replacement boats for the fishermen of Galle, and many of these boats now sport the name of their sponsors.

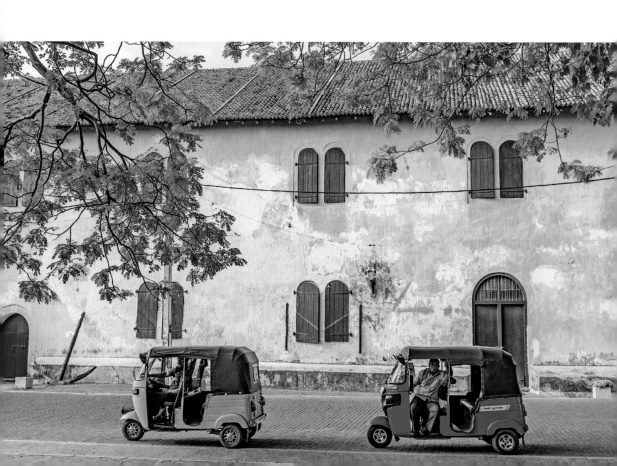

353 Mountain climber

▲ Kandy, Sri Lanka

Longitude: 80.6° E
When to go: December to April

Often touted as the most scenic train ride in the world, the express train from Kandy to Ella is known for its epic views of sprawling tea plantations and lushly forested mountains. But the most colourful part of the experience is the train itself. New trains, introduced in 2012, have striking sky-blue exteriors that create a perfect contrast to the soft green valleys. Top tip—the right-hand side of the train has the best views from Kandy to Nuwara Eliya, while the left-hand side is slightly better from then on.

354 Discover an ancient cave of wonders

Dambulla Cave Temple, Dambulla, Sri Lanka

Longitude: 80.6° E
When to go: All year

Five caves make up the Dambulla Cave Temple in Sri Lanka, the walls of which are completely covered in murals. The oldest dates back more than two thousand years. There are 150 paintings and sculptures of the Buddha dotted about the caves, as well as statues of kings and the Hindu gods Vishnu and Ganesha.

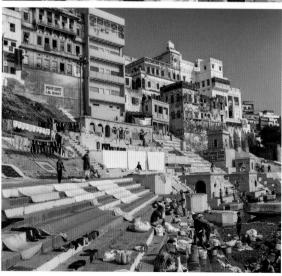
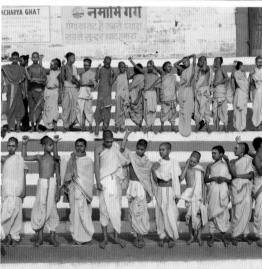

355 The old ones are the best

Varanasi, Uttar Pradesh, India

Longitude: 82.9° E
When to go: October to March (November for Divali)

Varanasi has many claims to fame. The oldest city in India, and the holiest city in the world for Hindus, it lies on the banks of the sacred River Ganges. It is up there with the most historic and cultural cities in the world and it's also one of the most colorful. The banks of the river are lined with stone-step ghats—famous for the cremations and puja ceremonies that take place on them daily. The ghats are flanked by a jumble of brightly painted buildings, and the chaos of city life plays out all along the Ganges. Every evening, the Ganga Aarti ceremony sees Hindu priests leading a ritual to thank the Mother Ganges. Candles are lit in offering and placed onto the river in floating dishes, filling the night with twinkling orange flames. Visitors should take a boat tour to best appreciate the spectacle. Varanasi isn't only a significant place for Hindus, as Buddhists also consider the city a sacred spot. The nearby village of Sarnath, lying northeast of Varanasi near the confluence of the Ganges and the Varuna rivers, is where the religion's founder, Gautama Buddha, taught his disciples.

356 Say it with flags

Everest Base Camp, Nepal

Longitude: 86.9° E
When to go: February to May and September to December

You'd be forgiven for assuming that trekking to Everest base camp would be a fairly monochrome affair. This spectacular landscape is dominated, after all, by pristine white snow and jagged slate-colored mountains. But high in the Himalayas, Tibetan Buddhist prayer flags flutter on the breeze, their joyful hues representing the five elements. Blue is for sky, white for air, red for fire, green for water, and yellow for earth. Displayed together, the five colors represent balance. Buddhists believe that when the wind blows the flags, it carries the mantras and blessings printed on them out into the world. A common misconception is that the prayers are meant for the gods; in fact, these are prayers designed to spread goodwill and positive energy throughout the land. Tibetan legend holds that the first prayer flags were used by Gautama Buddha, on whose teachings Buddhism is founded. God-like deities called *devas* would carry flags with the prayers of Gautama Buddha written on them into battle. Today, the flags are hung across the Himalayas—and beyond—with the belief that the prayers on them will spread positivity far and wide.

357 Kathmandu's culture of color

Kupondole, Patan, Nepal

Longitude: 85.3° E
When to go: October to November and March to April

Nepal's sprawling capital city is known for its eclecticism and colorful temples. But in recent years a new phenomenon has added to the vibrancy of the city's winding streets: street art. There are brightly painted murals to discover all over Kathmandu and the neighboring city of Patan, with one of the best spots in the residential Kupondole district, on the south bank of the river that divides the two cities. Many of the paintings feature elements from local culture, from religious iconography, to people in traditional clothing, to Nepalese wildlife. The art started to arrive courtesy of a year-long project in 2012, called Kolor Kathmandu, which brought together Nepalese and international artists to paint seventy-five murals across the city. This sparked a huge rise in the popularity of street art in Nepal's capital, as artists and university students began to take advantage of the lack of laws against public painting.

358 The dance behind the mask

Boudhanath Stupa, Kathmandu, Nepal

Longitude: 85.3° E
When to go: February or March (dates change each year)

Losar Festival is Tibetan New Year, and is celebrated throughout the Himalayas, with temples and stupas bedecked in colorful prayer flags. In Kathmandu, the best place to witness the spectacle is the Boudhanath Stupa. Colorful and extravagant dances are performed to celebrate the new year, with the mask dance being one of the most incredible.

359 Round and round the monastery

Gangteng Monastery, Bhutan

Longitude: 90.1° E
When to go: All year

High in the mountains of Bhutan, on a hilltop overlooking the Phobjika valley, lies the historic Buddhist Gangteng monastery, where monks have practiced their religion in simple maroon robes since 1613. The monastery is a beautiful structure centered around a hall with eight wooden pillars. Black cranes come to the valley to roost, and it is said they always circle the monastery three times when they arrive and again when they leave.

360 Row, row, row your boats

▲ Phewa Lake, Pokhara, Nepal

Longitude: 83.9° E
When to go: March to May and September to October

Home to the popular tourist city of Pokhara, Phewa Lake is often calm enough to reflect the surrounding snowcapped mountains of the Himalayas. Ubiquitous upon the lake's glittering emerald surface are wooden boats painted in bold colors, which can be rented by tourists seeking the peace and quiet of the lake.

361 A palace fit for a goddess

Janaki Mandir, Janakpur, Nepal

Longitude: 85.9° E
When to go: All year (although the summertime monsoons are best avoided)

One of the most important religious cities in Nepal, Janakpur is considered the birthplace of the Hindu goddess Sita. An enormous white temple dedicated to the goddess dominates the city skyline, covered with brightly painted detailing both inside and out. During important festivals, such as Vivah Panchami in November, the temple is decked out with garish colored lights.

362 Siberia's hypnotic lake

▶ Blue Geyser Lake, Altai, Russia

Longitude: 86.2° E
When to go: May to September

An otherworldly phenomenon can be found in the mountainous Altai region in southern Siberia. At the heart of the bright turquoise Geyzernoye Lake, or Blue Geyser Lake, lies a swirling pool that would look more at home on another planet. The hypnotic effect is caused by the thermal springs that feed the lake. The force of the geyser eruptions pushes blue sludge up from the bottom, creating several gray-blue circles across the surface. These swirling circles are constantly changing shape and size. The same thermal activity that causes the misty whorls also means that Blue Geyser Lake never freezes, even in the below-zero temperatures that are common in the region during wintertime. The mountains around Altai are famed for their foreboding and rugged beauty, and for their abundant wildlife, most famously the beautiful and elusive snow leopard, nicknamed "ghost of the mountains" (although the chances of actually spotting one of these super rare creatures are incredibly slim).

363 Mystical, magical mosque

Chandanpura Mosque, Chittagong, Bangladesh

Longitude: 91.8° E
When to go: All year, but November to March for mild, dry weather

One of the most popular tourist attractions in the coastal city of Chittagong is also one of the most colorful. The unique architecture of Chandanpura Mosque involves multiple tiers, domes, and minarets, all painted in bright colors. There are turquoise domes and red-and-gold fences around the balconied walkways. Most distinctive is a bulbous dome painted in circus-like yellow, red, and cyan stripes.

364 Myanmar's heart of gold

Shwedagon Pagoda, Yangon, Myanmar

Longitude: 96.1° E
When to go: All year

Dominating the skyline of Yangon, Shwedagon Zedi Daw, or the Shwedagon Pagoda, is one of the most famous pagodas in the world. There's no missing it: at an impressive 326 ft/100 m tall, the gilded stupa sits on a hilltop overlooking the city. Dazzlingly golden in color, it is studded with more than seven thousand diamonds and rubies, and its pinnacle is topped with an enormous 72-carat diamond.

365 Bridge of sighs

▲ U Bein Bridge, Mandalay, Myanmar

Longitude: 96.0° E
When to go: November to February

Spanning the width of the Tuang Tha Man Lake in Myanmar, at 0.75 mi/1.2 km the wooden structure of U Bein Bridge is extremely long and narrow. Built around 1850, it's believed to be the oldest teakwood bridge in the world, and was built from the remains of the old royal palace of Inwa. The remarkable length of the bridge has led to it becoming a popular tourist attraction. At sunset, with the rickety, uneven posts silhouetted against the orange sky and the golden light reflected on the surface of the lake, U Bein Bridge is a dazzling sight.

366 An adventurer's playground

Dark Horse Falls, Lashio, Myanmar

Longitude: 98.1° E
When to go: November to February

With its deep green pools and rust-colored rocks, Dark Horse Falls is one of the most popular destinations in Myanmar's Shan State. In the wild setting of Lashio's verdant green forests, the multitiered cliffs of the waterfalls form a natural playground. Many travelers head here to leap from the cliffs into the emerald pools below, which range from a few feet up, to dizzying heights of more than 50 ft/15 m. Lashio is fairly off the beaten path in Myanmar, right up near the border with China, so the region is perfect for travelers in search of adventure.

367 Jungle glories

Bagan, Myanmar

Longitude: 94.8° E
When to go: November to February, at sunrise

There are few places quite as mystical as Bagan at sunrise as the orange roofs of its temples and pagodas poke through the green jungle into the soft mist above. This ancient site is home to the remains of over 2,200 temples, pagodas, and stupas, dating from the ninth to the thirteenth centuries. It is the largest and densest concentration of Buddhist temples in the world. Myanmar's frequent earthquakes have damaged, or even completely destroyed, many of the pagodas over the years, but restoration work is ongoing and it is possible to imagine the city at the height of its rule. The temples are scattered across the green plains, half lost among lush vegetation.

368 Tectonic treasure trove

Rainbow Mountains, Zhangye Danxia National Geological Park, Gansu, China

Longitude: 100.1° E
When to go: June to September for the best weather, late afternoon for the best colors

Imagine a giant hand reached down from the sky and painted a rainbow onto the side of a mountain. That's exactly what you get at the Zhangye Danxia National Geological Park in Gansu Province. Lying within the arid landscapes of the Gobi Desert, the distinctive rock formations are often nicknamed the Rainbow Mountains or Painted Mountains. Although the effect looks almost manmade, the unusually striped rocks are actually layers of sandstone and siltstone that were deposited long before the Himalayas were formed. Originally, the horizontal layers, formed from different minerals, were flat and hidden below the earth's surface, but fifty-five million years ago, the tectonic plates below China collided, pushing the flat sandstone up to form mountains and revealing the hidden layers. The result is a mountain that looks as if it's been neatly painted with a rainbow of rust-red shades.

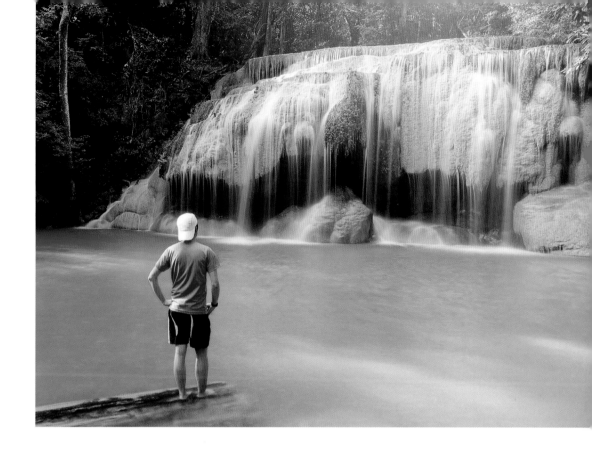

369 Falls you'll never forget

▲ Erawan Falls, Erawan National Park, Thailand

Longitude: 99.1° E
When to go: September to December

At the heart of Erawan National Park, the seven tiers of the Erawan Falls are famed for the unreal hues and unique shapes of their limestone pools. Named for Erawan, the three-headed white elephant of Hindu mythology, the pools of each tier can be accessed by a series of hiking trails and footbridges.

370 Jewel of the sea

Emerald Lake, Ang Thong Marine Park, Thailand

Longitude: 99.6° E
When to go: March to October

Ang Thong Marine Park near Koh Samui gained notoriety among backpackers as the setting for Alex Garland's novel *The Beach*, and it's easy to imagine a secret island utopia perched on the dreamy shores of the archipelago. Centuries of erosion have created wondrous shapes from the limestone, including an inland saltwater lagoon on Koh Mae, Emerald Lake.

371 A palace built by kings . . . and more kings

Grand Palace, Bangkok, Thailand

Longitude: 100.4° E
When to go: All year, but best in November and December

As opulent as it is historic, the Grand Palace of Bangkok was established in 1782. The huge complex of palaces, government offices, and temples grew organically over two hundred years, as each new king added and rebuilt sections. There's an eclectic mix of styles and a distinct lack of symmetry, which adds to the charm.

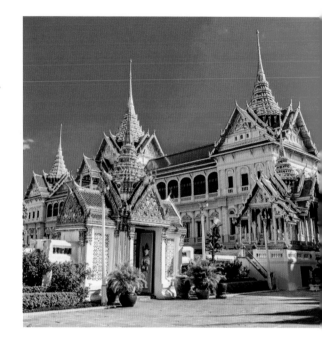

372 Spaghetti with your unicorns?

Unicorn Café, 44/1 Soi Sathon 8, Silom, Bangkok, Thailand

Longitude: 100.5° E
When to go: All year

Cotton candy walls, rainbow-striped cakes, and a menagerie of stuffed unicorn toys . . . welcome to Bangkok's Unicorn Café. Even the food is unwaveringly cutesy and colorful, running the gamut from rainbow waffles to bubblegum-pink spaghetti noodles. It's everything your inner child ever dreamed of—if your inner child is a five-year-old girl obsessed with unicorns and glitter.

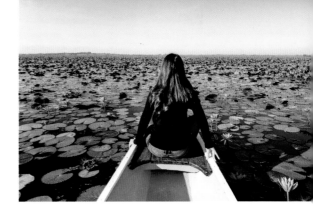

373 The lake of a million flowers

Nong Han Kumphawapi Lake, Chiang Haeo, Thailand

Longitude: 103.0° E
When to go: December to February

Every winter, Nong Han Kumphawapi Lake in Udon Thani becomes the Red Lotus Sea. The inland freshwater lake is covered in lotus plants. When they bloom, the lake's surface is carpeted with cheerful magenta flowers in every direction. Arrive early for the best view of the spectacle, as the flowers tend to close up a little toward the heat of midday. Local folklore holds that the lake is part of a deadly swamp that was created by Phaya Nak, ruler of the deeps, after his son was killed and eaten while disguised as a squirrel. Phaya Nak vowed that no one who had eaten his son's flesh—which had miraculously turned into eight thousand cartloads of meat—would remain alive and created this deadly swamp.

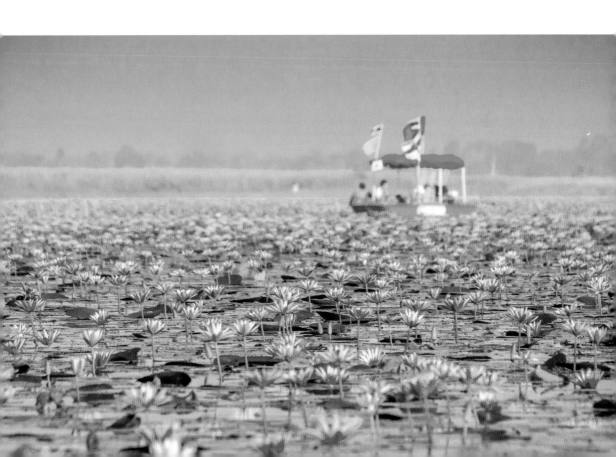

374 **Breathtaking Buddhism**

Wat Pha Sorn Kaew, Thailand

Longitude: 101.0° E
When to go: November to early April

Set deep in the mountains of Northern Thailand, Wat Pha Sorn Kaew, the Temple on a Glass Cliff, is straight out of a fairy tale. Surrounded by massive green mountains, this modern temple pops against its background, creating a colorful oasis in the serene jungle. Decorated with over five million pieces of tiles, gems, stones, and ceramic, every corner of this paradise is covered in glittering mosaics. Stained glass gazebos sit in the garden overlooking five seated Buddha statues that stand tall, watching over the entire town of Khao Kho in the Phetchabun region. The incredibly detailed arches and idols can be found all over the complex. The pagoda, inspired by the shape of a lotus flower, is set over five levels and has a large glass structure hanging through the center, connecting each floor. Even the ground and staircases are covered in intricate mosaics and are pieces of art in their own right.

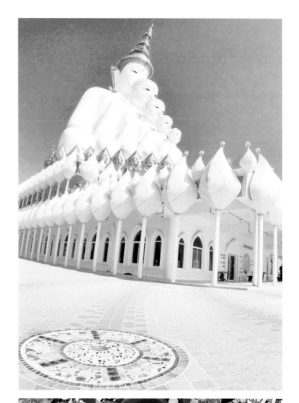

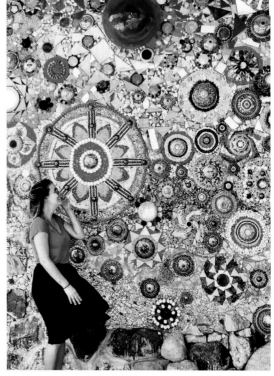

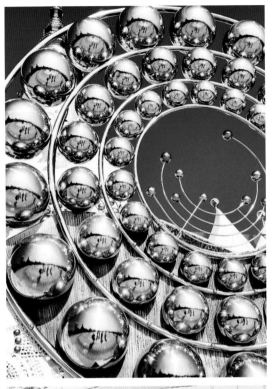

375 It's just Phi Phi-perfect

▼ Koh Phi Phi, Krabi, Thailand

Longitude: 98.7° E
When to go: November to April

With its nighttime bioluminescence, turquoise seas, and jungle-topped limestone stacks, Koh Phi Phi is a heaven-on-earth setting of colorful tropical scenes. Add to that a scattering of painted wooden boats decked out with flower garlands and streaming banners, and this quickly becomes one of the most colorful spots in Thailand.

376 Shoulder holder

Doi Suthep, Chiang Mai, Thailand

Longitude: 98.9° E
When to go: November to early April

On a mountainside just west of the Old City of Chiang Mai, the temple of Wat Phra That Doi Suthep towers over the northern city of Thailand. The impressive golden temple was built in the late 1300s and according to local legend, it was created to hold a piece of bone from the Buddha's shoulder.

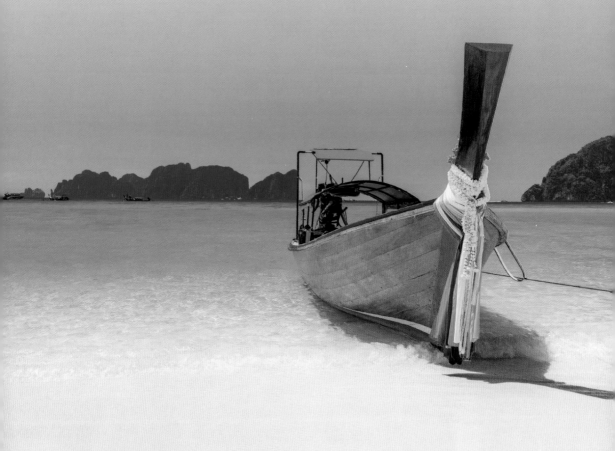

377 **One sight in Bangkok**

Wat Pho, Bangkok, Thailand

Longitude: 100.4° E
When to go: November to early April

One of the largest temple complexes in all of Bangkok, Wat Pho is home to detailed murals covering walkways, tiled pagodas, and its most famous inhabitant, the giant Reclining Buddha. At just over 150 ft/45 m, the Reclining Buddha, covered in gold leaf, is quite something to behold.

378 **Bright and active**

Basketball court, Klong Toey, Bangkok, Thailand

Longitude: 100.5° E
When to go: November to April

A bird's-eye view of the vibrant basketball court in the Klong Toey area in Bangkok is the best way to see the artistic project created by Sunkist. Vivid geometric shapes in bold primary and neon shades cover the ground, creating an epic backdrop for local children staying active.

379 The bright side of the tracks

Ratchada Train Market, Bangkok, Thailand

Longitude: 100.5° E
When to go: All year, Thursdays to Sundays

Most of Bangkok's markets are colorful, atmospheric affairs. Up there with the best is the incredible Rod Fai, or Train Market, in Ratchada, a weekend night bazaar famed for its brightly colored canopies. These are especially striking when viewed from above as they are lit from underneath, so head to one of the second-story bars surrounding the market to truly appreciate the kaleidoscope of colors. This vibrant market was built as a more accessible version of the original Rot Fai Market in Srinakarin, way out in the suburbs of Bangkok. Bringing the same buzzing night bazaar atmosphere, the new branch is right by the Cultural Centre MRT Underground Station and is far easier to reach, although it is a little smaller than the original market. That said, the compact size makes shopping a much easier experience. Within the bustle of Rot Fai, you'll find everything from souvenirs to street food, as well as bunting-clad food trucks and quirky, upcycled décor. Ratchada Train Market is the perfect combination of traditional and modern-day culture.

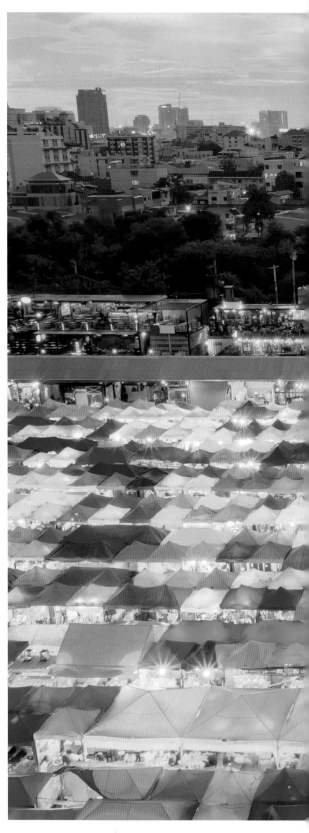

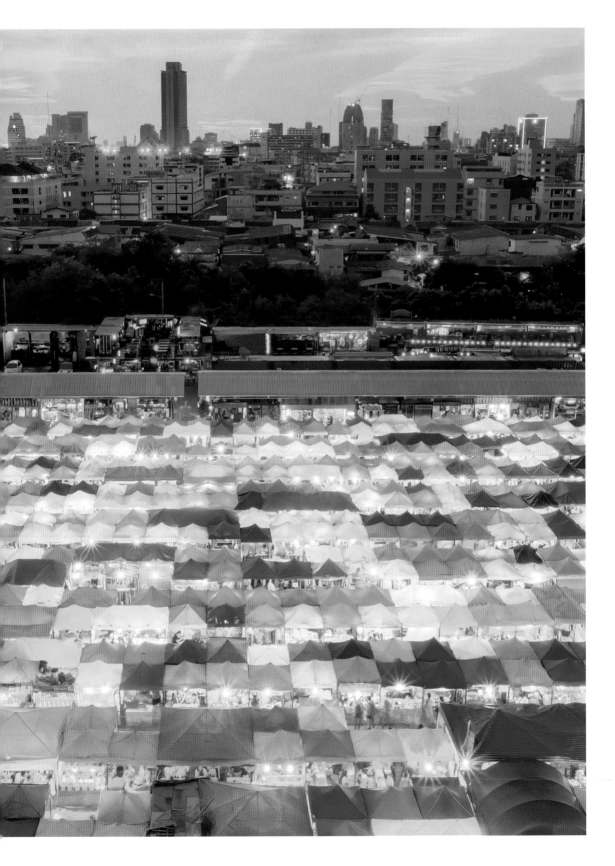

380 Climb up a rainbow

◀ Batu Caves, Malaysia

Longitude: 101.6° E
When to go: All year

Beautifully intricate with detail and color, the Batu Caves temple complex is a work of art, but the 272 stairs leading up to the caves received a rainbow paint job in 2018 and now steal the show. The explosion of color generated some controversy, but overwhelming love for the new look won out.

381 Stop and stay

Pulau Perhentian, Terengganu, Malaysia

Longitude: 102.7° E
When to go: March to November

Once a little-known backpacker paradise, the Perhentian Islands remain much quieter than some of the better-known islands of Southeast Asia, loved for their turquoise waters and colorful coral reefs. The name Perhentian means "stopping place," because of the island's original use as a staging point for traders en route to Bangkok.

382 Catch a glimpse of yellow fever

Istana Negara, Kuala Lumpur, Malaysia

Longitude: 101.6° E
When to go: All year, but May to July and December to February for the best weather

One of the most iconic landmarks in Kuala Lumpur is the impressive Istana Negara, the National Palace. The striking cream building, with its lemon-colored trim and twenty-two dazzling yellow domes, was built in 2011 to replace the old palace and is still the official residence of the Malaysian monarch. This means it's not actually open to the public, but you can catch a glimpse through the majestic entrance gate.

383 Going Dutch

Red Square, Malacca, Malaysia

Longitude: 102.2° E
When to go: All year

Once a colonial stronghold, Malacca still bears the traces of British, Dutch, and Portuguese influences. Nowhere more so than in the aptly nicknamed Red Square, constructed by the Dutch in the 1600s and painted a uniform shade of terracotta. The Stadthuys is believed to be the oldest surviving Dutch building in the East.

384 **Living walls**

Penang, Malaysia

Longitude: 100.3° E
When to go: December to March

In 2012, 3D murals popped up all over
George Town, Penang. The Malaysian city
commissioned Ernest Zacharevic to create
murals that use props such as bicycles,
swings, and motorcycles to bring them to
life. Since 2008, when the city was declared
a UNESCO World Heritage Site, quirky
pieces of art have been marking the walls.

Cameron Highlands, Pahang, Malaysia

Longitude: 101.3° E
When to go: February to April for the lowest rainfall

The rolling green hills of the Cameron Highlands are one of Malaysia's most popular tourist destinations, famed for their serene, verdant slopes and abundant wildlife. They were named after British explorer William Cameron, who mapped out the region in 1885. During the 1930s, the area was developed as a tourist resort for British colonialists seeking the cooler climate of the highlands, and many of the hotels today bear traces of the colonial style. With more than seven hundred species of plants growing in the region, this is the perfect area to enjoy nature and spot wildlife. An interesting splash of color comes from the deep red rafflesia plant, which is endemic to the region and produces the largest flower on Earth.

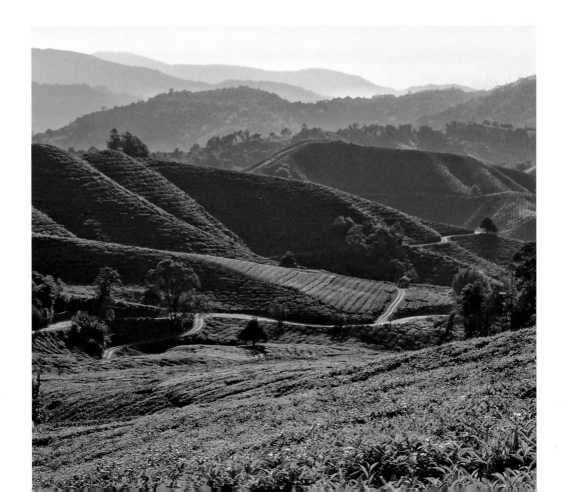

386 **Cherry on top**

Putra Mosque, Putrajaya, Malaysia

Longitude: 101.6° E
When to go: All year

Constructed from rose-tinted granite and topped with a patterned pink dome, Putra Mosque can hold up to fifteen thousand worshippers. Built in 1997, the mosque incorporates design elements of Malaysian, Persian, and Arabic Islam, taking influence from mosques around the world, including the Sheikh Omar mosque in Baghdad and the King Hassan mosque in Casablanca, Morocco.

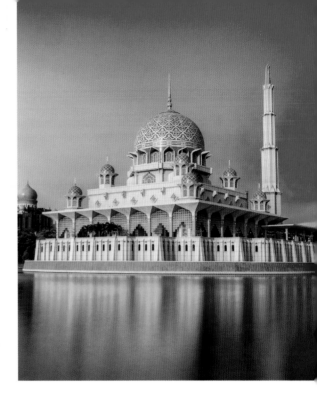

387 **Shapes in the hills**

Huanglong Valley, Sichuan, China

Longitude: 103.8° E
When to go: April to November

High in the Minshan mountains, Huanglong is a lush valley hiding a fairy-tale landscape of bright blue pools. The valley is one of the most beautiful in Sichuan Province, and is a UNESCO World Heritage Site. Dotted throughout the valley are terraces of travertine limestone, which create small circular pools. Calcite deposits lend these ponds vivid blue, green, or turquoise shades, varying from pool to pool. There are dozens to see; some of the more spectacular even have their own names such as Flamboyant Pond, Multicolor Pond, and Mirror Pond.

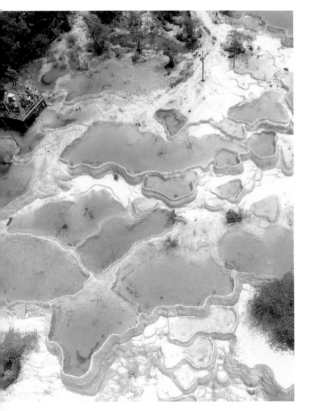

388 Man masters the mountains

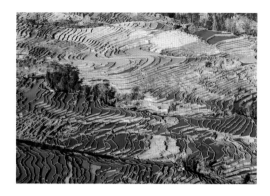

Honghe Hani Rice Terraces, Yuanyang County, China

Longitude: 102.7° E
When to go: November to early March

Developed over the past 1,300 years by the indigenous Hani people, the Honghe Hani Rice Terraces are a shining example of what can be achieved when humans work in partnership with nature. The Honghe Hani Rice Terraces span 41,000 ac/165 km² with the core area concentrated in Yuangyang County. The terraces include a highly complex irrigation system to grow rice in the limited space of the mountainsides surrounding the Hong River. They trace around the contours of the mountains, creating a striped pattern of sweeping layers. In some places you'll find as many as three thousand rice terraces lacing the slopes of the mountains, each one containing a small bed of rice plants. Not only is the region famous as an example of the ingenuity and creativity of the local farmers, but also for the stunning rainbow display as the flooded terraces change color depending on the time of day. Most impressive is sunrise and sunset, when the valleys glow with the reflection of the golden light.

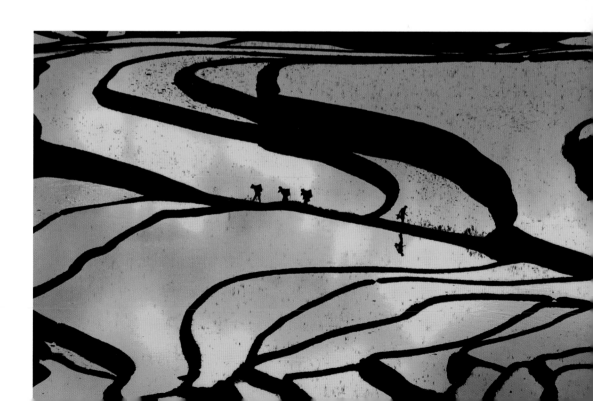

389 Find peace among the parties

Blue Lagoon, Vang Vieng, Laos

Longitude: 102.4° E
When to go: October to March

With its river tubing and madcap backpacker parties, Vang Vieng has a bad-boy reputation among southeast Asian destinations. But escape into the mountain landscape and you'll find a series of idyllic aquamarine pools. Known as the Blue Lagoons, some are as busy as the town, with tourists playing on rope swings, but many more are divinely quiet. Adventuring in search of a glorious blue lagoon all to yourself is part of the fun.

390 Cascade of colors

Kuang Si Falls, Luang Prabang, Laos

Longitude: 101.9° E
When to go: November to late April

Cascading down three sculpted limestone tiered pools is the Kuang Si Falls in Northern Laos. Located just outside Luang Prabang, this jungle oasis could be confused with a dramatic painting. The mindblowingly beautiful pale turquoise water tumbles down 164 ft/50 m, dropping into shallow pools that make relaxing swimming holes. Surrounded by a lush jungle the color of chartreuse and sage, the falls are popular among both locals and tourists.

391 The joy of giving

Luang Prabang, Laos

Longitude: 102.1° E
When to go: Daily at sunrise

Every morning at sunrise, the Buddhist monks of Luang Prabang walk in silent, meditative procession through the streets for a ceremony known as Tak Bat—collecting alms from local residents. Hundreds of monks walk in single file, their saffron robes creating a dazzling spectacle. The ritual dates back six hundred years and is an integral part of Lao Buddhism. To avoid turning this beautiful ceremony into a garish tourist attraction, keep a respectful distance if you're not giving alms yourself.

392 As good as gold

Wat Pha That Luang, Vientiane, Laos

Longitude: 102.6° E
When to go: October to April

Towering and golden, the stupa of Wat Pha That Luang is the most significant national monument in Laos. Supposedly, this is the site of the first Buddhist temple in Laos, established in the third century by missionaries from the Mauryan Empire in India. Legend has it that the stupa was constructed to enclose a piece of the Buddha's breastbone. The stupa's three tiers are merely painted golden, while the pinnacle itself is real gold, glinting in the sunshine.

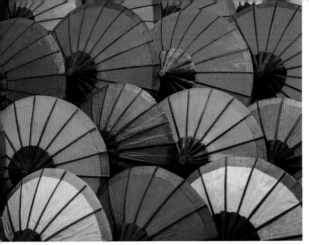
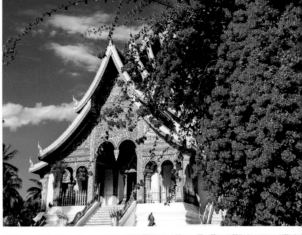
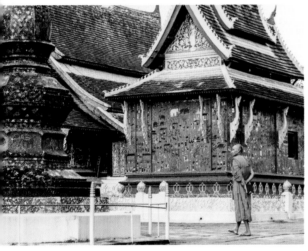

393 C'est trop beau

▲ Luang Prabang, Laos

Longitude: 102.1° E
When to go: November to March

Nestled on a peninsula between the Mekong and Nam Khan rivers, and skirted by dense green jungle, the Old Quarter of Luang Prabang is one of the most idyllic urban areas in Laos. Dazzling gold Buddhist temples vie for space with the faded grandeur of French colonialist architecture, many of them painted in shades of creamy yellow, which look amazing at sunset. The true beauty is found in the details, though. Up close, colorful floral tiles line the stairs and entryways of many buildings in the Old Quarter, while sparkling mosaics cover the temples beneath flared red rooftops. Between them all, lush vegetation towers over the buildings as though the forest is determined to reclaim the city.

394 Hop to the hip Haji Lane

Kampong Glam, Singapore

Longitude: 103.8° E
When to go: March to September

Hipsters, foodies, and street-art lovers will adore this area of Singapore, which brims with a mix of Malay and Arab cultures. Kampong Glam was founded before Singapore, so think of it as the cultural and historic heart of the country. It became known as the pride of the east after merchants converged in the area to trade. Around Haji Lane you'll find Middle Eastern cafés covered in ceramic tiles next to bars specializing in craft beer; quirky boutiques such as Crayon and Mondays Off; ice cream parlor Lickety; and the domed Sultan

Mosque. The walls of the area itself are vibrant too, with colorful murals at every turn. Some of the best are tucked down the alleyways that link Arab Street and Haji Lane. To see Kampong Glam at its liveliest, visit during Ramadan and join in the *iftar* (breaking of fast) or explore the Muslim quarter's vibrant night markets. For one of the tastiest meals, head to the restaurants on Kanndahar Street and tuck into a *nasi padang*—steamed rice with tasty side dishes.

395 Old, new, and buzzing

Chinatown, Singapore

Longitude: 103.8° E
When to go: March to September

Singapore's Chinatown is buzzing with energy. Old temples and traditional medicine shops sit cheek by jowl with cafés, restaurants, and funky modern shops. Lanterns are strung across streets and the whole area shouts with lucky splashes of red throughout. While the area began life as a Chinese enclave, it is now multiethnic and nowhere more so than among the tastes and aromas of the street food on Smith Street.

396 **Culture clash**

Little India, Singapore

Longitude: 103.8° E
When to go: March to September

Little India is a true feast for the senses. From stalls selling fresh flower garlands, to Tekka Market with its delicious curried scents of *roti* and *pratha*, to the beautiful pastel-colored Sri Veeramakaliamman Temple and sari shops galore, it's the most colorful of Singapore's multicultural neighborhoods. In the 1840s it was a popular area with Europeans, and later with Indian traders. One must-see in the area is The House of Tan Teng Niah, a rainbow-colored, two-story villa dating back to 1900. It's one of the only remaining Chinese structures in Little India that was built during the colonization of Singapore.

397 Pretty pastel Peranakan

Koon Seng Road, Joo Chiat, Singapore

Longitude: 103.9° E
When to go: All year, but June to August are the driest months

Singapore has long been a melting pot of different world cultures and influences. One of the more predominant ethnic groups found in the city-state is Peranakan, the descendants of Chinese settlers. Throughout the district of Joo Chiat you can spot distinctive Peranakan architecture: brightly painted two-story terraced shophouses with ornate façades and intricate motifs. The pastel shades of the houses along Koon Seng Road are particularly good examples, but the whole area is rich with Peranakan culture. Here you'll find shops bursting with colorful sarongs and beaded slippers, trendy cafés designed for the social media generation, and old world coffeeshops serving up *katong laksa* as they have done for decades.

398 In line with the law

Old Hill Street Police Station, Central Area, Singapore

Longitude:103.8° E
When to go: All year

Singapore seems determined to leave no building without some form of glamour. Even the historic police station on Hill Street, once gray and blockish, has not escaped a colorful facelift. The station's 927 windows have been painted the colors of the rainbow, in orderly rows of three. The resulting bands of color turn the exterior from a drab office building into a vibrant part of Singapore's heritage. The makeover came after an $82 million restoration project in 1997, when the building became the headquarters of the Ministry of Information and Arts.

399 Back to the future

▼ Gardens by the Bay, Singapore

Longitude: 103.8° E
When to go: January to May

Rising out of the lavishly green Gardens by the Bay are futuristic structures that take sustainability to the next level. The Flower Dome and Cloud Dome stand without any pillars and house the world's largest indoor waterfall. But the real showstoppers at the Singapore site are the Supertrees. Towering over the grounds, the nine to sixteen story-tall vertical gardens are beautiful, but they also collect rainwater and generate solar power. At night, they light up in every color on the spectrum for an epic light and sound show.

400 Step back in time

Pulau Ubin, Singapore

Longitude: 103.9° E
When to go: All year, but June to August are the driest months

Just a short boat ride from Singapore, Pulau Ubin feels very much like stepping back in time, as you swap skyscrapers for lush mangrove forests and wetlands. Particularly striking are the vivid blue lakes that have formed in Ubin's former granite quarries. The island is home to an abundance of wildlife, including playful otters and, on occasion, crocodiles.

401 **Key to survival**

Clarke Quay, River Planning Area, Singapore

Longitude: 103.8° E
When to go: All year

While much of Singapore seems to be increasingly modern, with towering skyscrapers and fascinating architecture, there are still plenty of historical areas in the city. Clarke Quay is an historic quay along the riverside in central Singapore. The original terraced shophouses and warehouses, such as The Cannery, have been lovingly restored, painted in a rainbow of funky pastels, and turned into nightclubs and restaurants. From the water, the contrast between Singapore's historic riverside buildings and the towering skyscrapers behind is even more apparent.

402 When Abad design is good

Alkaff Bridge, Robertson Quay, Singapore

Longitude: 103.8° E
When to go: All year

Singapore seems determined to become the most colorful city in the world. Take the Alkaff Bridge for example, which was built in 1997 to resemble a traditional local boat known as a tongkang. In 2007, it was given a vibrant facelift by Filipino artist Pacita Abad, who coated the bridge in fifty-five different colors and myriad swirling shapes, leading to its new name, the "Bridge of Art."

403 Cambodia's most famous sunrise

Angkor Wat, Angkor Archaeological Park, Siem Reap, Cambodia

Longitude: 103.8° E
When to go: All year

One of the most iconic sights in Asia, Angkor Wat was built in the twelfth century. It's actually one of several hundred ancient buildings across Angkor National Park. Sunrise is always a vibrant spectacle, thanks to the pools in front of the temple, which capture a perfect reflection of the spires silhouetted against the pink and golden sky.

404 A garden within a garden

Singapore Botanical Gardens, Singapore

Longitude: 103.8° E
When to go: January to May

Spread lavishly along a hillside in the Botanical Gardens, Singapore's National Orchid Garden is home to colorful blooms all year round, thanks to the tropical climate. As well as an abundance of fabulous orchids—including Singapore's national flower, the Miss Joaquim orchid—visitors can enjoy several attractions and floral tunnels.

405 **Turn back the flow**

Tonle Sap Lake, Siem Reap, Cambodia

Longitude: 104.0° E
When to go: November to April for best birdlife

Pulsing from Siem Reap to Phnom Penh, the Tonle Sap River is the lifeblood of Cambodia. During monsoon season, the river's flow reverses, flooding the lake at its source. To combat this, the brightly painted wooden houses of the lake's villages are built on stilts above the water, while some actually float on bamboo rafts and barrels.

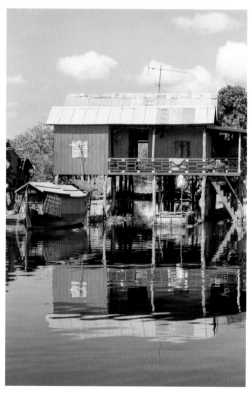

406 Tales of the Buddha

Wat Preah Prom Rath, Siem Reap, Cambodia

Longitude: 103.8° E
When to go: All year

Siem Reap is better known for the crumbling brown temples that litter the Angkor Archaeological Park. But the pagoda of Wat Preah Prom Rath in the city center is much more colorful. The gardens of this Buddhist monastery are dotted with garishly painted sculptures telling stories of the Buddha and monks who have lived here. Throughout the gardens benches invite you to sit and contemplate the artworks. Few places are quite as still and serene in the midst of a bustling city.

407 Row in the new season

▼ Phnom Penh, Cambodia

Longitude: 104.9° E
When to go: October and November (dates change annually)

Cambodia's annual Water Festival, Bon Om Tuk, is a celebration of the Harvest Moon and the reversal of the Tonle Sap river's current that dates back to the twelfth century. Today, the biggest celebrations take place in Phnom Penh. The water is filled with painted wooden boats; their teams—who come from villages across Cambodia—dress in matching bright colors.

408 If you've got it, flaunt it

Royal Palace and Silver Pagoda, Phnom Penh, Cambodia

Longitude: 104.9° E
When to go: November to May (dry season) for the most pleasant weather

Set within neatly manicured gardens behind distinctive yellow walls, the Royal Palace complex in Phnom Penh offers a peaceful respite from the city's chaos. It was built in 1866 when King Norodom relocated Cambodia's capital to Phnom Penh. His palace, filled with marble, precious stones, and ornate detailing, has left behind a seriously extravagant legacy.

409 Who left the hot tap on?

▼ Five Flower Lake, Jiuzhaigou Valley Nature Reserve, Sichuan, China

Longitude: 103.9° E
When to go: All year

Jiuzhaigou Valley Nature Reserve in the Sichuan Province is famous for its amazing views, waterfalls, and lakes—and the most famous of all is the incredible Five Flower Lake. Fed by an underwater hot spring, the water of this magical lake never freezes, even when everywhere else in the valley has. The lake's color depends on the water levels and mineral concentrations, but varies from sapphire blue to deep emerald green.

410 Shopping with style

Central Market, Phnom Penh, Cambodia

Longitude: 104.9° E
When to go: Mid-November to early May

Constructed in 1937, the Central Market in Phnom Penh features a striking art deco design. At its center is an enormous golden dome, from which four hallways branch out like splayed arms. Inside the dome is the section of the market reserved for gold and jewelry vendors, clustered beneath the towering, flower-like yellow ceiling.

411 Islands in the bloom

▲ Luoping, Yunnan, China

Longitude: 104.3° E
When to go: Mid-February to early April

Every spring, the countryside of Luoping in Yunnan becomes an endless sea of vivid yellow. Fields of canola—also known as rapeseed—stretch as far as the eye can see. Hills and mountains dotted throughout the region form small islands in the ocean of color, while in some of the valleys the crop lies in layered terraces, creating unique, looping patterns. Luoping's annual yellow spectacle is best viewed from above to fully appreciate the sheer size of it, so the mountains provide perfect viewing spots.

412 Float into the past

Prek Svay, Koh Rong, Cambodia

Longitude: 103.2° E
When to go: November to May

Once a jungle-clad wilderness with a scattering of fishing villages, the island of Koh Rong has evolved into a tourist hotspot off the coast of Cambodia. Lining both sides of a sea-green river, the colorfully painted wooden boats and stilted houses of Prek Svay are a genuine floating village, surrounded by dense jungle.

413 A kingdom of isolation

▲ Lake Baikal, Siberia, Russia

Longitude: 108.1° E
When to go: February and March

Lake Baikal is best known as a summer holiday destination. But during the winter months, the lake becomes a winter wonderland Queen Elsa would be proud of. Baikal is the deepest lake in the world and it's also considered one of the cleanest. During winter, giant shards of turquoise ice cover the lake's surface. These startlingly transparent icicles erupt from the lake in fascinating formations, looking almost manmade. Elsewhere, frozen bubbles of methane gas float above the inky blue depths, while crisscrossing white-blue lines form where the ice has frozen in layers. The result is a fairy-tale land of ice and snow that must be seen to be believed.

414 Crimson tide

Crab Migration, Christmas Island, Australia

Longitude: 105.6° E
When to go: October to December

Every year, Christmas Island, northwest of Perth, experiences a natural phenomenon: forty million red crabs migrate from the forest to the coast to spawn. The migration can last up to eighteen days, and with the crabs moving in mass waves, can look like an eerie red wave flowing across the land.

415 Choose any color . . . except black

Naran Tuul Market, Ulaanbaatar, Mongolia

Longitude: 106.9° E
When to go: Avoid weekends when it's very busy

Despite its alternative name translating as "Black Market," there is nothing illegal about Naran Tuul and nothing very black. Color is everywhere, from the reams of bright, patterned fabrics to the lino flooring and the aisles of bright orange, wooden furniture—a traditional color in Mongolian yurts.

416 Walk on a dragon's back

Dragon Bridge, Da Nang, Vietnam

Longitude: 108.2° E
When to go: February to May

Da Nang has been nicknamed the City of Bridges, thanks to the numerous crossings traversing the Han River. Many of them are elaborate architectural feats, but none are quite as striking as the Dragon Bridge. Looping over and under the bridge in huge arches is a gigantic yellow-gold dragon, with pointed scales lining its back. At 2,185 ft/ 666 m, it's the largest steel dragon bridge in the world—although it's hard to imagine there's much competition for that title! After dark, the towering archways are spectacularly lit, and on weekends and holidays the Dragon even spouts fire.

417 Staircases of green

Sa Pa, Vietnam

Longitude: 103.8° E
When to go: March to May for hiking. June to August is when the rice terraces are greenest.

In the mountains of northwestern Vietnam, the region around Sa Pa is one of the most popular trekking spots in the country. The region is famed for its rice terraces, which form snaking, staircase-like patterns around the valleys. Built to maximize farming space in the mountains, the effect is a mesmerizing pattern of undulating green.

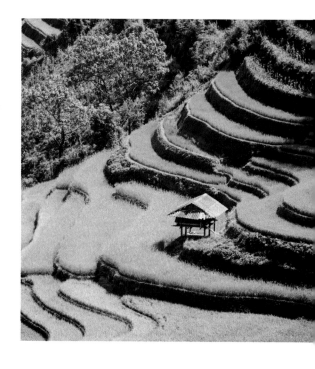

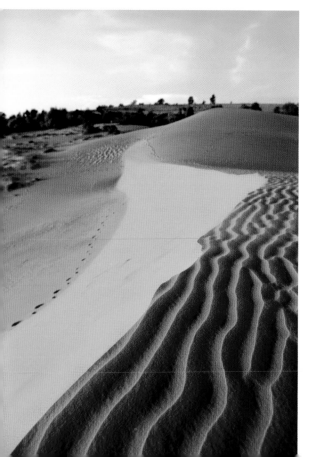

418 Desert of the east

Red Sand Dunes, Mui Ne, Vietnam

Longitude: 108.2° E
When to go: All year. Best at sunset

Who knew Vietnam had a desert region? In the southeast, the fishing village of Mui Ne is surrounded by rolling sand dunes. The rich, amber hues of the Red Dunes are particularly striking, especially around sunset. They were formed by the strong winds of the coast, which carried sand inland and whipped it into towering cones.

419 Night lights

▶ Hoi An, Vietnam

Longitude: 108.3° E
When to go: February to August

Known for its intricate silk lanterns, a walk through the city of Hoi An feels like walking in a wonderland. Brightly colored lanterns are strung across the pedestrian-only streets and bob from the trees. The whimsical atmosphere is reminiscent of a fairy tale, and the bold yellow homes that line the roads and bougainvillea growing up the walls make it brim with color. Symbolizing harmony and balance, and attracting warmth, peace, and luck to a household, the lanterns were first created in the late sixteenth century when the silk trade brought the material to Hoi An.

Originally, only traditional red lanterns were made. Now, a rainbow of lanterns in shapes such as diamonds, lotus, and balloons are created from bamboo and silk. On the fourteenth of each lunar month, a night of lantern festivities takes place in the city center, and the craftsmanship is put on display. Candy-colored lanterns line the streets and lantern boats are sent down the river. The town comes to life and lights up. Stall upon stall sell replicas of the picture-perfect lanterns so tourists can take a little slice of the dreamland home with them.

420 Under the arches

27 Phung Hung, Hanoi, Vietnam

Longitude: 105.8° E
When to go: All year

On Hanoi's Long Bien Bridge, a series of nineteen trompe l'œil murals fill the stone archways, bringing to life colorful scenes from Hanoi's past. The project was a collaboration between Hanoi People's Committee and the Korea Foundation, to celebrate twenty-five years of diplomatic relations between Vietnam and South Korea.

421 A garden of islands

Halong Bay, Quang Ninh Province, Vietnam

Longitude: 107.1° E
When to go: March to May and September to November

One of the most famous tourist destinations in Vietnam, Halong Bay is a stunning landscape of naturally vibrant colors. The emerald waters of the Gulf of Tonkin are filled with a garden of islands. Around two thousand towering limestone karsts and islands are dotted throughout the bay, each one topped with a fuzz of deep green forest.

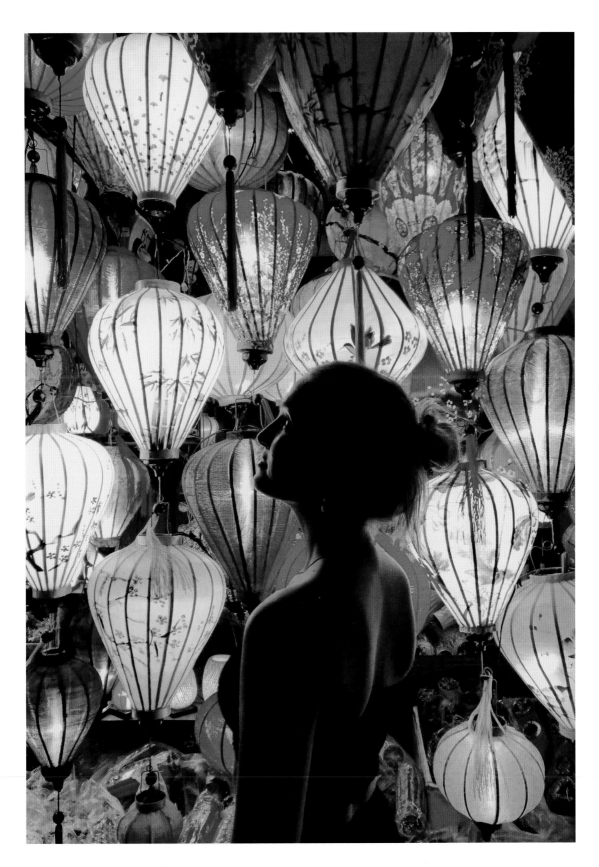

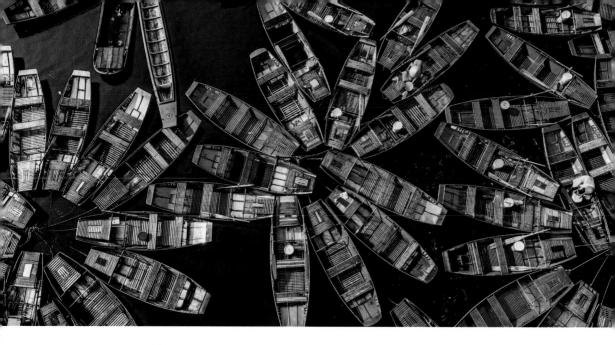

422 Stacks of appeal

Ninh Bin, Vietnam

Longitude: 105.9° E
When to go: May to June

Often nicknamed the "inland Halong Bay," Ninh Binh is a small city surrounded by a unique landscape. Filled with lush rice paddies, the rolling countryside of the Red River Delta is dotted with towering limestone karsts similar to the ones found in Halong Bay. Jutting from the greenery of the otherwise flat landscape, these stacks resemble huge green islands. At Tam Coc, visitors can glide through emerald waters and rocky grottoes on a wooden boat—get ready to be wowed by the craft's captain who rows with their feet—or climb the five hundred steps to the stone dragon of Hang Mua temple for spectacular views of the karst-dotted landscape.

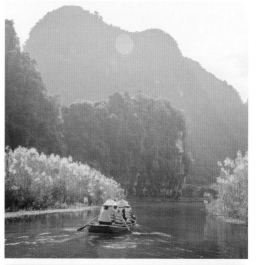

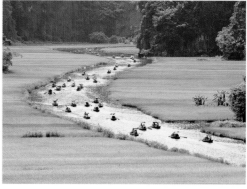

423 Pockets full of gold

Imperial Citadel, Hue, Vietnam

Longitude: 107.5° E
When to go: February to April

The walled and imposing Imperial City in Hue was once the capital of Vietnam. Abandoned during French colonial rule, the citadel fell into disrepair, and was almost lost during the Vietnam War, when a violent battle wiped out all but ten of the 160 buildings. Today, only an echo of the site's former grandeur remains, but ongoing restoration projects are bringing back the former glory of the Imperial City. From the decadent carmine-and-gold throne room, to the weather-beaten primary colors of the Gate of the Splendor Pavilion, to the tranquil greens of the manicured gardens, colorful pockets of the Imperial City's original majesty still exist within the grounds.

424 When worlds collide

Cao Dai Temple, Tay Ninh, Vietnam

Longitude: 106.1° E
When to go: All year. Try to make the noon service

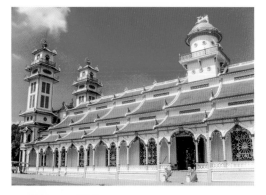

About three hours from Ho Chi Minh City lies the fascinating Cao Dai Temple. The temple's bright yellow exterior, tiered red roofing and sky-blue trim is nothing compared with the interior. A baby-blue ceiling painted with puffy clouds arches over an explosion of colourful carvings and various religious motifs. Caodaism is a relatively new religion, founded here in 1926, and it combines elements of Buddhism, Taoism and Catholicism. Hence the chaotic—and at times kitschy—collision of styles and iconography found in the temple.

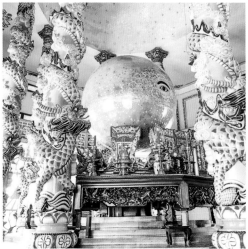

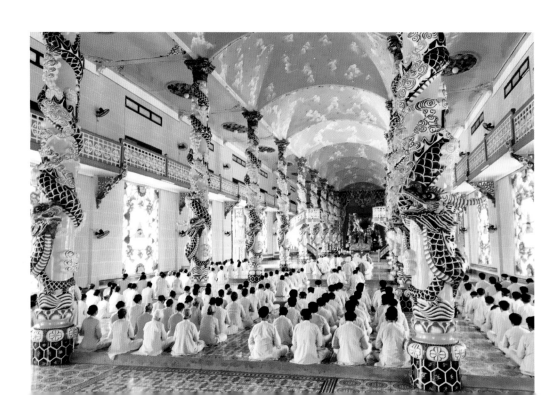

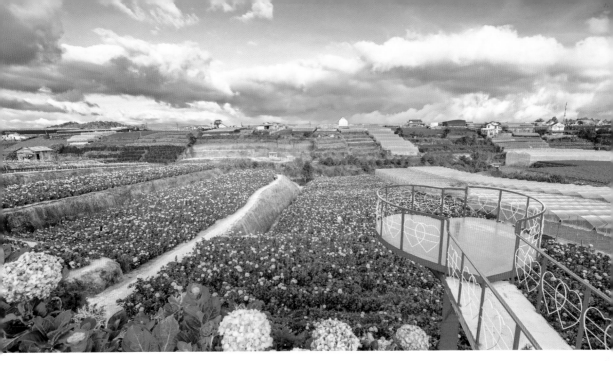

425 Flower power, Vietnamese style

▲ Da Lat Flower Park, Da Lat, Vietnam

Longitude: 108.4° E
When to go: December to March

Da Lat has a lot of nicknames: La Petit Paris, the City of Eternal Spring, and City in the Fog, to name a few. It's also known as the City of a Thousand Flowers, and a quick trip to the Da Lat Flower Park reveals why. The park's sprawling gardens are bursting with hundreds of species of colorful flowers, many of which blossom all year round. This being Vietnam, there's plenty of kitsch topiary and bizarre embellishments to explore. Think flower-studded teddy bears and horse-drawn carriages decked in colorful garlands. But there's also an impressive collection of flowers from around the world, including hydrangeas, fuchsias, and orchids.

426 Paddle into fairy land

Fairy Stream, Mui Ne, Vietnam

Longitude: 108.2° E
When to go: All year

Close to the Red Dunes of Mui Ne lies the quaintly named Fairy Stream. Another surreal landscape that seems completely at odds with the rest of Vietnam, the Fairy Stream looks like the Grand Canyon in miniature. Winding its way between rust-red cliffs and through bamboo forests, the stream is an ankle-deep creek colored vivid orange by the clay and limestone of the surrounding landscape. The name comes from bizarre limestone formations that line the stream, swirled by wind and erosion into shapes that could easily be mistaken for the villages of tiny magical creatures.

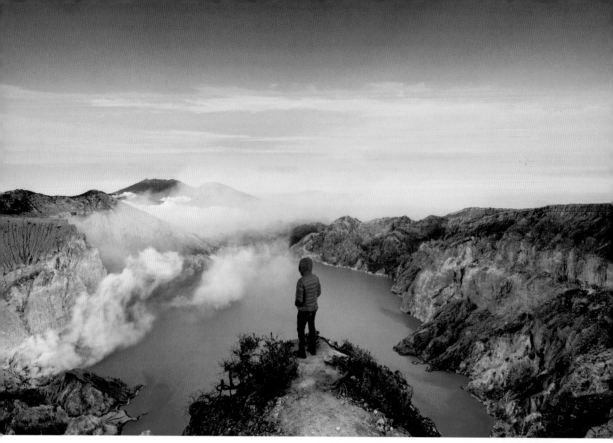

427 Hot as blue blazes

Kawah Ijen, East Java, Indonesia

Longitude: 114.2° E
When to go: April to October

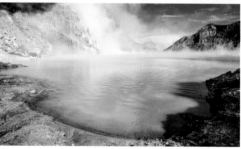

Kawah Ijen is one of a string of volcanoes on the island of Java, but this towering Indonesian volcano boasts a surprisingly colorful attraction at its summit. By day, the crater lake at Kawah Ijen's summit is a vivid turquoise pool of water. At the edge of the lake, an active vent pours forth bright yellow clouds of sulfur. But the most exciting phenomenon occurs at night, when dazzling neon blue rivers of fire can be seen streaming down the mountain. This is caused by sulfuric gases emerging from cracks in the volcano at high pressures and temperatures of up to 1,112°F/600°C. When the gas hits the air, it ignites, sending blue flames up into the night sky, before condensing into liquid sulfur and flowing down the slopes, still burning bright blue.

428 **Blow your mind**

Pulau Boheydulang, Borneo, Malaysia

Longitude: 118.7° E
When to go: February to April

Mountainous Boheydulang is a tiny island in the Tun Sakaran Marine Park off Borneo's northeastern coast. Formed from the remnants of an ancient volcano, the hills of the island offer the perfect vantage point to appreciate the dazzling aquamarine waters of the marine park.

429 **Live your lushest life**

Tegalalang Rice Terraces, Bali, Indonesia

Longitude: 115.3° E
When to go: June to September

North of the rainforest town of Ubud are the island's most iconic rice paddies. The lush green rice fields look as if the green has been dialed up to eleven. You can enter the fields free of charge, but to continue to different sections, you'll pay small fees.

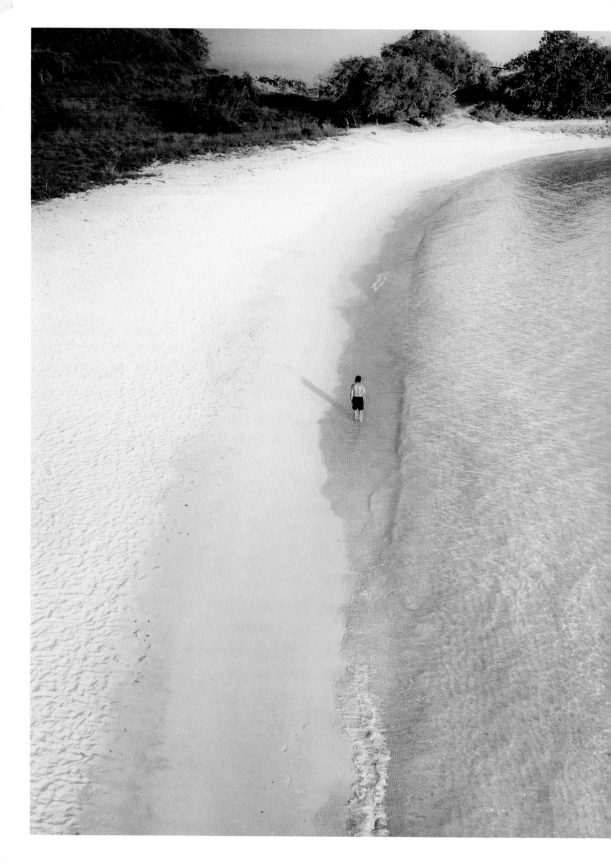

430 **Here be dragons**

Pink Beach, Komodo Island, Flores, Indonesia

Longitude: 119.5° E
When to go: April to December (although it's best to avoid the July to August high season)

Komodo Island is known for more than just dragons. On the southeastern corner of the island you can visit one of its most unusual natural attractions: Pink Beach. Pentai Merah, as it's called locally, is a magical landscape of pink sand, and is one of just a handful of such beaches in the world. Contrasting with the turquoise water of the sea, the color is amazing. But there's a scientific explanation for the pink sand. The rosy hues are caused by the red pigment in the shells of foraminifera, minuscule marine creatures that live on the nearby coral reefs. Most visitors to Pink Beach come as part of a tour of the Komodo National Park, the only place in the world where the magnificent Komodo dragons live in the wild.

431 Sulfur, so good

Telaga Warna, Dieng Plateau, Central Java, Indonesia

Longitude: 106.7° E
When to go: Dry season runs from April to October

Dieng Plateau in Central Java is known for an array of natural beauties. Among them is the incredible color-changing lake, Telaga Warna. The high sulfur content means that when the sun hits the water, it reflects in various colors. At times it can be bright turquoise, at others dark green, yellow, or even purple.

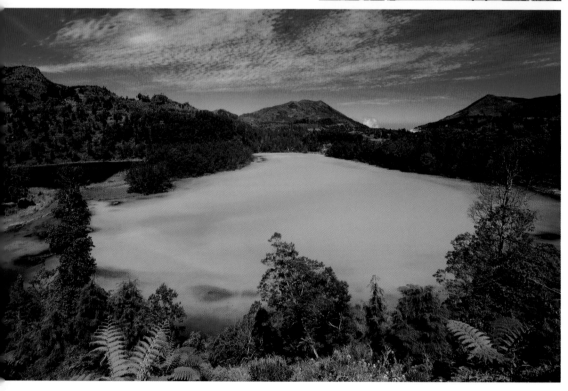

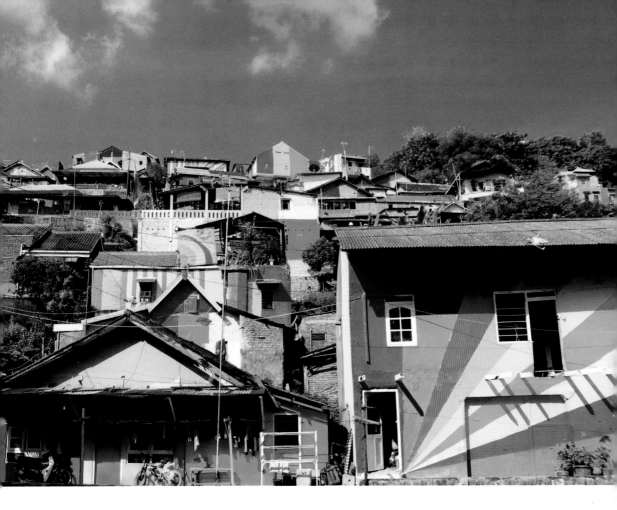

432 Visitor attraction

Kampung Pelangi, Semarang, Central Java, Indonesia

Longitude: 110.4° E
When to go: All year, but best from June to September

In early 2017, the village of Kampung Pelangi won a grant from the local government to undertake a massive redecoration project in an attempt to attract more tourists. The local community pulled together to paint every wall and roof in bright rainbow stripes. Even the mayor pitched in.

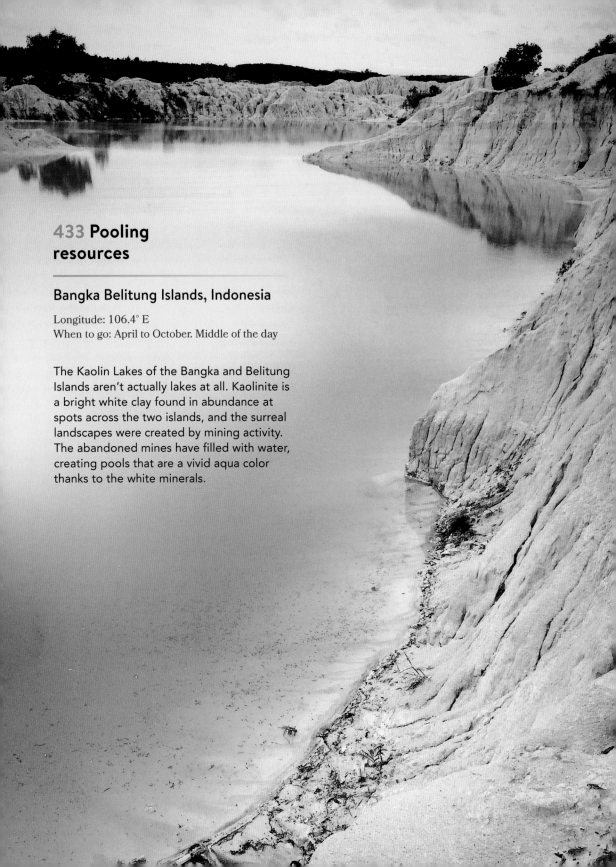

433 Pooling resources

Bangka Belitung Islands, Indonesia

Longitude: 106.4° E
When to go: April to October. Middle of the day

The Kaolin Lakes of the Bangka and Belitung Islands aren't actually lakes at all. Kaolinite is a bright white clay found in abundance at spots across the two islands, and the surreal landscapes were created by mining activity. The abandoned mines have filled with water, creating pools that are a vivid aqua color thanks to the white minerals.

434 Color economy

Kampung Warna Warni Jodipan, Malang, East Java, Indonesia

Longitude: 112.6° E
When to go: All year

Once a run-down slum with little prospects for the residents, Jodipan was revitalized into a rainbow village by a group of students from Universitas Muhammadiyah Malang that thought a unique paint job would transform the neighborhood. And they were right—tourists noticed and now pay to view the vibrant community, creating an economy for the locals.

435 The jewel within

Mount Rinjani, Lombok, Indonesia

Longitude: 116.4° E
When to go: April to October. Trails are closed from early January to April

Mount Rinjani, Indonesia's second-highest volcano, has long been a favorite trekking challenge among the hordes of backpackers flocking to Lombok island. At 12,224 ft/ 3,726 m above sea level, the views from the top are breathtaking. But the real attraction is Rinjani's crescent-shaped crater lake, which curls around the tip of an active volcanic cone. The lake's water is a rich sea-blue, earning it the name Segara Anak, meaning "child of the sea." Both the lake and the volcano are considered sacred by Indonesians, and many make pilgrimages to honor the spirit of the mountain. One of these, Pekelan, involves pilgrims throwing offerings of gold and jewelry into the lake, before continuing the climb to the summit.

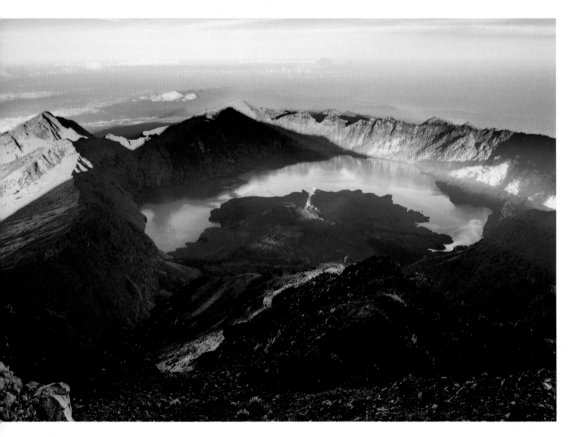

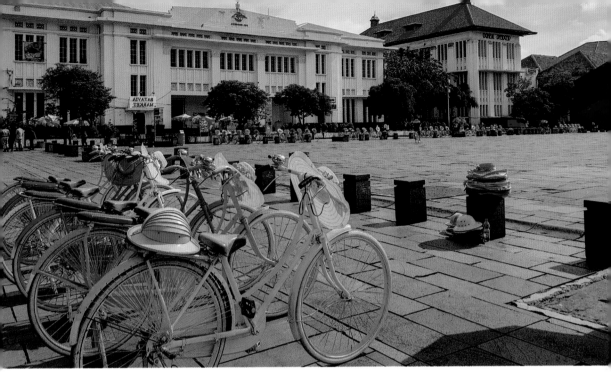

436 Pedal power

Fatahillah Square, Jakarta, Indonesia

Longitude: 106.8° E
When to go: April to September to avoid the rainy season

For many years Indonesia was a Dutch colony, and while much of its legacy is tied up in political tensions between the two nations, one stylish Dutch import are the classic sit-up-and-beg bicycles still found throughout the country. Lining one side of the historic Fatahillah Square in Jakarta Old Town is a bike hire business which rents out these old bikes, repainted and reupholstered, paired with similarly brightly colored old-fashioned bike helmets and sunhats. For those who would rather not pedal, you can hire a "driver" to pedal you round while you enjoy the tour from a padded rear seat.

437 Colors apart

Apartment Complex, Hong Kong

Longitude: 114.1° E
When to go: March to June, September to November

One of the most vibrant cities in the world, Hong Kong is littered with multicolored locations. Over the years, rainbow-colored apartment complexes have sprung up all over the city. Clusters of brightly colored buildings such as the Blue House, which is listed as a Grade I historic building and made up of blue, orange, and yellow houses, showcase the history of architecture of Hong Kong. Surrounded by a myriad of candy-colored buildings, it's hard to miss. But the real winner of the title of "Colorful Hong Kong" goes to the Choi Hung Estate, which translates as rainbow from the Cantonese. Built in 1962, it houses over eighteen thousand people. The façade of the apartment complex is covered in hues of pastel purple, blue, green, and orange. Below the color-shaded exterior, on the roof of the car park, is a vibrant basketball court that adds even more personality to the spot.

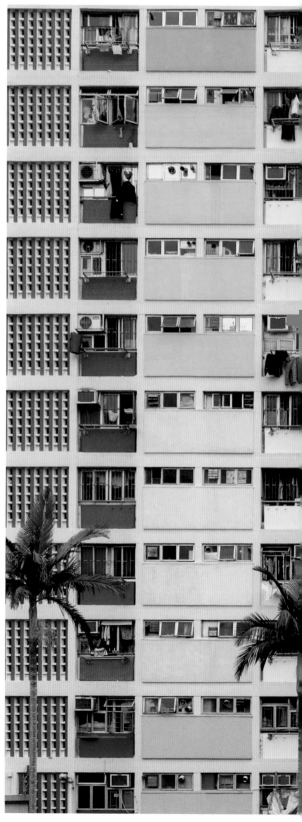

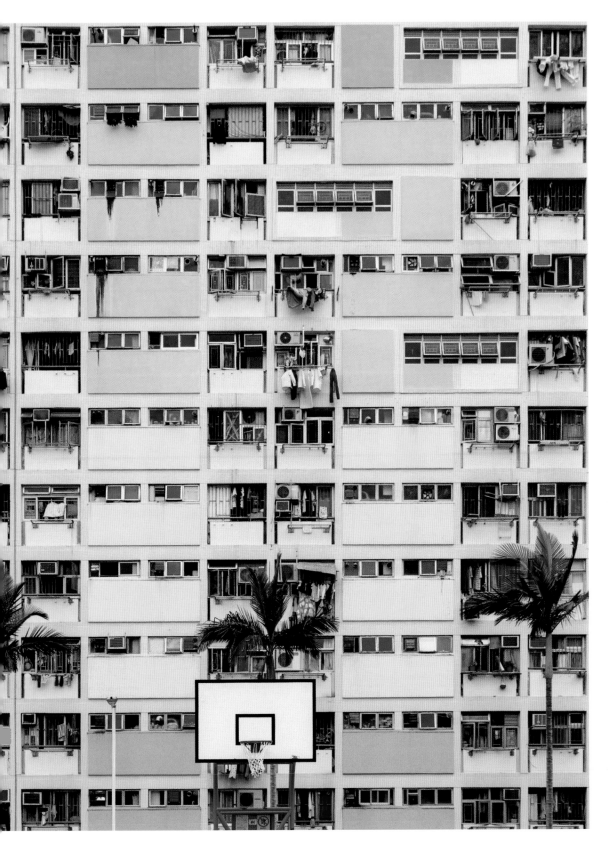

438 Nailed it.
Or did they?

▼ Chi Lin Nunnery, Hong Kong

Longitude: 114.2° E
When to go: March to June, September to November

The juxtaposition of the large Buddhist temple complex of Chi Lin Nunnery is captivating against huge skyscrapers in Kowloon, Hong Kong. Designed in the traditional Tang Dynasty style, the complex, golden pagoda and red bridge are constructed entirely of cypress wood, without the use of nails.

439 Cotton
candy skies

Sunsets, Bali, Indonesia

Longitude: 115.0° E
When to go: April to September

Beautiful beaches, friendly locals, and tasty food are the reasons people flock to the Indonesian island of Bali. But one thing they all remember on leaving, are the insanely beautiful sunsets. Nearly every night the skies turn the color of sweet candy from Seminyak to Uluwatu to Ubud to the Gili Islands and everywhere in between.

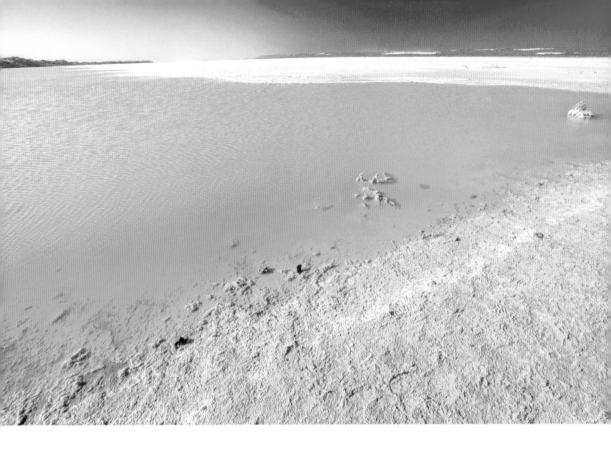

440 Nature with a hint of bubblegum

▲ Hutt Lagoon, Australia

Longitude: 114.2° E
When to go: All year

Western Australia has a few fabulous pink lakes. Hutt Lagoon is one of them, and it's notable for the range of colors the water turns. The color is created by a special type of algae and can range from bubblegum pink to red and purple. To see it at its most impressive, pick a day with clear skies and arrive around midday.

441 Early bird eats the egg

Mount Batur, Bali, Indonesia

Longitude: 115.4° E
When to go: June to September

An early-morning hike up active volcano Mount Batur may be physically and mentally challenging, but you'll be rewarded by an incredible sunrise. Glistening gold rays burst from the silhouette of Mount Agung, while low mist hangs over a shimmery Lake Batur. Peckish? Tuck into boiled eggs cooked in the volcanic steam.

442 In the frame

Kalbarri National Park, Australia

Longitude: 114.1° E
When to go: September and October

A sea of pink, magenta, and yellow wildflowers covers the rolling hills of Kalbarri National Park in Australia. Add to this deep red gorges, greenish-blue water, and views of plummeting sandstone cliff faces, all of which can be viewed through Nature's Window—a massive red rock frame—and it's a color-lover's dream.

443 **Light up, light up**

North Mole and South Mole Lighthouses, Perth, Australia

Longitude: 115.7° E
When to go: September to November.

Red and green should never be seen, unless they're in lighthouse form, of course. The North Mole and South Mole lighthouses in Perth are the last remaining of their type. The 50-ft/15-m-high towers are made of cast iron and painted red and green with stand-out bright white windows and doors.

The brightly colored pair have provided safe access to ships coming in to Perth's Fremantle Harbour for more than a hundred years and are a well-known landmark to sailors visiting the port. They're also popular for recreational fishing and bird-watching and can easily be reached on foot.

CHAPTER EIGHT

120°–180°

444 Go fish

Seafront Hualien, Taiwan

Longitude: 121.6° E
When to go: November to April

The Hualien Pacific Landscape Park is home to a boardwalk surrounded by tall, neon, candy-colored art-deco buildings. Further up the boardwalk, fish appear to climb up a staircase in a wonderful blue mural, draped in lanterns and next to an ornate local temple.

445 Rainbows in the mist

Shifen Waterfall, Pingxi, Taiwan

Longitude: 121.7° E
When to go: October to December

Nicknamed the "Little Niagara" for its horseshoe shape, at 130 ft/40 m wide Shifen is the broadest waterfall in Taiwan. On sunny days, the spray sends up distinct rainbows as it splashes into the emerald lake. The walk there is particularly scenic, as you cross the river via suspension bridges, surrounded by verdant mountains.

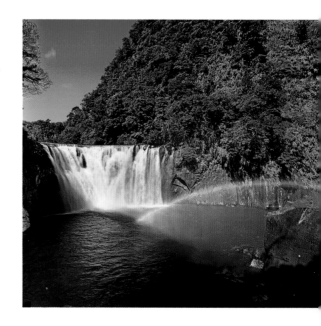

446 Valley of colors

Taroko Gorge, Hualien, Taiwan

Longitude: 121.4° E
When to go: November to April

With breathtaking view upon breathtaking view, Taroko Gorge National Park is a true natural wonder. Lush trees climb the sides of gray and white limestone cliffs. In between a gorge is filled with deep blue water. Bright red temples can be found high in the mountains surrounded by dark green treetops.

447 Feed me street art

Taipei, Taiwan

Longitude: 121.5° E
When to go: November to April

One of the oldest in Taipei City, the Wanhua District is home to tons of restaurants, shopping, and temples. But all along the walls are bold murals in a broad spectrum of color. Further down the road, even more vibrant street art has popped up in the bustling Ximending Shopping District.

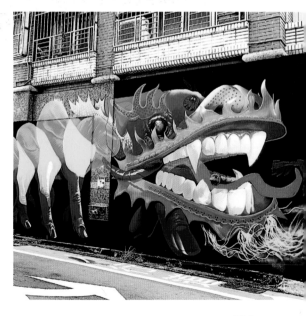

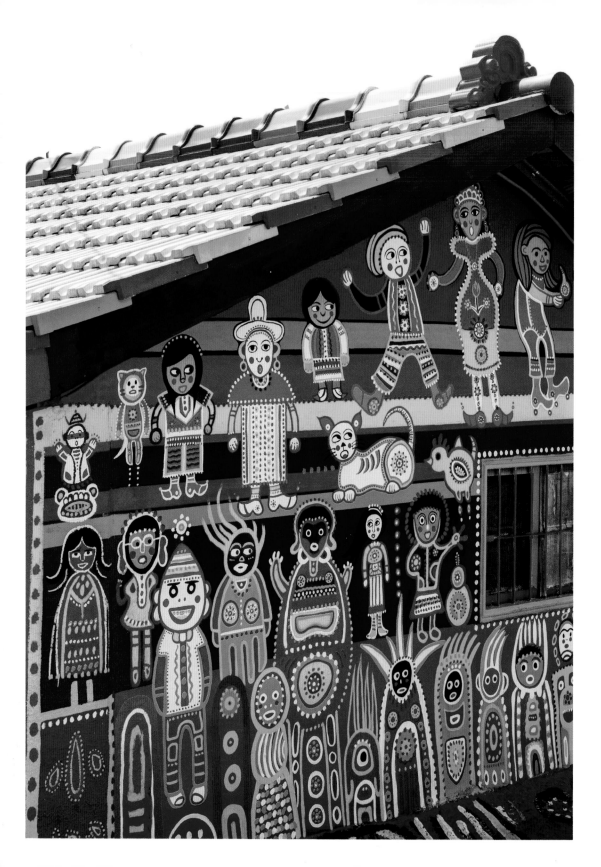

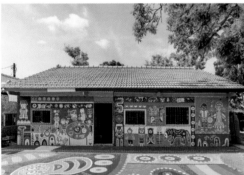

448 Color salvation

Rainbow Village, Taichung, Taiwan

Longitude: 120.6° E
When to go: November to April

When Huang Yong-Fu heard that the government planned to demolish his village—which was a complex for war veterans—he thought he better do something to stop it. So he started to paint the walls of his home and the surrounding buildings in the neighborhood. Now known as Rainbow Village, the most colorful place in Taiwan, this technicolor town is completely covered in color. The vibrant artwork of "Rainbow Grandpa" has a surrealist element, mixed with humor, and love, in a somewhat childlike design. Dolls, animals, airplanes, and more fill the walls, floors, and ceilings of each building. What began as a project to save his beloved home—and worked—has turned into a famous location in the city of Taichung. On some days, visitors are lucky enough to meet Rainbow Grandpa, now in his nineties, who can still be found taking a stroll around his colorful wonderland. The real magic of the tiny town is the unparalleled joy and meaning it has brought to the community of Taichung. And it all started with a man with a paintbrush and big, vibrant dreams.

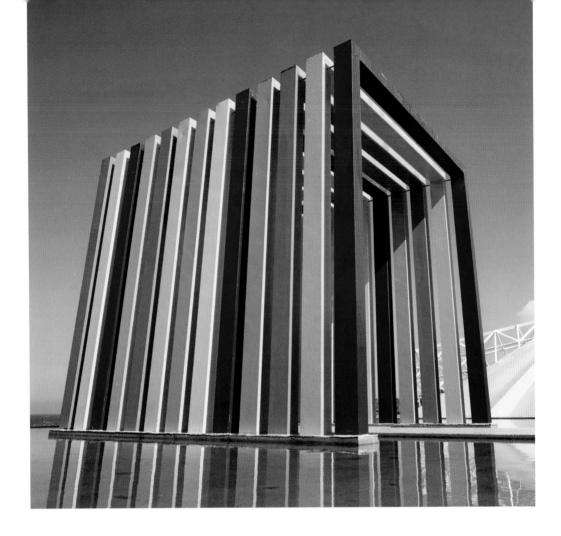

449 **Underneath the arches**

Rainbow Arch, Section 3 Qijin Road, Kaohsiung City, Taiwan

Longitude: 120.3° E
When to go: October to December

Kaohsiung is Taiwan's second city, and while it's not always at the top of the traveler's bucket list, it's a vibrant place with numerous beaches and several quirky tourist attractions, including Qijin's Rainbow Arch. Set in a small pool of water, a series of multicolored square archways cover a paved walkway. It's a popular photo spot and so many newlyweds come to have a wedding photo taken here that it has earned the nickname of "Rainbow Church."

450 When is a beach not a beach?

Red Beach, Dawa County, Panjin, China

Longitude: 121.8° E
When to go: September to October

One of the most bizarre landscapes in China has to be Panjin Red Beach. It's not actually a beach, but the largest reed marsh and wetland in the world. From late summer to early fall, it turns a spectacular shade of flaming crimson. The whole area is covered in a variety of seepweed and because of the makeup of the soil in Panjin, the plant flowers a much brighter shade of red here than anywhere else in the world.

451 Color in the trunk

Rainbow Eucalyptus Trees, Mindanao, Philippines

Longitude: 123.3° E
When to go: All year

Rainbow eucalyptus trees are native to the island of Mindanao in The Philippines, although you'll find them around the world now as people have taken a shine to their colorful bark. As the previous season's bark peels off in strips, it reveals a bright green trunk below that changes color the longer it is exposed. Gradually, these brushstrokes of green change to red, orange, blue, purple, and gray. It's like a living work of art.

452 Flowers on the rooftops

▼ La Trinidad, Benguet, Philippines

Longitude: 120.5° E
When to go: All year (but May to October is rainy season)

What do you do when you have a steep hillside full of shanty houses that is considered an eyesore by some? Paint them into an enormous, colorful mural, of course! Inspired by the painting of favelas in Rio de Janeiro, the village of La Trinidad in Benguet decided to create a more welcoming spectacle for tourists by painting a huge mural across 170 of the houses. Under the direction of a group of artists, the local residents banded together to repaint the buildings, making this a true community project. Sunflowers, which are ubiquitous in the valley, were used as the primary motif for the initial designs, but the final result is more a blooming of color.

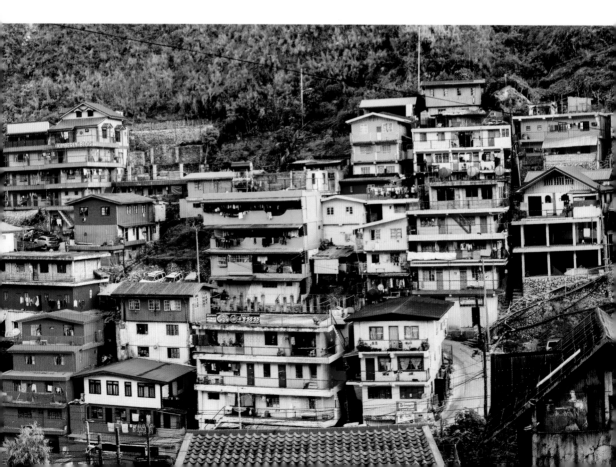

453 Through the green tunnel

Manmade Mahogany Forest, Bohol, Philippines

Longitude: 124.0° E
When to go: All year

The manmade mahogany forest of Bohol is a densely planted forest that carpets the mountainside between Loboc and Bilar. Planted so thickly, the trees have created an impenetrable wall of vivid green. It's particularly stunning where the branches curve across the winding road to create a dark tunnel of green.

454 Life beneath the sea

Wakatobi Reef, Flores, Indonesia

Longitude: 123.5° E
When to go: March to December for the best scuba diving

A UNESCO Marine Biosphere Reserve and the second-largest barrier reef in the world, Wakatobi is considered the world's epicenter of coral biodiversity. The reef is home to 750 coral species, as well as a vast array of colorful sea creatures and marine vegetation.

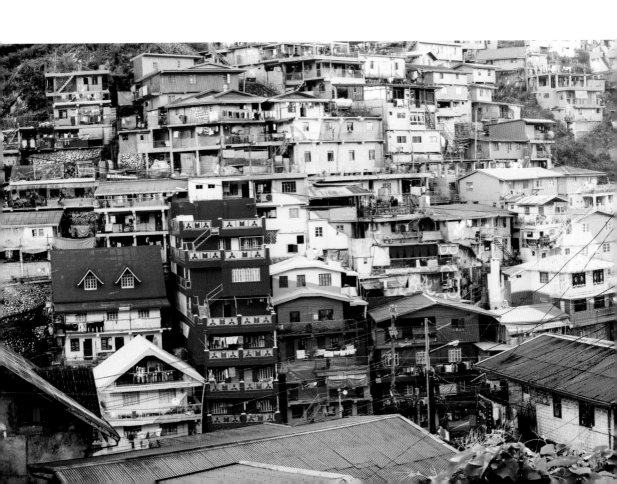

455 Adults in a candy store

Dessert Museum, Manila, Philippines

Longitude: 120.9° E
When to go: All year

Ever wondered what it would be like to go through the hole in your doughnut? In Manila, there is a museum dedicated to dessert that encourages visitors to find out just that! This is not your average museum; rather it's a series of interactive art installations dedicated to desserts and candy. Visitors can slide, swing, jump, and play their way through rooms decked out in bubblegum pink or dreamy lavender. Pose with gigantic cookies, wander through a cotton candy forest, and dive into a pastel-colored ball pit. Part art gallery, part gigantic adult playground, the Dessert Museum is everything you could hope it would be! Acting like a kid in a candy store is very much encouraged—so embrace your inner sweet tooth and get ready for a sugar rush.

456 Ride a giant unicorn

Inflatable Island, Mactan Beach, Cebu, Philippines

Longitude: 120.2° E
When to go: All year

A relatively new addition to the stunning Cebu coastline is the popular Inflatable Island on Mactan Beach. On the shore, a sea of bubblegum pink parasols dominates the white sand while around the bar, a jungle of multicolored palm trees lines the gateway to what the owners promise is "the happiest floating playground in Asia." A menagerie of unicorn and flamingo floaties bob on the waves around a floating obstacle course, including the main event: a gigantic unicorn with a slide on its back.

457 In search of paradise

Siargao, Philippines

Longitude: 126.0° E
When to go: All year (March to October for dry season)

Known for its palm-lined beaches, rich forests, and crystal-clear turquoise waters, Siargao is a paradise of natural colors. Perhaps most impressive is Sugba Lagoon, on Caob Island just off Siargao's west coast. Sheltered by thickly forested hills, the waters of the lagoon are impossibly calm and unbelievably blue.

458 Seek and you shall find

Busan Gamcheon Culture Village, Busan, South Korea

Longitude: 129.0° E
When to go: All year

Roam around the streets and alleys of Gamcheon Village and be in awe of what a little art can do. In 2009, painters and sculptors got creative in the alleys, homes, and businesses of this neighborhood that housed many refugees from the Korean War. Their mission was to revitalize the community with art and their coat of paint transformed the village into a colorful display of spirit that caught the eye of tourists. Wander the village to discover its treasures. There's even a very enjoyable scavenger hunt you can do: buy a map and visit various locations on it around the village and you'll be rewarded with stamps. Collect all the stamps and you'll receive a prize.

459 Immerse yourself in nature

Raja Ampat, Indonesia

Longitude: 130.8° E
When to go: October to April

Located off the coast of West Papua, Raja Ampat is tricky to reach, and as a result, virtually devoid of tourists. It's raw, rugged, and home to the most biodiverse waters in the world. Aboveground, exotic birds call to each other and gigantic colorful butterflies flutter by, while hermit crabs dance along the sand. Meanwhile, below sea level majestic lionfish prowl through the clear waters past purple pufferfish, turtles, dolphins, and sharks.

460 Three, two, one . . . go

Kelimutu, Flores, Indonesia

Longitude: 121.8° E
When to go: Best during the May to September dry season

At the center of Flores Island, the Kelimutu volcano hides a spectacular secret. Not only are the three crater lakes at the summit different colors, but they also change color. Depending on the levels of different minerals in each pool, the water can appear blue, green, white, red, or even black.

461 Trees that grow red?

Palm Valley, Australia

Longitude: 132.7° E
When to go: April to September

Just west of Alice Springs lies Palm Valley, the only place in the world you'll find the red cabbage palm. Along with the unique tree, there's also the stunning mountain range of the West MacDonnells, which changes color in the sun: from a vivid red to a deep orange as the sun sets over the desert.

462 Rocks to remark upon

Kangaroo Island Remarkable Rocks, Australia

Longitude: 137.2° E
When to go: All year

Splattered with golden-red pigments, the Remarkable Rocks on Kangaroo Island are a wonder. Formed centuries ago when molten rock bubbled up to the earth's surface to create granite, the Rocks have undergone wind and sea erosion. What's left is a collection of eerily shaped rocks spotted with black mica, bluish quartz, and pinkish feldspar.

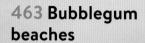

463 Bubblegum beaches

Lake MacDonnell, Eyre Peninsula, Australia

Longitude: 133.0° E
When to go: All year

South Australia has several pink lakes scattered throughout the state, but the causeway dividing pink Lake MacDonnell and its green-blue neighbor creates a dramatic contrast of colors, emphasizing the beauty of the bubblegum-colored water. Once the site of a salt mine and now a gypsum mine, it's best to visit Lake MacDonnell midmorning or at sundown on a clear day for the most brilliant pink and contrasts.

464 Transformed by pixie dust

Uluru, Northern Territory, Australia

Longitude: 131.0° E
When to go: August to September, sunrise or sunset

An iconic image of Australia, Uluru, or Ayers Rock, is a sandstone legend in the country's center and an extremely sacred spot for the Pitjantjatjara Anangu, an aboriginal people of Central Australia. At 1142 ft/348 m high and 5.8 mi/9.3 km around, viewing it in varying lights is the best way to experience Uluru's magic as its color transforms before your eyes. Dust particles and water vapor in the atmosphere create a light filter, removing blue light from the sun's rays, leaving the red light to shine and enhance its surrounding colors. Thanks to this pixie dust, Uluru is remarkable at any time of day, but reaches its most spectacular red at sunset.

465 Bright lights, big city

Shinjuku, Tokyo, Japan

Longitude: 139.7° E
When to go: All year

Daytime or nighttime, the Tokyo district of Shinjuku is always buzzing. It is one of those places that has its own special energy: it's not overcrowded or over cool but you always feel as if at any moment you could walk off the street and stumble into an undiscovered out-of-this-world restaurant or equally plausibly a seedy sex show. The area around Shinjuku station—the world's busiest—is a wonderful mix of epic skyscrapers stretching up into the air with bustling old-world alleyways that have been there for decades snuck in between them, as well as the more prevalent Tokyo street of post-war office blocks. These are where you often find the most color with advertising hoardings on every floor. Life here is lived vertically, so it's not just the ground floors that house shops and bars, there's always more to discover higher up the building too. By day it looks good; by night, it looks amazing. Go up high in the Tokyo Metropolitan Government Building for aerial views—or the Park Hyatt for a *Lost in Translation* moment. Or stay low in the Golden Gai area for bustling atmospheric nightlife.

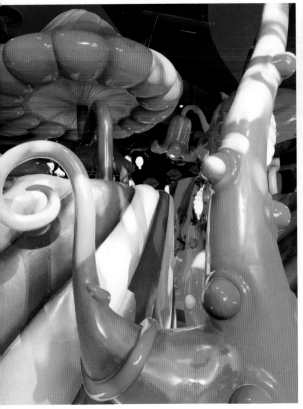

466 **Monster madness**

Kawaii Monster Café, Tokyo, Japan

Longitude: 139.7° E
When to go: All year

Tokyo is known for its weird and wacky cafés and restaurants, of which there are hundreds. But one of the most colorful—and utterly bonkers—has to be the Kawaii Monster Café in Harajuku. The district of Harajuku is famous for crazy cosplay and colorful pop culture, and the Kawaii Monster Café is the neighborhood's crowning glory. The whole restaurant was decorated by artist and sculptor Sebastian Masuda, who has created a world of giant desserts and half-cutesy,

half-terrifying monsters. Think disco lighting, glow-in-the-dark acid-pop paint, and mirrored ceilings. Even the food is colorful, with rainbow spaghetti and bright blue dipping sauces for your fries. At the center of the restaurant an enormous, hot-pink cake doubles as a stage for surreal dance acts that keep diners entertained (or confused) while they eat. The effect is like a drug-fueled trip to Wonderland, and it's sure to leave your senses reeling.

467 Off with a bang

Nagaoka, Japan

Longitude: 138.8° E
When to go: Beginning of August

There's nothing quite like a fireworks festival in Japan, where epic pyrotechnic displays last for hours at a time, synchronized perfectly to music. Nagaoka Festival is one of the biggest, taking place every August. These aren't your typical backyard fireworks. The finale covers more than 1 mi/2 km of the river, making it potentially the widest span of fireworks in the world.

468 Swirls on the lawn

Hitsujiyama Park, Chichibu, Japan

Longitude: 139.1° E
When to go: Late April to early May

Every spring, Shibazakura Hill in Chichibu's Hitsujiyama Park becomes a carpet of striking hot pink, thanks to the blooms of shibazakura (pink moss) that carpet the valley. More than four hundred thousand flowers in varying shades are planted strategically into swirls and shapes, creating a garden that wouldn't look out of place beside a Disney castle.

469 Wisteria hysteria

▼ Kawachi Fuji Gardens, Fukuoka, Japan

Longitude: 130.7° E
When to go: April and May

Spring may be best known in Japan as cherry blossom season, but these aren't the only blooms at this time of year. At the Kawachi Fuji Gardens in Kitakyushu City, the annual Kawachi Wisteria Garden has become a major event. Two 330-ft/100-m tunnels of wisteria trees create a lavender rainbow of shades ranging from white to dark purple.

470 Red marks the spot

Danjo Garan, Mount Koya, Japan

Longitude: 135.5° E
When to go: All year

Nestled within the mountains of Wakayama prefecture lies the tiny temple town of Kōyasan. This is the birthplace of Shingon Buddhism in Japan, and the Danjo Garan is where the religion's founder, Kobo Daishi, taught his disciples. The complex is dominated by the Konpon Daitō, the Great Pagoda, a 164-ft/50-m-high tower in striking red.

471 The perfect spot for a shoe-fie

Towada Art Center, Towada, Japan

Longitude: 141.2° E
When to go: All year

An ongoing series of multicolored floor designs by artist Jim Lambie, Zobop is the collective title of these psychedelic works. The installation, which uses brightly colored vinyl tape laid out in flowing stripe patterns, covers the entire entrance lobby floor of the Towada Art Center. Lambie's hypnotic designs have been installed in galleries across the world, including the Tate in London and the MoMA in New York City. Lambie begins by applying a strip of tape along the baseboard of a room, until the entire space has been outlined with a single color. Then, he adds another strip of a different color, overlapping the first one by precisely 2 mm. Each new color is chosen at random. This continues until the entire floorplan has been covered, resulting in a totally unique and site-specific artwork that is different every time. Not quite a painting, not quite a sculpture, but somewhere in between.

472 Summertime in the flower fields

Hokkaido, Japan

Longitude: 142.8° E
When to go: May to August

Hokkaido, the northernmost of Japan's main islands, is best known for its ski season. But as spring arrives and the snows melt, the island becomes a hotbed of colorful scenes, as the Hokkaido flower fields bloom. Farm Tomita is home to the largest lavender field in Japan; then there's the rainbow-striped Shikisai Hill; Kamiyubetsu Tulip Park, with over two hundred kinds of tulips, stretching in orderly rows; and Hokuryu Sunflower Field, which epitomizes summertime.

473 They call it hanami

Cherry Blossoms, Japan

Longitude: 138.2° E
When to go: Late March to early April

Each year, cherry red blossoms open on the
sakura trees in Japan. Pink flowers cover the
country in a blanket of color. Symbolizing the
return of spring, the Japanese have a word
for the pastel pastime. *Hanami* means
"watching blossoms," and is a tradition of
gathering under blossom trees to picnic with
family and friends.

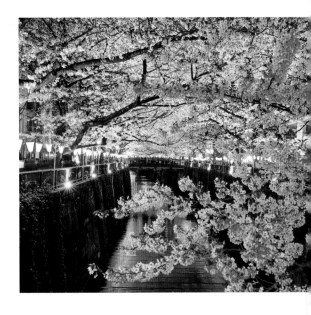

474 From the depths of hell

Chinoike Jigoku, Beppu City, Japan

Longitude: 131.4° E
When to go: All year, but summer can be
unbearably hot

Beppu is one of the most famous hot spring
resorts in Japan, home to the intriguing
Bloody Hell Pond or Chinoike Jigoku. Named
for the violent orange color caused by iron
oxide, it's one of seven "hells" found in
Beppu. Apparently once used for torture, the
intense 172° F/78° C heat means this *onsen*
is for viewing only.

475 A rainbow of ramen

Cup Noodles Museum Osaka Ikeda, Osaka, Japan

Longitude: 135.4° E
When to go: All year

Only Japan could create a museum for instant ramen—and make it colorful. The Cup Noodles Museum in Osaka may sound like one of the weirder tourist attractions in the city, but its interactive exhibits are a surprisingly fascinating, and fun, look at the history of cup noodles. Exhibitions showcasing the mind-boggling array of cup noodle flavors and styles from around the world create a rainbow tunnel of ramen. And in the neon-orange-striped factory, visitors can learn to make chicken ramen by hand. Osaka is the spiritual home of the instant noodle as they were invented here in 1958 by Momofuku Ando, who spent a year working on the idea from his garden shed. Later, after spending some time in the U.S.A., Momofuku had the idea to create cup noodles in 1971, which transformed Japanese instant ramen into a global food. This quirky museum dedicated to the food's father is the perfect place to discover the history of cup noodles.

476 Tunnel of Torii

Fushimi Inari Taisha, Kyoto, Japan

Longitude: 135.7° E
When to go: October, November or March to May

A magical tunnel made from thousands of vermilion torii gates wraps around the wooded forest of Mount Inari in Kyoto. The seemingly never-ending pathway leads to the summit of the mountain. Along the way, small shrines stacked with even more torii gates line the trail. Inscripted on the backs of the torii gates in beautiful black lettering are the names of the donor of the gate. Accompanying the inscription is their wish of health, wealth, or happiness. Dedicated to the god of rice and sake, the shrine features dozens of statues of foxes, which are said to be the messenger of the god Inari.

477 Beautiful bamboo

Bamboo Grove, Arashiyama, Kyoto, Japan

Longitude: 135.6° E
When to go: October, November, March to May

Rows and rows of imposing bamboo shoots line a shaded pathway in the Arashiyama district of Kyoto. The sprawling green bamboo stretches up to the sky, glowing in the early-morning light while it slowly sways back and forth in the breeze. The Bamboo Grove is the epitome of peacefulness.

478 When art is nature, and nature is art

Yoro Park, Gifu, Japan

Longitude: 136.5° E
When to go: March to June

Yoro Park is beautiful in both a natural and an artificial sense. The experience park was designed to combine nature and art to give visitors a sense of the unexpected. The park boasts around three thousand cherry trees that bloom in springtime as well as maple trees in autumn for shades of yellow, orange, and red. You can also find 100-ft/32-m-high Yoro Falls here, one of Japan's most idyllic waterfalls, loved by writers and artists. For art and nature lovers, the Site of Reversible Destiny will hit the spot. This conceptual art project developed by contemporary artist Shusaku Arakawa and poet Madeline Gins is a created landscape containing a series of pavilions, billowing planes, shifting colors, and disorienting spaces that play with the visitor's sense of balance and perspective.

479 Treat in the fall

Daigoji, Kyoto, Japan

Longitude: 139.7° E
When to go: October to December for fall colors

At the foot of Kyoto's Mount Hiei lies the Daigoji temple complex, home to around seventy temples, bridges, and pagodas. The most significant is the five-story Goju-no-to Pagoda, the oldest building in Kyoto. But the star of the show is the tiny Benten-dō hall, a small red altar dedicated to the goddess Benzaiten. Situated on a small island surrounded by a picturesque lake, the altar is connected to the land by a carmine-colored bridge. This pretty lakeside scene is particularly gorgeous in the fall, when the leaves of the surrounding forests turn ruby and gold, dotted with the electro-bright yellow of ginko trees.

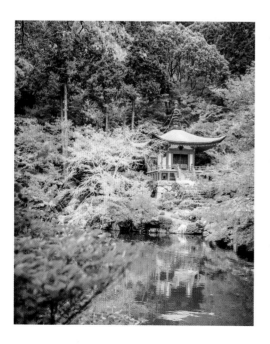

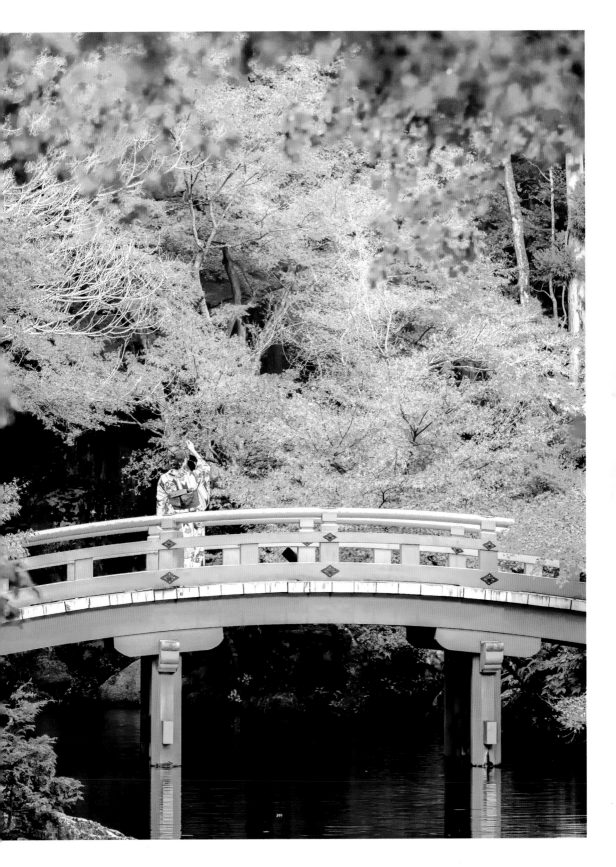

480 In the land of Dr. Seuss

Hitachi Seaside Park, Hitachinaka, Japan

Longitude: 140.5° E
When to go: All year, but best from late April to early May

Known for its spectacular displays of seasonal plants, the biggest draw at Hitachi Seaside Park are the fields of nemophila, which bloom during mid-spring. Also known as Baby Blue Eyes, around 4.5 million of these dainty little flowers coat the slopes of Miharashi Hill, carpeting it in a gorgeously soft powder blue.

481 Say it loud

Shinsekai, Osaka, Japan

Longitude: 135.5° E
When to go: All year

Jam-packed with cheap shops, Shinsekai in Osaka, is a vibrant area most famous for the iconic Tsutenkaku Tower. The technicolor district was modeled after New York and Paris. Modern and filled with bright and gaudy signage for countless restaurants, the run-down carnival vibes make it come to life.

482 Could it look more Japanese?

Seigantoji Pagoda, Wakayama, Japan

Longitude: 135.9° E
When to go: All year

Deep in Japan's Wakayama Prefecture, a region known for soy sauce, fresh tuna, and beautiful mountains, is one of the most quintessentially Japanese views you'll ever see. At 436 ft/133 m, Nachi Waterfall is the tallest waterfall in Japan. It sits close to the beautiful Seigantoji Pagoda—a bright red three-story structure.

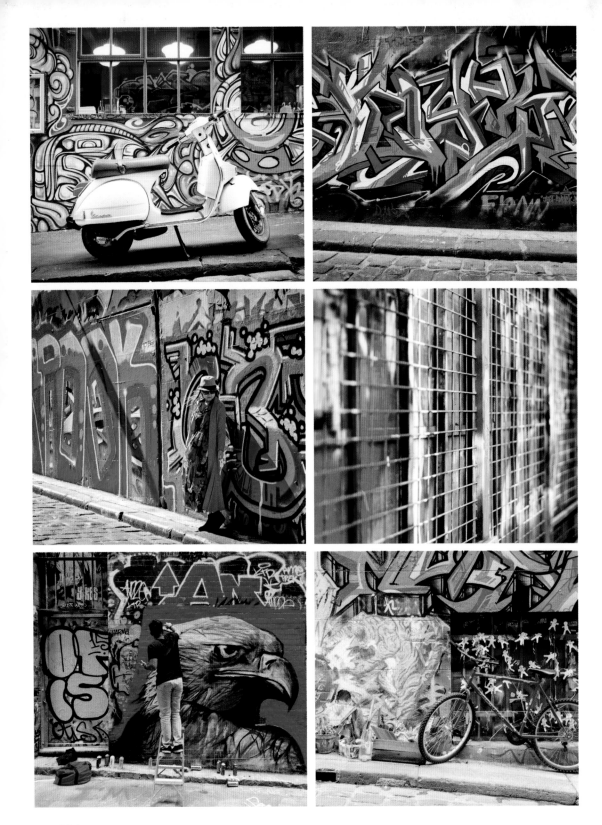

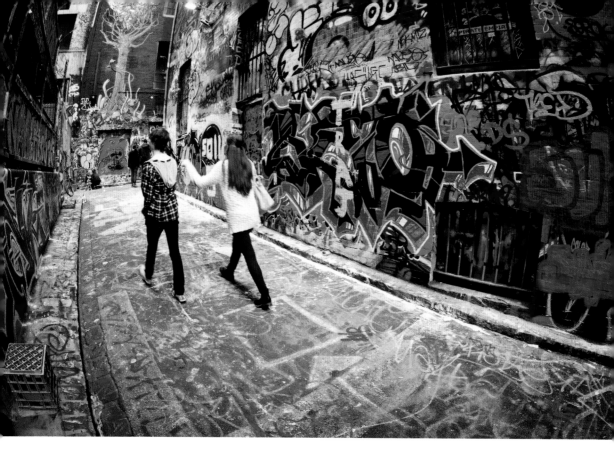

483 Art for all

Hosier Lane, Melbourne, Australia

Longitude: 144.9° E
When to go: All year

Melbourne's street art scene is internationally recognized and Hosier Lane is front and center and in your face. The stretch between Flinders Lane and Flinders Street gained notoriety as a place for street art in the 1990s and grew, hosting events such as All Your Walls in 2013, where more than one hundred local artists were invited to repaint the entire street. Now, almost every inch of the laneway is touched by artistic magic. Outside of Hosier Lane there is an impressive array of street art scattered throughout the city. Other areas include Centre Place, AC/DC Lane, the Keith Haring mural, Caledonian Lane, Croft Alley, and Duckboard Place. The city of Melbourne has also taken the love for street art to the next level by creating a mentoring program for young people between thirteen and twenty-five who have an artistic interest in the medium. Fostering spaces and artists, it's clear why Melbourne garners international attention for its art.

484 Stunning views and rainbow hues

Table Cape Tulips, Table Cape, Tasmania, Australia

Longitude: 145.7° E
When to go: October

An extinct volcanic vent with dramatic cliff drops into Bass Strait is home to the largest open tulip fields in the southern hemisphere. Farming on the land since 1910, the Roberts-Thomson family imported their first tulip bulbs from the Netherlands in 1984 and Table Cape tulips began. The stunning views and rainbow hues are a must-see annual delight.

485 Swirls of heaven

Whitsunday Islands, Australia

Longitude: 148.1° E
When to go: September

The gateway to the Great Barrier Reef, the Whitsunday Islands are home to one of the best beaches in the world. Bright powdery sand on Whitehaven Beach can't be found on any other island in the archipelago, making it a mysterious paradise. Surrounded by the bluest water imaginable, the islands really are a dream.

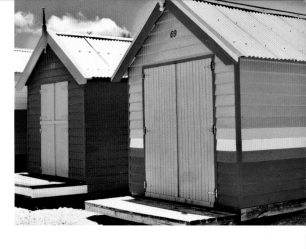

486 Modest beginnings

Brighton Beach Boxes, Dendy Street Beach, Melbourne, Australia

Longitude: 144.9° E
When to go: September to May for best weather

Like many things bright and beautiful, these boxes are a social media sensation, but their history goes much further back than Instagram or Facebook. Over one hundred years old, they are iconic to Dendy Street Beach and the Melbourne beach scene. Originally used as covered change areas for female swimmers, the boxes are now privately owned and used as a sheltered place to sit on the beach or a spot to store beach necessities. There were calls to tear them down in the 1950s and 1970s, but they survived both and were then painted the bright colors they are today. Since only a limited number of the eighty-plus boxes still exist, they are often passed down from generation to generation.

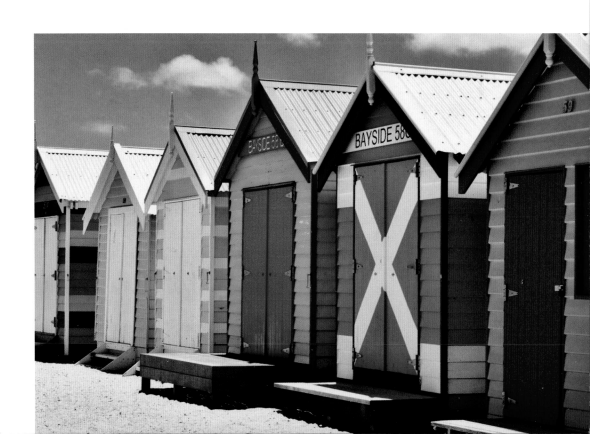

487 Surf's up

▼ Piha Beach, New Zealand

Longitude: 174.4° E
When to go: November to April

Black sand, the result of high iron content, covers the coast of Piha Beach, a popular surfing beach in New Zealand. Deemed the birthplace of New Zealand board riding in 1958, Piha Beach is the perfect place to watch surfers ride the bright blue waves of the Tasman Sea.

488 It's OK if you're caught

Bondi Beach Sea Wall, Sydney, Australia

Longitude: 151.2° E
When to go: All year

Bondi's famous beach has more to it than the sand and surf. Along the seawall is a rotating display of street art that is renowned for its talent and heart. With origins in the 1970s and 1980s when graffiti was the thing to do (and not get caught), it has since become a community space for young artists, and has grown into an internationally recognized place for street artists to showcase their work.

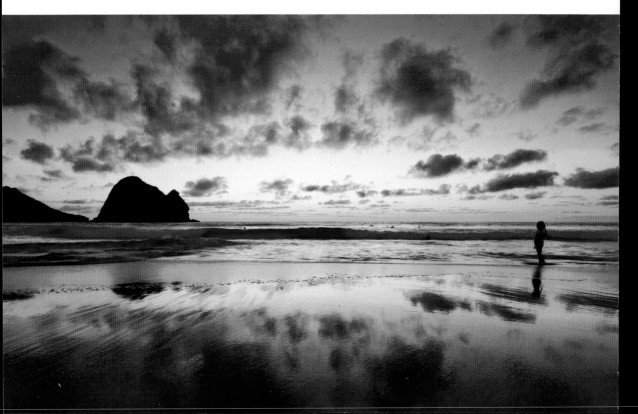

489 People as canvas

◀ Vanuatu Color Festival, Le Life Resort, Vanuatu

Longitude: 166.9° E
When to go: September or October (check dates beforehand)

Dress in white to party at this dance festival with a difference: Every hour, colored powder is thrown over guests, transforming their washing-commercial white outfits into a multicolored rainbow. Set on a beach on this stunning island, if it all gets too bright, just wash it away in the surf.

490 Storybook dreams

Lake Tekapo, Mackenzie Basin, South Island, New Zealand

Longitude: 170.4° E
When to go: November to December for lupine season

Lake Tekapo shines turquoise thanks to glacier water flowing from the Southern Alps, and from November to December the lupines bloom, creating an idyllic storybook mountain scene. Part of the Aoraki Mackenzie International Dark Sky Reserve, it's best to go while the sun's up for the blue water, and stay for a night under the perfectly visible stars.

491 Purple haze

Jacaranda Trees, Grafton, Clarence Valley, Australia

Longitude: 152.9° E
When to go: Mid-October to mid-November

Jacaranda trees are an iconic springtime sight in Australia, but to celebrate this natural beauty properly, the place to go is Grafton. Every year when the trees are in full bloom, the town holds the Jacaranda Festival, ten days of parades and parties—with everything purple to pay tribute to these blossoming beauties.

492 So much to see, under the sea

Njari Island, Solomon Islands

Longitude: 156.4° E
When to go: May to September

Two-hundred-and-seventy-nine different fish species call the transparent aquamarine water of Njari Island in the Solomon Islands home. The small island, located in the South Pacific, is almost entirely covered in trees and is surrounded by a vibrant coral reef that gives divers a chance to see undersea life like nowhere else.

493 Legends of the flip

▲ Aoraki/Mt. Cook National Park, New Zealand

Longitude: 170.2° E
When to go: All year

According to the Ngai Tahu legend, Aoraki and his three brothers were canoeing through the sea when their canoe flipped and they climbed on top, turning to stone in the wind. The canoe became the South Island and the brothers, the peaks of the Southern Alps. The backdrop to this story is Mt. Cook National Park with its spectacular lakes and views.

494 Where oceans collide

Cape Reinga, New Zealand

Longitude: 172.6° E
When to go: January and February

Standing on the grassy edge of a steep rocky cliff is the Cape Reinga Lighthouse. Watching over the Tasman Sea and Pacific Ocean, the white lighthouse overlooks an ombre of blue water. Translated from Maori, Reigna means "Leaping-off Place of Spirits," and it is here that Maori spirits return to their ancestral homeland.

495 Peace in the flowers

Little Paradise Lodge and Dream Garden, Mount Creighton, South Island, New Zealand

Longitude: 168.4° E
When to go: All year

Located on Lake Wakatipu close to the action of Queenstown, Little Paradise Lodge offers a whimsical break from the adrenaline-pumping activities of its neighbor. With over forty thousand daffodils and three thousand roses and lilies that stand over 13 ft/4 m tall, this garden escape is a flower lover's dream.

496 Art therapy to heal a city

◀ Street art, Christchurch, New Zealand

Longitude: 172.6° E
When to go: All year

The street art in Christchurch began as a response to the devastation left by the earthquake of 2011. Many buildings were so badly damaged that they had to be demolished, which left the large empty walls of neighbouring buildings exposed. In 2013, art collector George Shaw mounted a street-art festival, and commissioned new works for these walls. The city is now full of murals. Enjoy them independently as you explore or take a guided walk to learn more about the artists behind them.

497 Unbelievable blue

Hokitika Gorge, New Zealand

Longitude: 171.0° E
When to go: June

The vivid turquoise water of the Hokitika Gorge looks more like a fluorescent sports drink than a river. Its unique color comes from the Southern Alps and glaciers that lead down to the gorge. Rock flour, which is ground-down mineral-rich rock and sandstone, suspends itself in the water, creating an almost glow-like effect. A swinging rope bridge hangs over the water, creating a passageway into the deep forest and onto winding hiking trails.

498 Wine not

Marlborough, New Zealand

Longitude: 173.4° E
When to go: March to July

From valleys of vines to sheltered waterways, the golden wine country of Marlborough is a field of dreams. Known for its famous Sauvignon Blanc and Pinot Noir, the colors of Marlborough are constantly changing. Every nook and cranny of the region is covered in lines of vines that transform from bright shades of green to hues of orange with the seasons. Surrounded by the Marlborough Sounds, the winding river valleys colored blue and green flow toward the Pacific Ocean.

499 Bath bombs with a difference

▲ Wai-O-Tapu, New Zealand

Longitude: 176.3° E
When to go: Fall and spring

Possibly one of the most surreal places in the world, the thermal wonderland of Wai-O-Tapu is home to a series of smelly sulfur mud pools, colored geothermal pools, and exploding geysers. Lady Knox Geyser blows a pillar of water into the sky each and every day. The Devil's Bathtub, an iridescent lime green pool, colored by sulfur floating on the surface, resembles a toxic bathtub. Nearby gray, sludgy mud pools spit, cough, and bubble mud onto the outer edges.

500 Lusty legends

Mount Taranaki, New Zealand

Longitude: 174.0° E
When to go: All year

An active volcano lies dormant on the west coast of New Zealand's North Island. Although the last eruption was hundreds of years ago, Mount Taranaki has erupted over 160 times in the last 36,000 years. Considered one of the most symmetrical volcano cones in the world, Mount Taranaki is shrouded in local legend. It is said Taranaki was banished to the west for making romantic advances toward a mountain named Pihanga, causing the Tongariro volcano to erupt in jealousy. Oh, those lusty mountains.

INDEX

IMAGE CREDITS

t = top, b = bottom, l = left, r = right, m = middle

Alamy: David Litschel front cover trm; Alan Majchrowicz 16bl; Javier Lira/NOTIMEX/Xinhua/Alamy Live News 24tl; David Litschel 27; Leigh Green 31t; Sandra Nykerk 31br; Inge Johnsson 35; Steve Bly 40l; Ellen Issacs 44bl; Javier Lira/NOTIMEX/Xinhua/Alamy Live News 48t, lm, bl; George Oze 59lm; Oliver Wintzen 59bl; age fotostock 60–61; Aliaksei Skreidzeleu 70bl; Sébastien Lecocq 76tr, rm; Seaphotoart 79tr; Randy Duchaine 81; Greg Balfour Evans 97tl; Juergen Ritterbach 103bl; Pep Roig 105tr; Jesse Kraft 105br; age fotostock 109; David South 112b; Rubens Alarcon 113; Michael Dwyer 116trm; Danita Delimont 116bl; Mauritius Images GmbH 119; Aliaksei Skreidzeleu 122t; Panther Media GmbH 122rm; Simon Holmes 123tr; Pulsar Imagens 123m; Robert Harding 123rm; Robert Pekar 126–127; Neil Luxford 128tl; Mauritius Images GmbH 129tr; John Warbuton-Lee Photography 129bl; Nik Wheeler 130l; Andrew Woodley 130br; Mike Saint 151tr; Nature Picture Library 153tr; Howard Litherland 153bl; Janos Gaspar 155tr; age fotostock 157t; Juan Carlos Muñoz 157br; David Rice 165lm; Guillermo Avello 168tr; Flyby Photography – www.flybyphotography. co.uk 172tl; Juan Bautista 173br; Peter de Kievith 180; Stefano Politi Markovina 184; Westend61 GmbH 185tr; CARTA Image 189tl; Hemis 189tr, b; Marina Spironetti 193tr, rm, bl, bm; Richard Downs 193br; ZUMA Press, Inc. 202; eye35.pix 204b; Eckhard Supp 209t; Jan Wlodarczyk 217tl; Ian Furniss 217br; Peter Forsberg 220; Eric Nathan 223rm; Viktor Drachev/TASS/Alamy Live News 228; Jochen Tack 230; Berengere Cavalier 245; Agencja Fotograficza Caro 250; Lukas Bischoff 258; PixelPro 296lm, 318b; Max Grizaard 351r; James Talalay 358; Leonardo Villasis 360–361; Rouelle Umali/Xinhua/Alamy Live News 362; Rouelle Umali/Xinhua/Alamy Live News 363tl, tr, b; Visual360.co.uk 370tr, l; Wibowo Rusli 372; Edmund Sumner-VIEW 373; Hemis 391lm

Dreamstime: Outline205 12tl; Outline205 20t; Denis Belitskiy 253br

Getty Images: REDA&CO/Universal Images Group via Getty Images 6; Mienny 16tr; Ericka Goldring 52lm; Mark D Callanan 56m; apomares 100; Aizar Raldes/AFP 102t, br; Marco Simoni/Robert Harding 112tr; Henryk Sadura 116tr, m, rm; peeterv 122br; Dougall Photography 144tr; Cesar Manso/AFP/Getty Images 148; Cesar Manso/AFP/Getty Images 148–149; Tom Bonaventure 152; nyxmedia 153lm; OLI SCARFF/Stringer 155bl; Iñaki Marquina Fotografía 157bm; Tristan Fewings/Stringer 165t; REDA&CO/Universal Images Group via Getty Images 192; Frédéric Soltan/Corbis via Getty Images 215tl, rm, bl, br; xavierarnau 254tr; xavierarnau 269; Stuart Freedman/In Pictures via Getty Images 274tl; Yousuf Tushar/LightRocket via Getty Images 275; JOHANNES EISELE/AFP 288tl; Alberto Mazza/500px 349; Tomohiro Ohsumi/Bloomberg 370rm; Katsuhiro Yamanashi/Aflo 371rm; Nazar Abbas Photography 388; Matteo Colombo 392br

Pixabay: skeeze 19bl; otsuka88 106; olafpictures 132; Mojpe 197tr; Efraimstochter 204tr; VISHNU_KV 272tr; vinatourist83 293; smartlang 320br; adrimarie 384lm

Shutterstock: ConanEdogawa front cover tl; 54613 front cover tlm; Carlos Neto front cover brm; muratart 2–3; Abbie Warnock-Matthews 14bl; Sean Lema 17; Didi Marie 19tr; Checubus 20rm; yhelfman 23t; joojoob27 23lm, rm; Jess Kraft 24rm; Lukas Bischoff Photograph 28–29; Hue Chee Kong 34; Scott Prokop 36bl; Lorcel 37; Richard Susanto 41bl; Dina Julayeva 42–43; Jessica Leyva 45; kan_khmpanya 46; Lucy Brown – loca4motion 49; Don Mammoser 50; amadeustx 52tl; Dawn L Adams 52tr; GTS Productions 52rm; Matthias Bachmaier 54; Jess Kraft 54–55; Johanna Veldstra 56t; Stephanie Free 56rm; aksenovden 57; John A. Anderson 59tr; Fotos593 63tr, m; Gabriele Maltinti 66lm; Mia2you 66tl, tr; Alexander Demyanenko 66rm; mariakray 68–69; sunsinger 70tl, 114t; jackbolla 73tl; Swedishnomad.com – Alex W 73br; Martina Birnbaum 74tl; ElvK 74br; Daniel Andis 76b; Fotos593 77lm; SL-Photography 77bl; Tonyz20 78t, rm; Daniel Korzeniewski 78lm; Pam Blizzard 78m; VarnaK 85bl; Iris van den Broek 87; Jess Kraft 88l; Manon van Goethem 89; Anne Richard 92–93; Styve Reineck 96rm; Gail Johnson 96br; Gem Russan 97lm; J. Karsh 97rm; Gerardo Borbolla 97br; Piu_Piu 98; eFesenko 98–99; Daboost 101; Gina Smith 103tr; vincent noel 103rm; Elzbieta Sekowska 104; anyisa 105tl; amkskad 118; saiko3p 120–121; R. M. Nunes 123lm; cineuno 124lm; Papuchalka – kaelaimages 128tr; Daria Medvedeva 131tl; Jon Chica 132–133; Vlad G 135; Carlos Neto 138br; Balate Dorin 139tl, lm; Hugh O'Connor 140–141; Ser Borakovskyy 142–143; Del Boy 143; Jose Arcos Aguilar 144bl; Massimo Santi 145; julpho 147bl; cineuno 150; Julio F 154t; LVV, 159t; Clive Chilversbl 160bl; Bikeworldtravel 161tl; DrimaFilm 163lm; EQRoy 163rm; Dave Smith 1965 165bl; blackboard1965 166tr; HelloRF Zcool 168b; Alessandro Colle 172br; Luciano Mortula – LGM 173tl; Dejan Gileski 173lm; Rodrigo Garrido 174tr, fokke baarssen 175tr; MarinaD_37 175bl; Marc Venema 178; Kiev.Victor 179; Stray Toki 180–181; Allard One 182; leoks 185bl; Pixhound 186tl; Nella 186rm; Boris Stroujko 186br; lara-sh 187; Alex Emanuel Koch 190; Olga Gavrilova 191t; TessarTheTegu 191rm; Lizavetta 194tl; monticello 195; funkyfrogstock 197b; Nikolay Antonov 198lm; Takako Picture Lab 198bm; Olga Gavrilova 199; Jule_Berlin 201tr; gary718 201lm; meunierd 201rm; liseykina 203tl; unterwegs 205; lukaszimilena 208tr; Mistervlad 208b; Henryk Sadura 209rm; MarinaD-37 210; Tatyana Bakul 211; May_Lana 212tl, lm; Lukasz Stefanski 212br; aerocaminua 213t; posztos 213br; aniad 214; trabantos 216t; Banet 216b; Madele 219tr; Quality Master 219rm; Marie-Anne AbersonM 219bl; PHOTOARTDESIGN 221bl; Subodh Agnihotri 222tr; BlueOrange Studio 222rm; SchnepfDesign 223t; cge2010 225; May_Lana 226; Andrew Mayoskyy 227t; cge2010 227br; ImagIN.gr Photography 229tr, rm; AlexelA 229bl; M.Igor 231t; Subodh Agnihotri 231lm; GTS Productions 231br; fokke baarsen 232tl, tr; muratart 233; blackboard1965 234; Dudarev Mikhail 235tl; Dance60 235br; Kokhanchikov 236tl; Mazur Travel 236lm; ConanEdogawa 236br; V_E 237; Katvic 238t; Popova Valeriya 238rm; dimbar76 239tr; Bibiana Castagna 239bl; ArtPanupat 240–241; dimbar76 241; Yulia_B 242; Tuzemka 243tl; AlexelA 243lm; Nick Brundle 243br; muratart 244; Ivy Yin 249t; James Harrison 249br; Sun_Shine 252tr; Ciprian23 252rm; paulthefreeman 252br; SAPhotog 253tl; Koverninska Olga